Til Wrong

Feels Right

IGGY POP

'Til Wrong Feels Right

CLARKSON POTTER/PUBLISHERS
New York

CONTENTS

INTRO

These are the words that came to me. They came on foot, horseback, in an Eldorado, by motorcycle; staggering, gun to my head, gun in my belly, needle in my arm, joint in my mouth, pills in my bloodstream, but no matter how they got here, they did the fucking job. Here are prophecy, idiocy, an eye for detail and delusions of grandeur. Their burden is heavy, my brain hurts. But they are my pride and joy, and that is that.

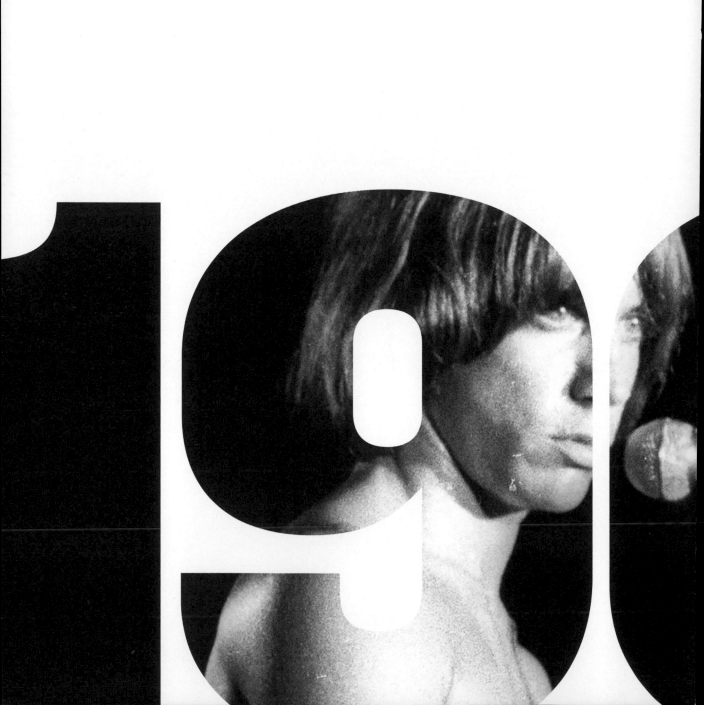

Dope, dope, dope. Fucking Vietnam. Nixon lurking behind everything. Joy and insecurity of being young. Discovery of black culture. Oblivion necessary to escape America. Birth control, LSD, love and pain.

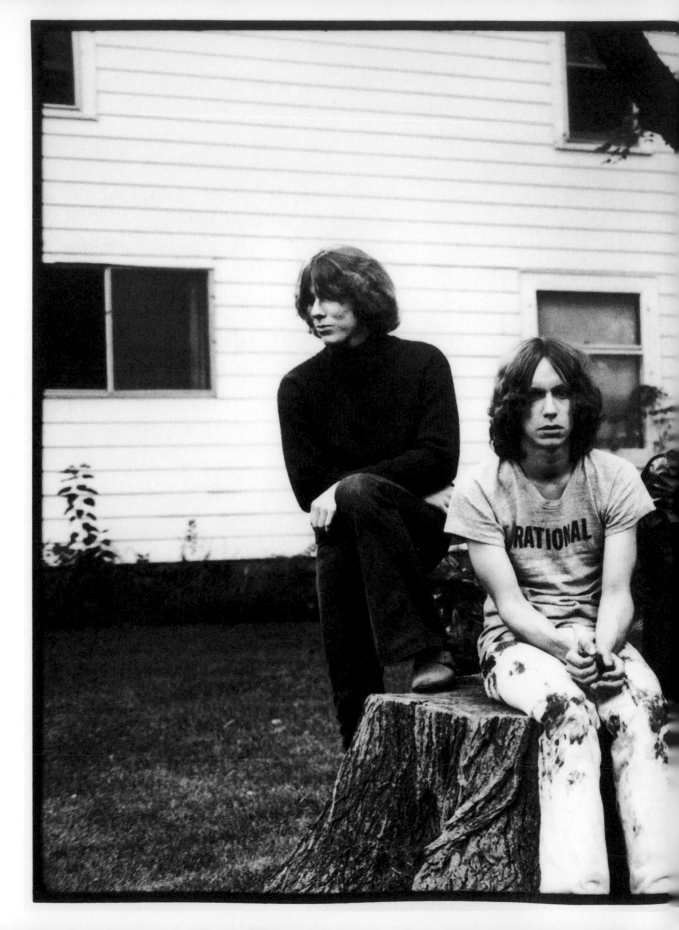

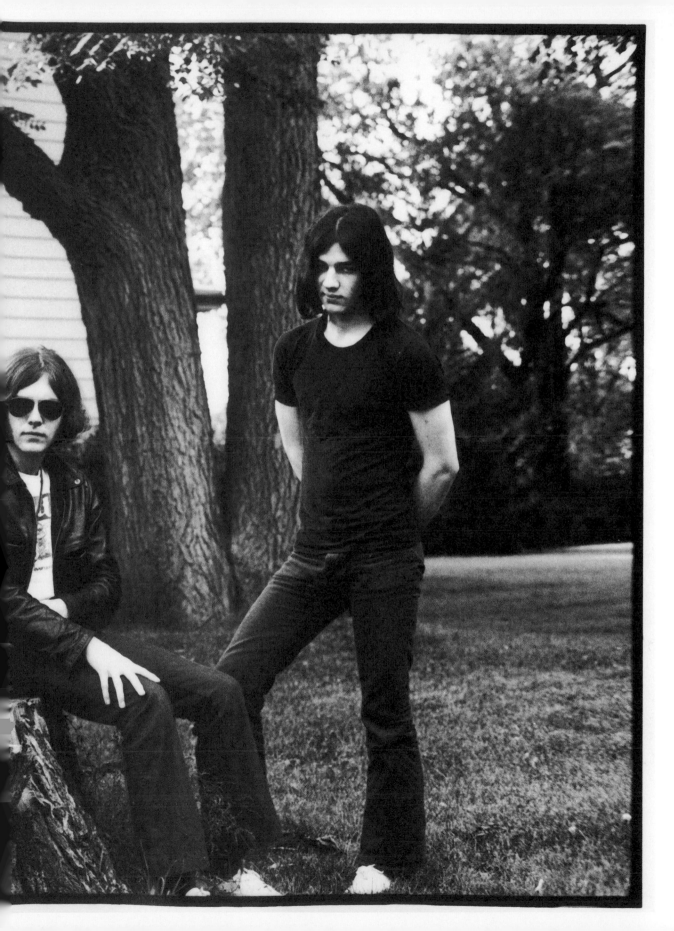

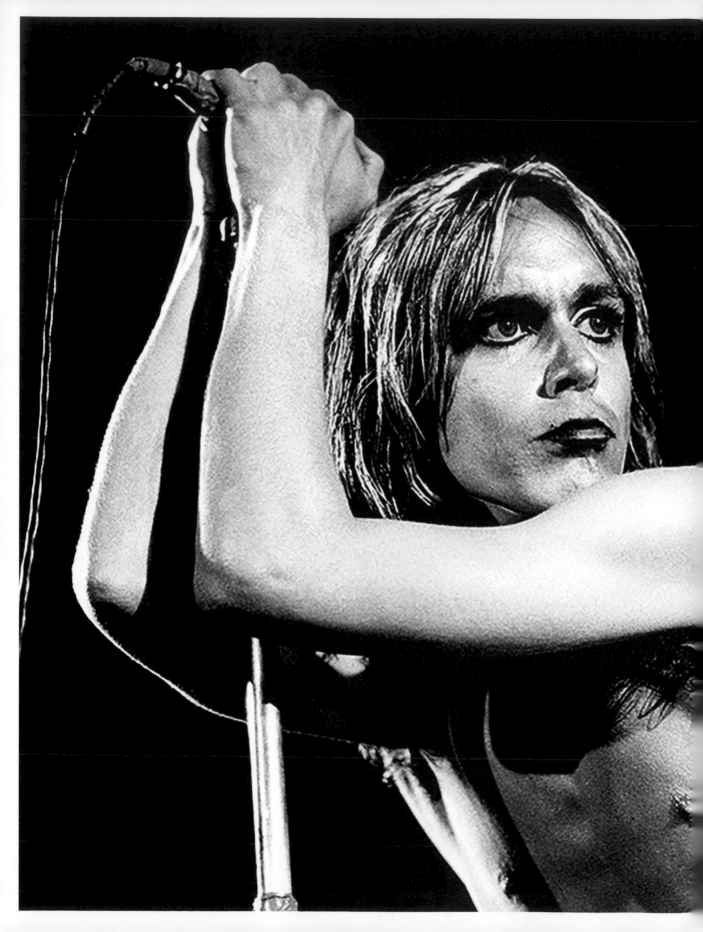

1969

(1969)

Well, it's nineteen sixty-nine okay
All across the USA
It's another year for me and you
Another year with nothing to do
Well it's another year for me and you
Another year with nothing to do

Now, last year I was twenty-one,
I didn't have a lot of fun
And now I'm gonna be twenty-two,
I say oh my and boo-hoo
Now I'm gonna be twenty-two,
Oh my and a boo-hoo

Well, it's nineteen sixty-nine, okay
All across the USA
It's another year for me and you
Another year with nothing to do

It's nineteen sixty-nine
Well, it's nineteen sixty-nine
Well, it's nineteen sixty-nine, baby

It's nineteen sixty-nine, baby

Well, it's nineteen sixty-nine
Well, it's nineteen sixty-nine
Well, it's nineteen sixty-nine
Well, it's nineteen sixty-nine
Well, it's nineteen sixty-nine, baby

Well, it's nineteen sixty-nine, baby

Well, it's nineteen sixty-nine, baby

NOT RIGHT
(1969)

She
Not right
I want something
I want something
Tonight
I want something
I want something all right

But she can't help 'cause she's not right

No, no, no, no
It's always
Well it's always this way

I
I'm not right
She wants something
She wants something
Tonight
She wants something
She wants something, all right

But I
Can't help
'Cause I'm not right

No
And it's always
And it's always this way

And it's
Always

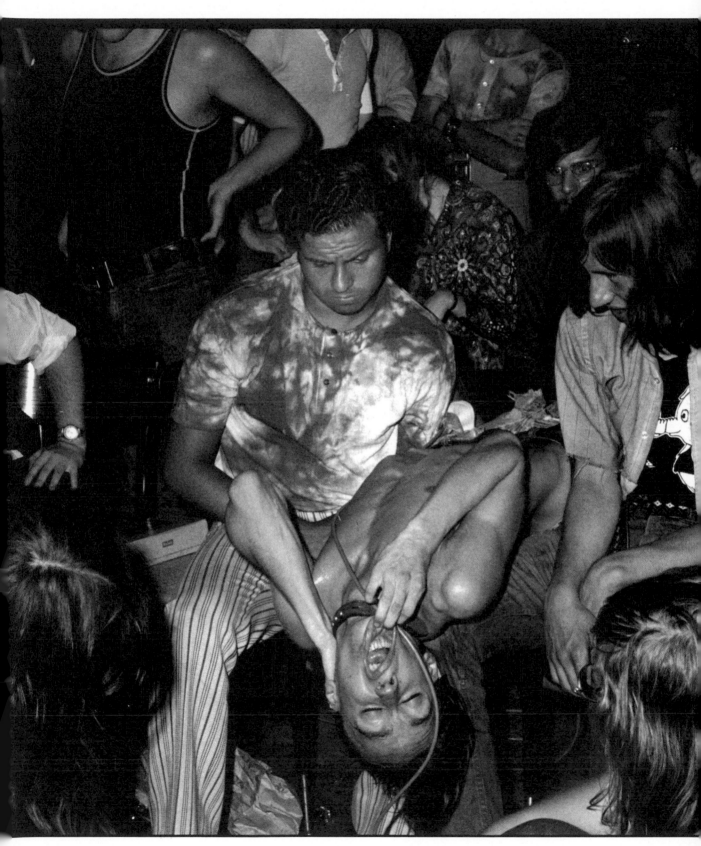

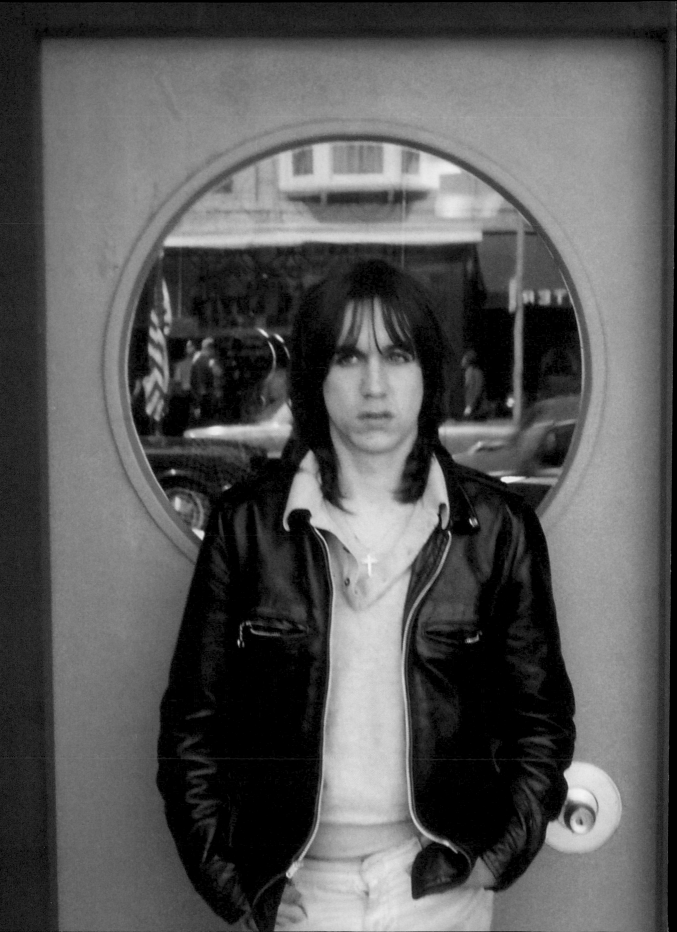

REAL COOL TIME

(1969)

Can I come over, tonight?
Can I come over, tonight?
What do you think I wanna do?
That's right
Can I come over tonight?

I say we will have a real cool time, tonight
I say we will have a real cool time, tonight
I say we will have a real cool time
I say we will have a real cool time, tonight

I'd say we will have a real cool time, tonight
I say we will have a real cool time
We will have a real cool time
A real cool time, tonight

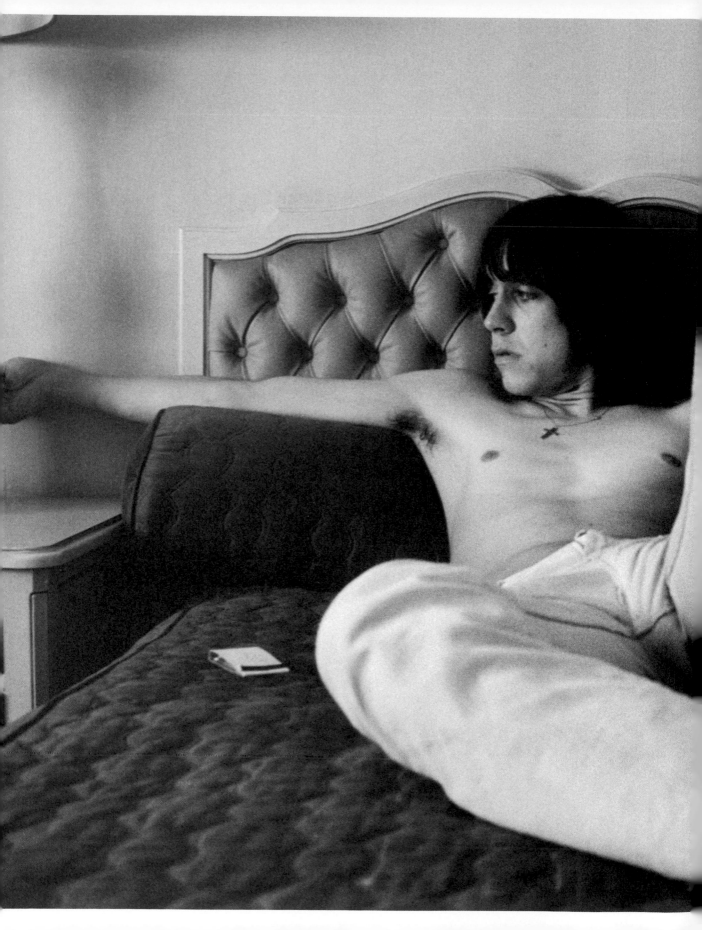

ANN (1969)

You took my arm and you broke my will
You made me shiver with a real thrill
You took my arm and we walked along
Down the road to a quiet song
I looked into your cool, cool eyes
I felt so fine, I felt so fine
I floated in your swimming pools
I felt so weak, I felt so blue
Ann
My Ann
I love you
Ann, my Ann
I love you
Right now

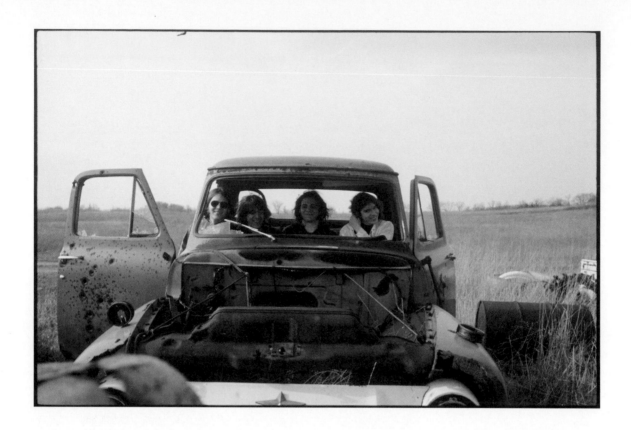

I started out with Syd Bernstein - the guy who took The Beatles and The Stones and The Who to the States. I ended up being part of the team that managed big jazz and blues artists - B B King and Miles Davis. So my photography's always gone alongside my work in the music industry. Working with musicians, producers and songwriters, you see a lot, and I tend to be a more fly-on-the-wall kind of guy.

I found out about The Stooges through Danny Fields, Josie Mori and her friend Natalie Schlossman. Danny and Josie were working at Elektra at the time and we'd crossed paths a few times over the years. Natalie was this huge Stooges fan, they called her Natalie Stoogeling. Danny mentioned to me that he'd seen this band

up in Detroit. "What do you think about going up there?" I said okay. Next thing I know I'm on a plane to Detroit, and then on to Ann Arbor.

It was kinda interesting, to say the least. I saw a whole lot of stuff at the Stooge House. Drugs. Sex. The usual.

Iggy was working at a record store in Ann Arbor. At that time, the hippy movement was just beginning, and he was very much influenced by the experimental music they played at the store - Sun Ra, jazz, things like that. I think it really spearheaded his direction in some ways - he had very broad tastes.

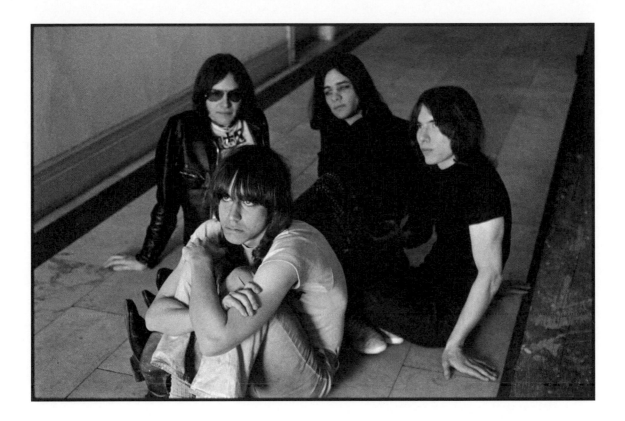

There was a really interesting Detroit scene that they were a part of. You had MC5, and you had John Sinclair and all of this experimental music was happening parallel to Motown, too, of course. The Stooges were in the middle of it all. Now, the two brothers, Scott and Ron, they were the driving force musically for that kind of proto-metal, not-yet-punk, powerhouse style. I think they chose Dave because he had a car.

I like to work as a fly on the wall. Get to know the guys, hang out, and then when the band's relaxed, just start shooting.

I stayed at the house for two weeks and after that we headed down to New York. They were starting work on their first album. I remember in the studio, they had these big Marshall stacks with everything turned up to ten, and John Cale from the Velvet Underground was screaming at them, "Turn the fuckin' amps down!" John's mixes didn't make the album.

One weird thing I remember about that time was that their manager's wife, Susan Silver, was kind of a semi-hippy. It was the late 60s. Now when I think Stooges, I think, you know, maybe burgers. Meat and potatoes. Beer. But because of Susan, they only ate a macrobiotic diet of whole grains and cereals and veg. Macrobiotic diet. It was kind of interesting to me.

Glen Craig

i wanna
Be

I WANNA BE YOUR DOG
(1969)

So messed up, I want you here
In my room, I want you here
Now we're gonna be face-to-face
And I'll lay right down in my favorite place

And now I wanna be your dog
Now I wanna be your dog
Now I wanna be your dog
Well, come on

Now I'm ready close my eyes
And now I'm ready close my mind
And now I'm ready feel your hand
And lose my heart on the burning sands

And now I wanna be your dog
And now I wanna be your dog
Now I wanna be your dog
Well, come on

Your
dog

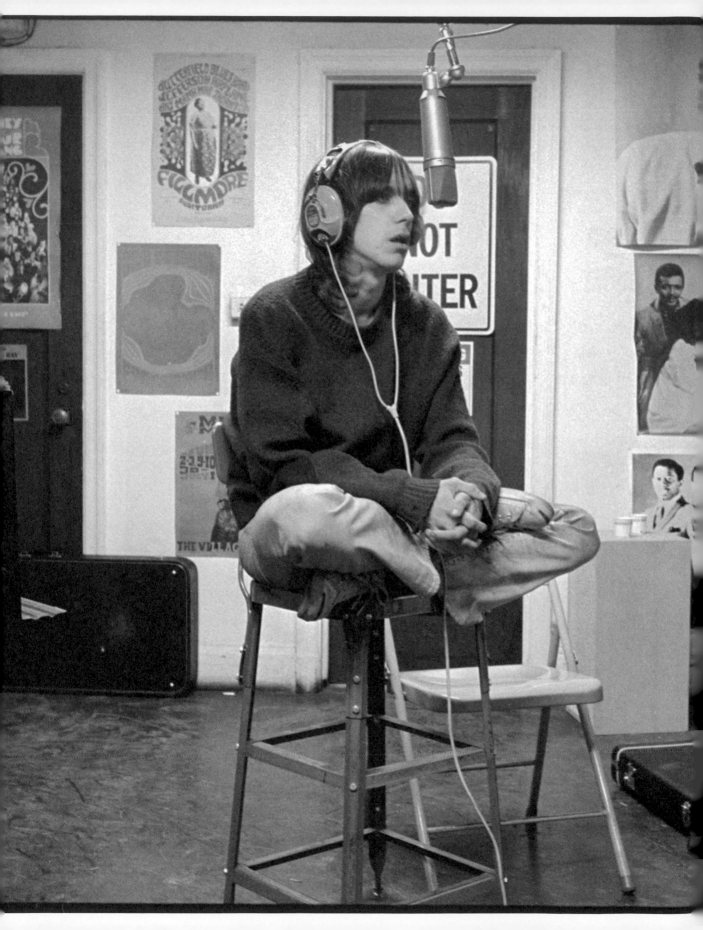

LITTLE DOLL
(1969)

Little doll, I can't forget
Smoking on a cigarette
In my life, a real queen
Prettiest thing I ever seen
Uh-huh

You're the one who makes me sing
Bring happiness and everything
You're the only real one
A real way to have some fun
Uh-huh

But I don't know you, little doll
I don't know you, little doll
Come on shake
Come on shake
Come on shake, you little doll
Shake you little doll
Come on . . . shake
Come on shake
Shake you little doll

No fun, my babe

No fun

No fun, my babe

No fun

No fun to hang around

Feelin' that same old way

No fun to hang around

Freaked out

For another day

No fun, my babe

No fun

No fun, my babe

No fun

No fun to be alone

Walking by myself

No fun to be alone

In love

With nobody else

Well, maybe go out, maybe stay home

Maybe call Mom on the telephone

Well c'mon, well c'mon

Well c'mon, well c'mon

Well c'mon, well c'mon

Well c'mon, well c'mon

No fun to be alone

No fun to be alone

Hang on

Don't you lemme go

No fun to be alone

I said to be alone

I said to be alone

No fun

Well I say, I say c'mon, Ron, I say

I say c'mon, Ron

I say c'mon, Ron, and lemme

I say c'mon, Ron, and lemme hear you tell 'em

Lemme hear you tell 'em how I

Tell 'em how I, tell 'em how I

Tell 'em how I, tell 'em how I

Tell 'em how I feel

I say c'mon and tell 'em, tell 'em how

I feel

Yeah, yeah, yeah

Well c'mon

Well c'mon

Well c'mon

Well c'mon

Well c'mon

Well c'mon

Well c'mon, yeah

Yeah, man

I say, I say, I say-say, c'mon

Lemme say it, c'mon

Lemme say it, c'mon

(1969)

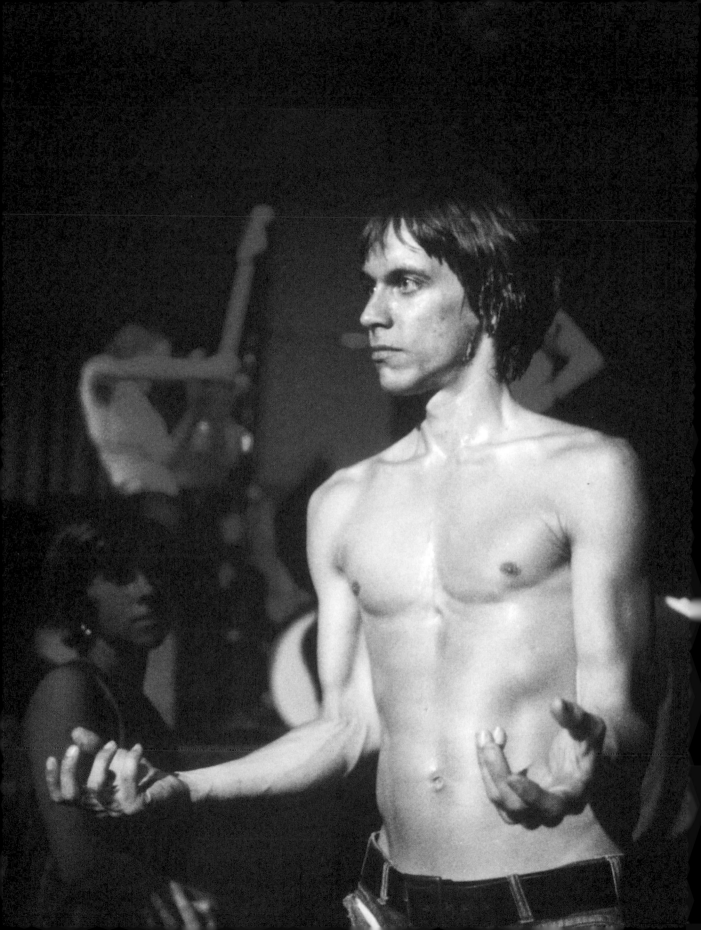

WE WILL FALL (1969)

Oh, gi, ran, ja, ran, ja, ja, ran
Oh, gi, ran, ja, ran, ja, ja, ran
Oh, gi, ran, ja, ran, ja, ja, ran
Tonight
(Oh, gi, ran, ja, ran, ja, ja, ran)
I'll hold myself tight
(Oh, gi, ran, ja, ran, ja, ja, ran)
I won't fight, I won't fight
(Oh, gi, ran, ja, ran, ja, ja, ran)
(Oh, gi, ran, ja, ran, ja, ja, ran)
Then I whisper to me
(Oh, gi, ran, ja, ran, ja, ja, ran)
Then I whisper to me
(Oh, gi, ran, ja, ran, ja, ja, ran)
Then I'll lay right down and I'll lay right down
(Oh, gi, ran, ja, ran, ja, ja, ran)
On my back, on my bed
(Oh, gi, ran, ja, ran, ja, ja, ran)
And I'll lay right down
(Oh, gi, ran, ja, ran, ja, ja, ran)
On my bed, on my bed
(Oh, gi, ran, ja, ran, ja, ja, ran)
In my hotel and I'll be in love
(Oh, gi, ran, ja, ran, ja, ja, ran)
Awake, all night
(Oh, gi, ran, ja, ran, ja, ja, ran)
All night, all night
(Oh, gi, ran, ja, ran, ja, ja, ran)
And in the mornin', I'll be ready
(Oh, gi, ran, ja, ran, ja, ja, ran)
To see you, to see you

(Oh, gi, ran, ja, ran, ja, ja, ran)
Don't forget to come, room 121
(Oh, gi, ran, ja, ran, ja, ja, ran)
Don't forget to come
(Oh, gi, ran, ja, ran, ja, ja, ran)
Oh, gi, ran, ja, ran, ja, ja, ran
I'll be shakin', I'll be tremblin'
I'll be happy, I'll be weak
(Oh, gi, ran, ja, ran, ja, ja, ran)
And I'll love you, and I'll love you and we'll fall to sleep
(Oh, gi, ran, ja, ran, ja, ja, ran)
We'll fall
(Oh, gi, ran, ja, ran, ja, ja, ran)
We'll fall
(Oh, gi, ran, ja, ran, ja, ja, ran)
Six o'clock, come
(Oh, gi, ran, ja, ran, ja, ja, ran)
Come, we'll fall
(Oh, gi, ran, ja, ran, ja, ja, ran)
We'll fall
(Oh, gi, ran, ja, ran, ja, ja, ran)
Come, good bye, good bye
(Oh, gi, ran, ja, ran, ja, ja, ran)
Good bye, good bye, bye
(Oh, gi, ran, ja, ran, ja, ja, ran)
Bye, bye
Oh, gi, ran, ja, ran, ja, ja, ran
Oh, gi, ran, ja, ran, ja, ja, ran
Oh, gi, ran, ja, ran, ja, ja, ran
Oh, gi, ran, ja, ran, ja, ja, ran
Oh, gi, ran, ja, ran, ja, ja, ran

Down on the street in my Cuban heels. Down in my Cuban heels on the street. In the street down on my Cuban heels. Everything is spinning. Sick and crazy. Also rather pretty. Nixon again. London fops parading King's Road in Boy Scout uniforms from Iowa. Sleek Hollywood girls with bottomless funds, relieved of all thought, Barney's Beanery. The Wall as a refuge that can stop Amerika. Lou Reed for form. Doors for beauty. Stones for freedom. Butterfield Blues Band for balls.

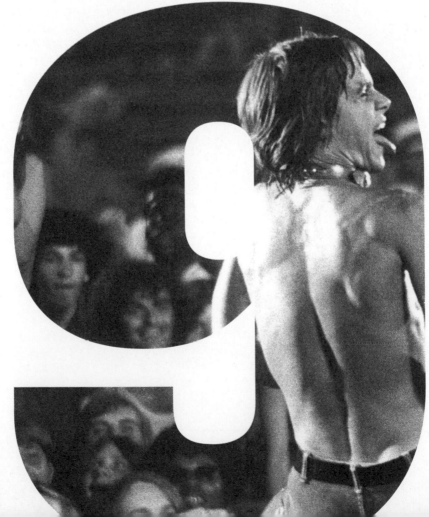

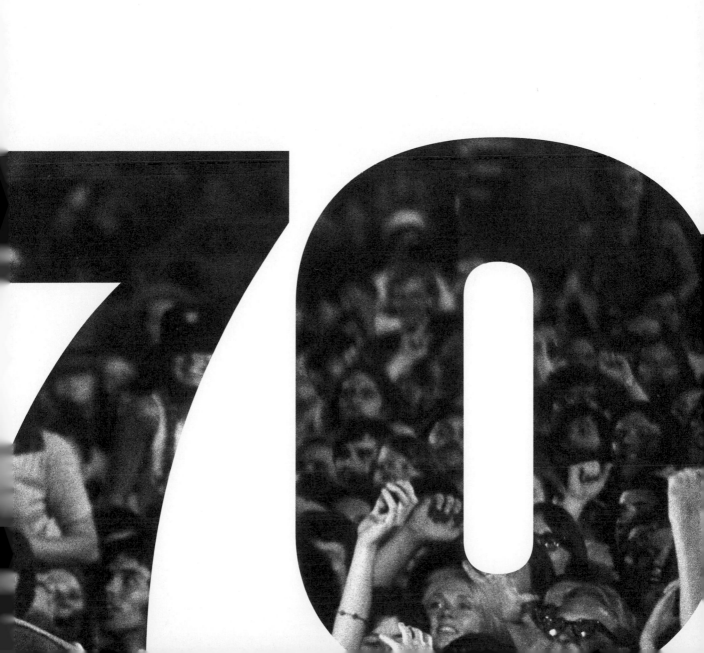

QUESTIONS

1. Iggy's real name is:
 ☐ David Jones
 ☐ Ignatus Pope
 ☐ Igor Sturgess
 ☐ James Osterberg
 ☐ James Pigby

2. His first band was called:
 ☐ Stormtroopers
 ☐ The Prime movers
 ☐ Jimmy and The Motherpuckers
 ☐ The gumbos
 ☐ Bald Alibis

3. The first person he co-opted for the Stooges was:
 ☐ Steve Mackey
 ☐ Zeke Zettner
 ☐ Ron Asheton
 ☐ Wayne Kramer
 ☐ Wayne Newton
 ☐ Duane Eddy

4. Had he been unable to fulfil his ambition to become 'the best singer in the world' Iggy suggested he might have become:
 ☐ a male prostitute
 ☐ a professional golfer
 ☐ a jockey
 ☐ a train driver

5. Iggy grew up in:
 ☐ a tenement block
 ☐ a caravan park
 ☐ Plum Street, Detroit
 ☐ borstal
 ☐ orphanage

6. How old is Iggy?
 ☐ Teenage
 ☐ 29
 ☐ 28
 ☐ Old enough to know better
 ☐ 30
 ☐ 3+

7. Iggy was born exactly:
 ☐ 28 years after the birth of Hitler
 ☐ 2700 years after the foundation of Rome by Romulus
 ☐ 22 years before the publication of the first Gigag
 ☐ 292 years after the Great Plague of London
 ☐ He was busted and jailed for indecent exposure in Romeo, Michigan
 ☐ He worked as a waiter during the early days of the Stooges

8. The Stooges first gig was:
 ☐ January 1967
 ☐ February 1968
 ☐ None of the above
 ☐ November 1960

9. Which of the following drugs shaped Iggy's future:
 ☐ hashish
 ☐ LSD
 ☐ tobacco
 ☐ alcohol
 ☐ heroin
 ☐ grass

10. Which of the following stories about Iggy and the First Stooges album are true?
 ☐ The First Stooges album was recorded in two days
 ☐ Frankly a lot of people aren't far out enough to understand lyrics so I don't write better by book ing into their ears for a minute than if I spent a day talking to him.
 ☐ I'm not a punk anymore... I'm a damned man!
 ☐ I could wipe the floor with the Eagles, Paco Jackson Browne and any of that L.A. shit.

11. Which of the following remarks is attributable to Iggy?
 ☐ I don't hardly fuck any more - except out of habit.

12. What was Iggy's course of action when racial strife gripped Detroit in the late sixties?
 ☐ He participated in the looting
 ☐ He went home to his mother
 ☐ He gave a benefit concert for
 [cut off]

13. The first time he met Tony de Fries (his subsequent manager), Iggy:
 ☐ was naked and proceeded to expose himself
 ☐ talked loudly and puked up ate six breakfasts
 ☐ embarrassed David Bowie by behaved with propriety
 ☐ demanded money for drugs

14. When Iggy quit Detroit for London in 1972, what did he miss most?
 ☐ Funky Spades
 ☐ Regular oats
 ☐ Bob Seger
 ☐ Baking in Lake Michigan
 ☐ Visiting John Sinclair in prison

15. Why did Guitarist James Williamson leave the Stooges in Summer 1973?
 ☐ He called Bowie a boring faggot
 ☐ Unrequited love for Dana Gillespie
 ☐ He was fired
 ☐ He missed the Stooges he was Napoleon
 ☐ He was homesick

16. What is Iggy's opinion of ex-manager Tony de Fries? Does he think he's:
 ☐ a wanker
 ☐ a great man
 ☐ an incompetent buffoon
 ☐ a lustful bugger
 ☐ a crook

17. Iggy almost died on stage at the Whisky A Go Go in LA. From what?
 ☐ a heart condition induced by excessive masturbation
 ☐ terminal syphilis
 ☐ physical exhaustion
 ☐ He drank 2 quarts of Tequila

18. When 'Raw Power' was released, Iggy had to borrow the money to buy a copy. Who from?
 ☐ Wayne Kramer
 ☐ Sable Starr
 ☐ Kim Fowley
 ☐ Mark P
 ☐ Marc Bolan
 ☐ Ian Hunter

19. Which of the following bands refused to appear on the same bill as the Stooges?
 ☐ Eagles
 ☐ Ramones
 ☐ Groundhogs
 ☐ Humble Pie
 ☐ T Rex
 ☐ Jethro Tull

20. 'Iggy pop sells sickness', 'rampant paranoia and mindlessness'. One of the following describes Iggy as a mad octopus, a lean and slimy caveman who had fallen into a battle of peroxide. Who wrote that?
 ☐ Mary Whitehouse
 ☐ Michael Watts
 ☐ Linda Solomon
 ☐ Clifferighton
 ☐ The Evening News

21. Ex-Stooge Ron Asheton recently formed a band in L.A. Who were they?
 ☐ Blood Spatter
 ☐ New Order
 ☐ Forces Sweethearts
 ☐ Los Angeles Fag Ends

22. Which of these singles was said to be about Iggy?
 ☐ All the Young Dudes - Mott the Hoople
 ☐ Jean Genie - David Bowie
 ☐ I'm bad - Kim Fowley
 ☐ Ziggy Stardust - David Bowie
 ☐ Through the eyes of Frost
 ☐ One take over the line Brewer & Shipley

23. Who said this: 'Iggy Pop is the real 45. If he doesn't make big (and I mean BIG) in the new year (1974), I'll lock myself away and listen to James Taylor albums solid for 14 days'?
 ☐ John Topler in Zigzag
 ☐ Dave Davies in the Sunday Times
 ☐ He was fornicating down at the Arts Workshop
 ☐ He was writing a thesis on Tom Repp and Pearly Before Swine.
 ☐ Arthur Askey on CBS Conference
 ☐ Nick Kent in NME

24. Why did Kris Needs miss Iggy's sole British gig (before the current tour) at Kings Cross Cinema?
 ☐ He was washing his hair
 ☐ He was answering Mott the Hoople fan club mail
 ☐ He was with David Bowie

25. Which was the first British publication to have a full-length feature on the Stooges?
 ☐ The Evening News
 ☐ Zigzag
 ☐ Jewish Chronicle
 ☐ NME
 ☐ MM
 ☐ DISC

26. Which of the following groups does Iggy admire?
 ☐ Abba
 ☐ Da Doo Ron Ron
 ☐ Papa Doo Ron Doo Ron
 ☐ M.C. & the Sunshine Band
 ☐ Eagles
 ☐ Mamas and Papas

27. In 1967 Iggy took part in a film with:
 ☐ a famous sort of person. Who?
 ☐ Jim Morrison
 ☐ Patti Smith
 ☐ Jimi Hendrix
 ☐ Alice Cooper
 ☐ Nico
 ☐ Brian Jones

28. When the Stooges first visited San Francisco what did Souvenirs did Iggy take home?
 ☐ Plastic statuette of Jerry Garcia
 ☐ A replica of the Golden Gate
 ☐ lice.
 ☐ Crabs
 ☐ Lobster
 ☐ 2 kinds of VD

29. Which of the following singles did Iggy play on?
 ☐ Singing the Blues - Tommy Steele
 ☐ Kick out the Jams - MC5
 ☐ I'm a hog for you baby
 ☐ Leader of the Pack - Shangri-la
 ☐ Vehicle - Ides of March

30. Critics have said that Iggy is bent on death. Is he?
 ☐ Yes ☐ No ☐ Maybe

31. Which of the following succulent delicacies does Iggy enjoy?
 ☐ Seaweed
 ☐ Raw Fish
 ☐ Pussy
 ☐ brown rice
 ☐ Dirty hot dogs
 ☐ Foodstuffs containing poison

32. Who discovered Iggy and the Stooges for Elektra Records, responsible for introducing him to the world?
 ☐ Lou Reed
 ☐ Danny Fields
 ☐ Seymour Stein
 ☐ Jac Holzman
 ☐ Greg Shaw
 ☐ John Sinclair

33. Is Iggy bi-sexual?
 ☐ Yes ☐ No

34. Who was Iggy's major inspiration and idol - for whom he would gladly have died?
 ☐ Bill Haley
 ☐ Sonny Bono
 ☐ Jim Morrison
 ☐ Jimi Hendrix
 ☐ Brian Jones
 ☐ John Lennon

35. When was the Stooges first album released?
 ☐ August 1969
 ☐ August 1970
 ☐ July 1973
 ☐ March 1977

36. Was it ever Iggy's intention to write a song for Judee Sill?
 ☐ Yes ☐ No

37. Who was the first auxiliary Stooge to be added to the original quartet?
 ☐ Steve Mackey
 ☐ Bill Cheatham
 ☐ Jimmy Silver
 ☐ Jim Thirston
 ☐ James Williamson

38. When did the Stooges pack up and call it a day (for the first time)?
 ☐ January 1971
 ☐ January 1972
 ☐ They never packed up at all

39. After John Cale produced the first Stooges album, which of the following was considered for the second?
 ☐ Jim Peterman
 ☐ Eddie Kramer
 ☐ John Madeira
 ☐ Don Gallucci

40. One critic wrote a 10 thousand word [cut] description longer than the Keith Richard story in the last issue) review of 'Fun House'. Was it:
 ☐ Jon Landau
 ☐ Nick Kent
 ☐ Tony Palmer
 ☐ Mick Farren
 ☐ Lester Bangs
 ☐ Derek Jewell

41. In August 1970 bassist Dave Alexander went missing. Who replaced him?
 ☐ Desolation Rowe
 ☐ Alex Chilton
 ☐ Zeke Zettner
 ☐ The guy from Uriah Heep

42. Which of these remarks appeared in reviews of Iggy concerts?
 ☐ Two hundred years ago, people would have been locked up for acting like that. Now, he's a star. He runs into the middle of the audience, leaps onto a table, grabs a burning candle-vase and lifts it high above his head. For a moment, it looks as if he'll put it back down - or else make him increase the towers of his chest wax, over his very slowly spills all its melted wax over his naked chest. Half the audience walked out after 5 minutes.
 ☐ After manically picking his nose, he plucked an imaginary piece from his ass, and flicked it toward the audience.
 ☐ His nauseating contortion can only appeal to really deep-down sick minds

43. Iggy made an unscheduled appearance at L.A.'s Whisky A Go Go on July 3 1971. It was during a concert to Commemorate the death of Jim Morrison
 ☐ raise bread for John Lennon's defence fund
 ☐ re-establish Simon Stokes and his Black Whip Thrill Band

44. Why is an intelligent publication like Zigzag wasting two pages on a washed-up, zero-talent, musically inept twirp like Iggy Pop?
 ☐ Allan Jones says he's jolly good
 ☐ He was a pioneer, and as such deserves recognition
 ☐ RCA Records bribed us
 ☐ He's a charismatic front cover to attract browsers in W.H. Smiths
 ☐ He's about to emerge as a world class superstar

45. Why did RCA refuse to allow any photographers to snap Iggy's set at Friars?
 ☐ Iggy has grown old and ugly
 ☐ David Bowie thinks he's more than a mortal
 ☐ They needed something to occupy the security gorillas they brought along to the gig

46. Has this guy become too stupid

Could this be the answer to Question No 45?

Johnny Pirate

Premier

ANSWERS

1. Score one point for James Osterberg.

2. Score one point for Iguanas, with whom he played "scrimbol" percussion. Before the Prime Movers he was at high school whilst in his time. He then joined Detroit based blues band called The Prime Movers when he was 19. After that, he went to Chicago with Sam Lay, discovered only black Chicago players, but the blues returned to his own Ann Arbor, Michigan to form a rock band the Stooges!

3. Score one point from Chicago. Iggy had old friend Ron Asheton, an whom got Ron a gig as bassplayer after Prime Movers; on 1969 got him a lift too with Scott Richardson's band. The Chosen Few.... who broke up the night Iggy got back from Chicago. Asheton was even then, possessor of a huge Nazi paraphernalia Collection.

4. Score one point each for life guard and professional golfer. He reasons that before one of his roadies pawned his golf clubs to settle a debt, and had a handicap of 4. Another time, pulling the hardships of a lifeguard job, he quit to become a life at the beach.

5. Score one point for a caravan park.

6. Score one point from Ann Arbor, Michigan.

7. Score one point for foundation of Raw Power band. Any of the others although they were close. Adolf was born on April 20th, Zigzag came out on April 16th, (I checked it all out.)

8. Score one point for each. Score and add one bonus point if you ticked them all - making a maximum of seven. Iggy on Hawaiian guitar, party after rehearsing for the whole of the year.

9. All of them. Score one point for each dropped acid. He claims that in a long time Iggy fan. Apparently Bowie did the distaste dwelling kind tripping acid with him.

10. They're all true. Score one point for each of them you ticked.

11. All of them except the last. Score one point for each you ticked, but subtract 3 if you ticked the last.

12. Score one point for each.

13. If you ticked 'ate six breakfasts' - Score three points. Apparently Bowie ravenous Stooge devoured 6 complete meals. London forthwith. (As a point of little interest. I once breakfasted with

14. Score two points for James Osterberg.

15. Score a point for Iguanas, with whom DeFries fired him, possibly having drug problems. This was an intensive move, according to Iggy. "Tony de Fries didn't understand what my music meant to me. He couldn't have, else he never would have before an audience as that I made music which played at well as that the Stooges made MEAT.

16. Said Iggy (in October 1973): "Mr DeFries is a great man, a hero that it was impossible for us to work together. Score 3 points for a correct tick.

17. Score 3 points for physical exhaustion injury. I saw Iggy a night before Show two nights at a night because I have to give it all I've got or else I think I've failed. By the third night I was simply incapable of getting up and breathing. People were going around saying I'd OD'd, and all this crap

18. Score two points for Kim Fowley. "The first time I saw Iggy he was in my sights. Two days later I was back in the bosom of Sweet Baby Jane so I could buy it."

19. Score two points each for T. Rex and Humble Pie. The others may have refused too, but there is nothing in print.

20. It was Linda Solomon in the NME. Score 2 points if you were correct.

21. Score one point for the New Order. who recently broke up.

22. Score 3 points for Jean Genie.

23. Score 3 points if you know it was Nick Kent. By the way, how did you enjoy your potential of solitude with Detroit principal. Nick you didn't look too different last time. Iggy. Should Stop. humming Sweet Baby Jane all the time

24. Score no points for this - even if you got the right answer - it is far too trivial even to think about.

25. It was Zigzag, of course. Page article in number 17 December 1970. Score two points if you knew.

26. Two points from your local if you like the KC and The Sunshine Band too.

27. Score 3 points for Nico. Apparently they made a film in which he and Nico were cavorting in a potato field in Michigan, wielding plastic arms a less says Iggy "I heavy made much Sonic and it was one the most Sense only Nico for the film - but we were fucking around with it, so she said "if you wanna do a film, you gotta put Jimmy in it too - and the guy aged

28. Score two points each for lice, crabs and two kinds of VD.

29. Subtract 10 points if you ticked any of them. He was rumoured to have played in the city especially but never been. He appeared with them on an obscure one might stand in the Oneworlds of Michigan all the same, I doubt it.

30. Score two points for each - he likes them all. (What a weird bloke)

31. Score two points for each, he saw him the other night.

32. It was Danny Fields, currently manager of the Ramones. Fields Iggy up the last said: "People say I'm Iggy at Michigan Union. Says Iggy had a maternity dress on after I saw him that I decided I'd be a singer, no matter how much people. Just like in the movies, this I laughed, and said that

33. Score one point for NO - it's an understandable mistake, you know. The Raw Power sleeve the association with "Working where they recorded "LA Woman", but no interview were told, lots of gay people are attracted to me - but Mick Jagger

34. Score 3 points for Jim Morrison was rehearsing at the Doors' work-shop, where they recorded "LA Woman", like being in heaven. Said Iggy: "Jim Morrison was dead until I decided I'd like being in heaven.

35. Score one point for August 1969 which is when Morrison's LA Woman came out in August 1970. "Raw Power" (Columbia) CBS 32111) came out in June 1973. and "The Idiot" (RCA) in Mar 77.

36. One point for yes. When he first arrived in England in Spring 1972, Iggy saw Judee Sill on the old Grey whistle

he worked for Elektra Records and, later, for Danny Fields...... Score one point for Danny Fields.

37. Score 3 points for Bill Cheatham who switched from being their roadie to their rhythm guitarist in March 1970. The Steve Miller Band James Williamson came in 1970 to replace Cheatham in October 1970. Jimmy Silver was their original manager. Score Thurston played piano for the when the Stooges reformed in 1972.

38. Score 3 points for August 1971

39. All of them. Score two points for each one you ticked. The Stooges favoured Peterman, who had joined Electra! At 17 staff after playing in their band. Danny Fields was pumping out their records, Asheton Led 28 Iggy the Stooges Joe Holtzman wanted Madeira, a TV cook by Danny & The Junior's, Less Twist Again by Lyn Barry Chuck had of Lesley Gore's early 'Hits' like California actually did it

40. Score two points for Lester Bangs, whose epic appeared in Creem magazine in December 1970

41. Score two points for Zeke Zetner - yet another ex-roadie. 'Desolation Row' was surrogate manager of the late MC5

42. All of them. Score one point for each. They were from Record Word 29 8.70. Zigzag Score one point January & Hits like Cream 10.69

43. Score 3 points for Jim Morrison commemoration concert. Al an encore the improvised one the following lines to "LA Woman" Jim Morrison died today, Jim Morrison was today, town, And now he's dead, Now I cry.

44. There's no answer to that one.

45. I don't know the answer to that one either. I know I'd like to know. Will RCA please explain.

46. Score one point for yes.

THE IGGY POP TRIVIA QUIZ

The above answers to this rare example of a CITY appeared in ZIGZAG by KIMBY PEARCEY

STEVE MACLAY

HOW YOU RATED

The maximum number of points you could have scored was one hundred and I have a useless yet here who can do something more productive than amassing knowledge of such a worthless nature. The only prize we can offer you is a night with Meathild (Iggy's only true fan) if you scored less than one point, you must be

that they were all so "young, loud and snotty". Iggy apparently wrote a song to immortalise that pearl of wisdom.

he was in the Aylesbury Borough Assem this with Bowie, who was playing his last gig there, on 15th July 1972.

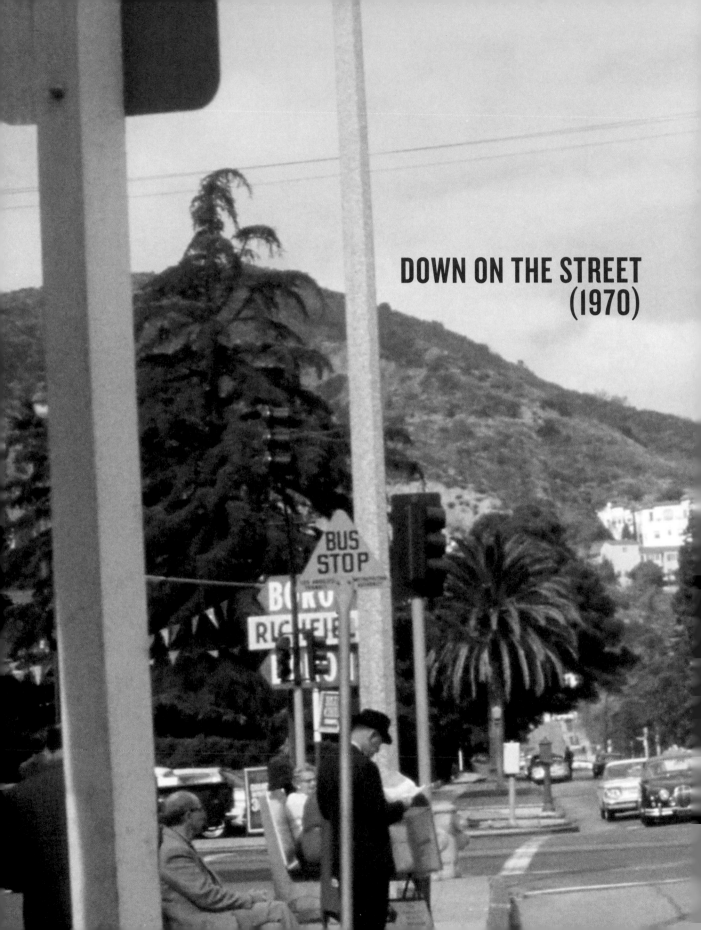

DOWN ON THE STREET
(1970)

Well, down on the street where the
faces shine
Floatin' around, I'm a real low mind
I see a pretty thing – ain't no wall
I see a pretty thing – ain't no wall
No walls
No walls
No walls

Yeah, deep in the night, I'm lost in love
Yeah, deep in the night, I'm lost in love
A thousand lights
I look at you
A thousand lights
I look at you

At you
At you
At you
Yeah
Come on
Come on, come on, come on

Come on, come on
Yeah
Yeah

Oooh, come on, come on, come on
Come on, come on
Where the faces shine
A real low mind
A real low mind
I'm a real low mind
A real low mind

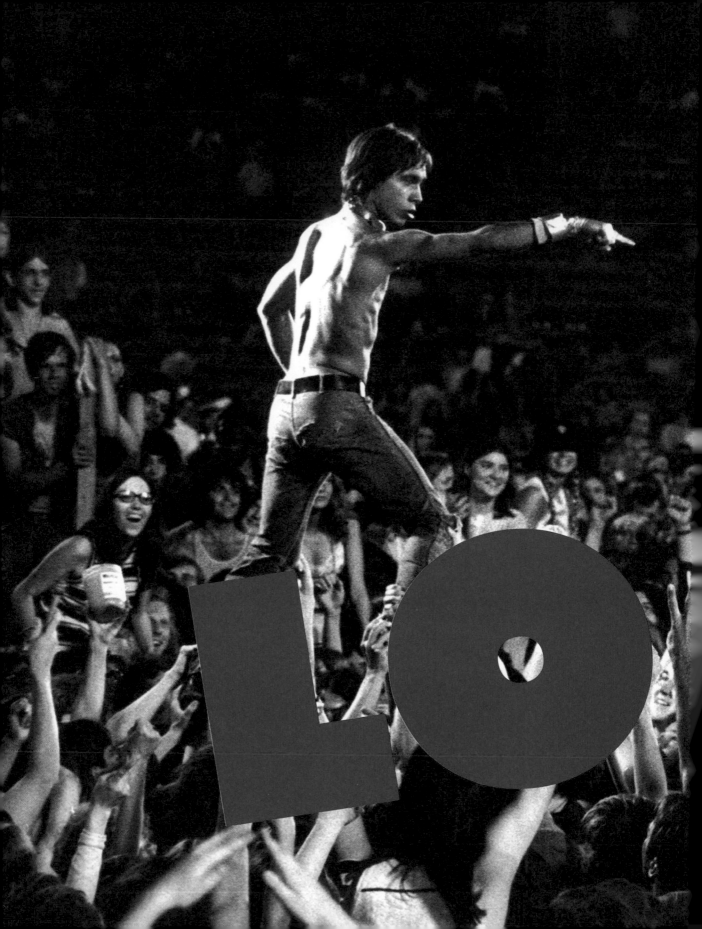

Now look out

I took a ride with the pretty music
I went down and baby you can tell
I took a ride with the pretty music
Now I'm putting it to you straight from hell

I'll stick it deep inside
I'll stick it deep inside
'Cause I'm loose, always

I feel fine to be dancin', baby
I feel fine, I'm a shakin' leaf
I feel fine to be dancin', baby
'Cause it's love, yeah I do believe
I'll stick it deep inside
I'll stick it deep inside
'Cause I'm loose

I took a ride with the pretty music
I went down and baby you can tell
I took a ride with the pretty music
Now I'm putting it to you straight
from hell

And I'll stick it deep inside
And I'll stick it, hey
Well I'm loose, well I'm loose
Well I'm loose

(1970)

OSE

FUNHOUSE (1970)

Blow right on it, now
Blow, Steve

I feel alright
Yeah, I feel alright

Let me in
Hey, let me in
Hey, bring it down

Callin' from the fun house, with my song
We been separated, baby, far too long
A-callin' all you whoop-dee, pretty things
Shinin' in your freedom, come and be my rings
Hold me tight, callin' from the fun house
Hold me tight, callin' from the fun house
Yeah, I came to play and I mean to play around
Yeah, I came to play and I mean to play real good
Yeah, I came to play

Alright
Hey, let me in
Take it down
I feel alright
A-take it down
Little baby girlie, little baby boy
Cover me with lovin' in a bundle o' joy
Do I care to show you what I'm dreamin' of
Do I dare to whoop y'all with my love
Every little baby knows just what I mean
Livin' in division in a shiftin' scene
Hold me tight, callin' from the fun house
Hold me tight, callin' from the fun house

Blow
Yeah, I came to play
I came to play

Blow, Steve
Hey
Hey now
Let me in
One more time
Take it down
Take it down
A-take it down

We been separated
We been separated
A little too long

Blow
Yeah, I came to play
Yeah, fun house, boy, will steal your heart away
Yeah, fun house, boy, will steal your heart away
Steal

Yeah
I came to play
I came to play
I came to play
This is it
Baby
Yeah, I came to play
I came to play

29501 29501 C2-A

DUGGAL G. McCain
646 638 7000 # 936584

In the early summer of 1970, there was a gathering of the young, the elite, the rebellious, and the well-connected at Goddard College in the lovely green hills of Vermont.

I had just come from Los Angeles where the Stooges' "Funhouse" sessions were being held at the Elektra studios, and it had been figured out that the near-final mixes would be ready while I was in Vermont. Through all the psychedelic fogs engulfing both of us, Iggy and I had somehow arranged that I would call him at a certain time, and he would play the tapes for me over the phone, you cannot imagine the status points I scored. At the appointed time, with the firefly population in full display around us, an eager little throng of about 20 Stooges fans had gathered around a phonebooth on the campus. The connection was made, Iggy held up his phone next to the speaker on his tape recorder, and I held the receiver high in the air, waving it around so everyone could hear something. Thus was held the world premiere of "Funhouse" on a Vermont hillside, Iggy's voice, the band's dawn-of-time sound and the crushing power of its attack were unmistakably recognizable and unarguably unique. The songs were pretty special too.

Danny Fields

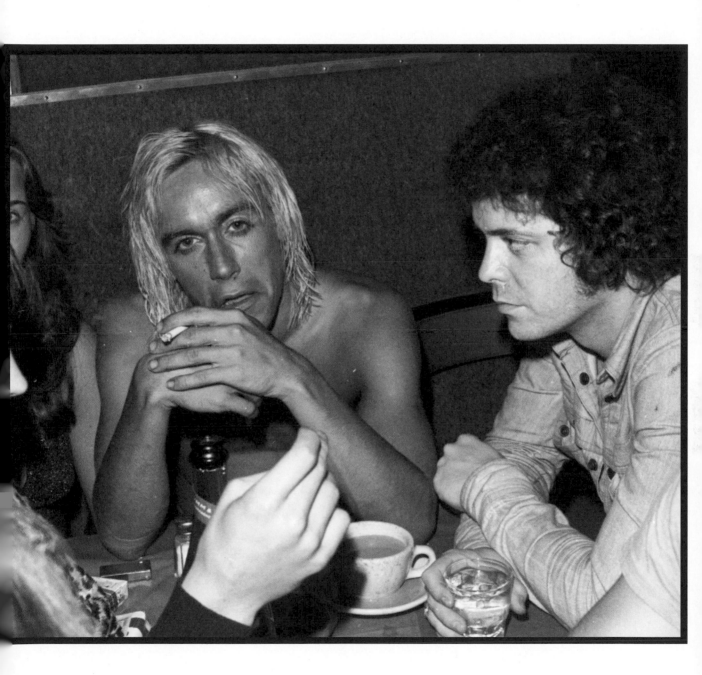

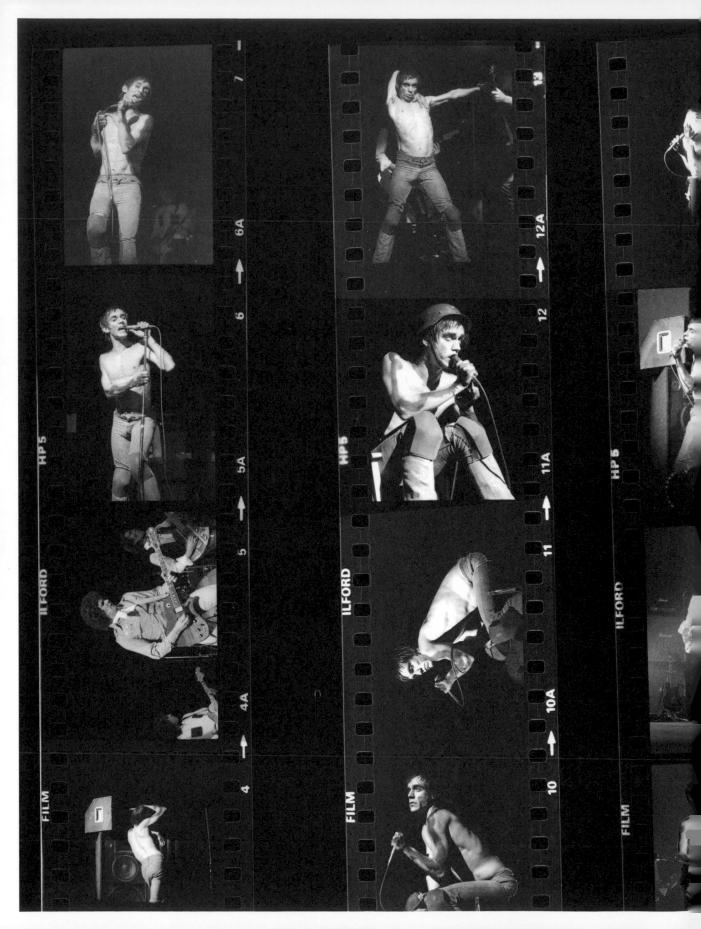

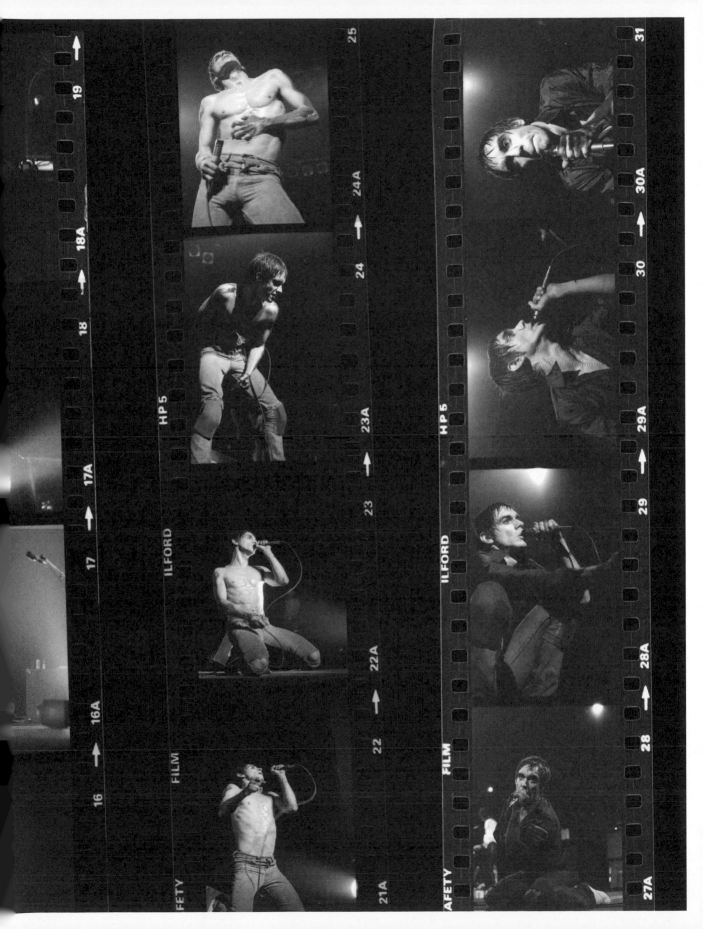

Lord
Aah, whoo
Stomp it

See that cat
Yeah, I do mean you
See that cat
Yeah, I do mean you
She got a TV eye on me
She got a TV eye
She got a TV eye on me
Oh

See that cat
Down on her back
See that cat
Down on her back
She got a TV eye on me
She got a TV eye
She got a TV eye on me
Oh

See that cat
Yeah, I love her so
See that cat
Yeah, I love her so

She got a TV eye on me
She got a TV eye
She got a TV eye on me
Oh, yeah

Ram it
Ram it
Ram it
Ram it

See that cat
Yeah, I love her so
You see that cat
Yeah, I love her so
She got a TV eye on me
She got a TV eye
She got a TV eye on me
Oh

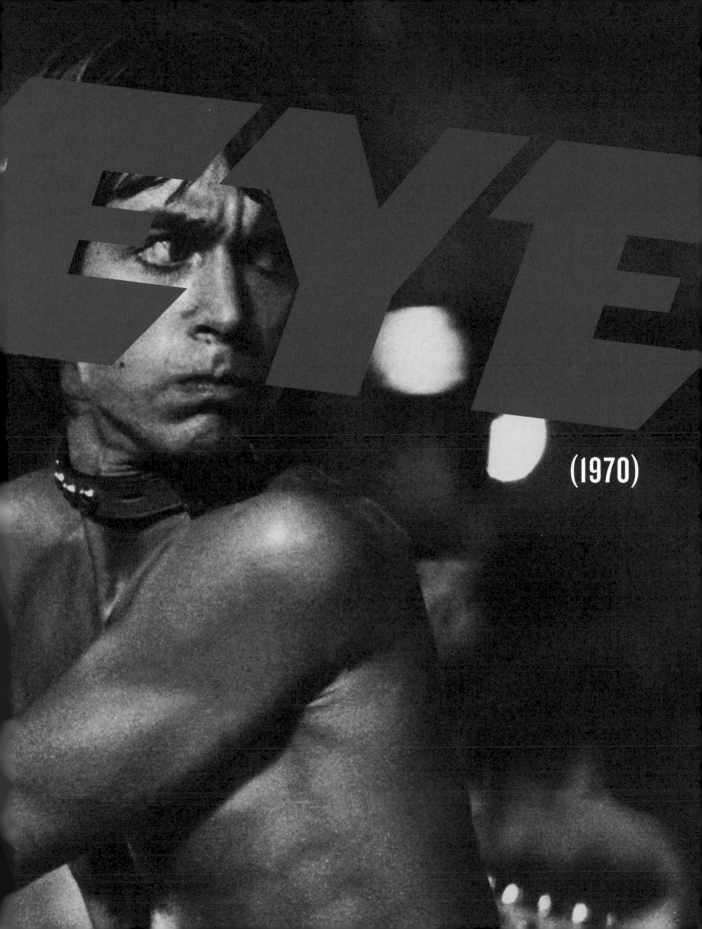

EYE

(1970)

Out of my mind on Saturday night
Nineteen-seventy rollin' in sight
Radio burnin' up above
Beautiful baby, feed my love all night
'Til I blow away
All night
'Til I blow away
I feel alright, I feel alright

Baby oh baby, burn my heart
Baby oh baby, burn my heart
Fall apart baby, fall apart
Baby oh baby, burn my heart all night
'Til I blow away
All night
'Til I blow away
I feel alright
I feel alright

Feel alright
Feel alright
Feel alright

Out of my mind on Saturday night
Nineteen-seventy rollin' in sight
Radio burnin' up above
Beautiful baby, feed my love all night

'Til I blow away
All night
'Til I blow away
I feel alright, I feel alright
I feel alright
I feel alright, I feel alright
I feel alright, I feel alright
I feel alright
I feel alright
Well, I feel alright
I feel alright
I feel alright
I feel alright
I feel alright
Feel alright
Feel alright
Feel alright
Feel alright
I feel alright
I feel alright
Feel
Feel
Blow
Blow
I feel alright
I feel alright I feel alright
Feel alright I feel alright
Feel alright Feel alright
Blow I feel alright
Blow I feel alright
I feel alright Feel alright
Feel alright Feel alright
I feel alright Feel alright
I feel alright Feel alright

DIRT (1970)

Ooh, I been dirt
And I don't care
Ooh, I been dirt
But I don't care
'Cause I'm
Burning
Inside
I'm just a-yearning
Inside
And I'm a fire of life

Yeah, alright

Ooh, I've been hurt
But I don't care
Ooh, I've been hurt
And I don't care
'Cause I'm
Burning
Inside
I'm just a-dreaming
This life
And do you feel it?

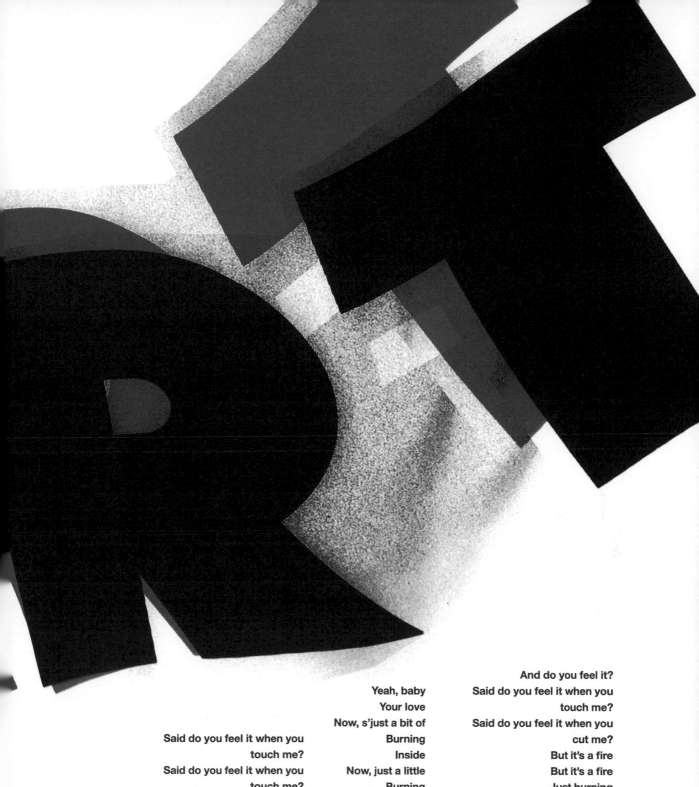

Said do you feel it when you
touch me?
Said do you feel it when you
touch me?
There's a fire
Well, it's a fire
Yeah, alright
Ooh

Yeah, baby
Your love
Now, s'just a bit of
Burning
Inside
Now, just a little
Burning
Just a dreaming
Just a burning
Just a dreaming
Just a dreaming

And do you feel it?
Said do you feel it when you
touch me?
Said do you feel it when you
cut me?
But it's a fire
But it's a fire
Just burning
Just a dreaming
Just a burning
Just a dreaming
Just a dreaming

SHAKE APPEAL
(1973)

One, two, three, four
Oow
Said-a shake appeal
Moves so fast on me
Shake appeal
Moves so fast to see
Moves so fast, moves so fast
Move away the misery
I'm sayin' shake appeal
Is so hot and low
Shake appeal
Is so hot and low
Hot and low baby, hot and low
Memory you gotta go
Memory you gotta go
Memories have gotta go
Baby baby got to go
Gotta go
Baby baby gotta go
Aoow!

I said shake appeal
Baby it fits so tight
Shake appeal
Baby with your fit so tight
Fits so tight, fits so tight
Baby, really gotta bite
Realize I gotta bite
Realize I gotta bite
Baby, gotta have a bite
Gotta bite
Baby, gotta have a bite
Aoow!
Ooh-ooh
Aaarh
Ooh-ooh
Ooh, shake appeal
Ooh-ooh
Ooh, ooh, ooh, sex appeal
Ooh, ooh, ooh, sex appeal
I said ooh, ooh, ooh, sex appeal
Ooh, aah, ooh, aah

I'm a streetwalking cheetah with a heart full of napalm
I'm a runaway son of the nuclear A-bomb
I am the world's forgotten boy
The one who searches and destroys
Honey, gotta help me please
Somebody gotta save my soul
Baby, detonate for me
Aaaoogh

Look out honey, 'cause I'm using technology
Ain't got time to make no apology
Soul radiation in the dead of night
Love in the middle of a fire fight
Honey, gotta strike me blind
Somebody gotta save my soul
Baby, penetrate my mind
And I'm the world's forgotten boy
The one who's searchin', searchin' to destroy
And honey I'm the world's forgotten boy
The one who's searchin', only to destroy, hey
hey, hey
hey, hey
Look out honey, 'cause I'm using technology
Ain't got time to make no apology

And I'm the world's forgotten boy
The one who's searchin', searchin' to destroy
And honey I'm the world's forgotten boy
The one who's searchin', searchin' to destroy
Forgotten boy, forgotten boy
Forgotten boy said, hey, forgotten boy, said
Hey, hey, hey, hey, hey, hey, hey

h&

strou

1973

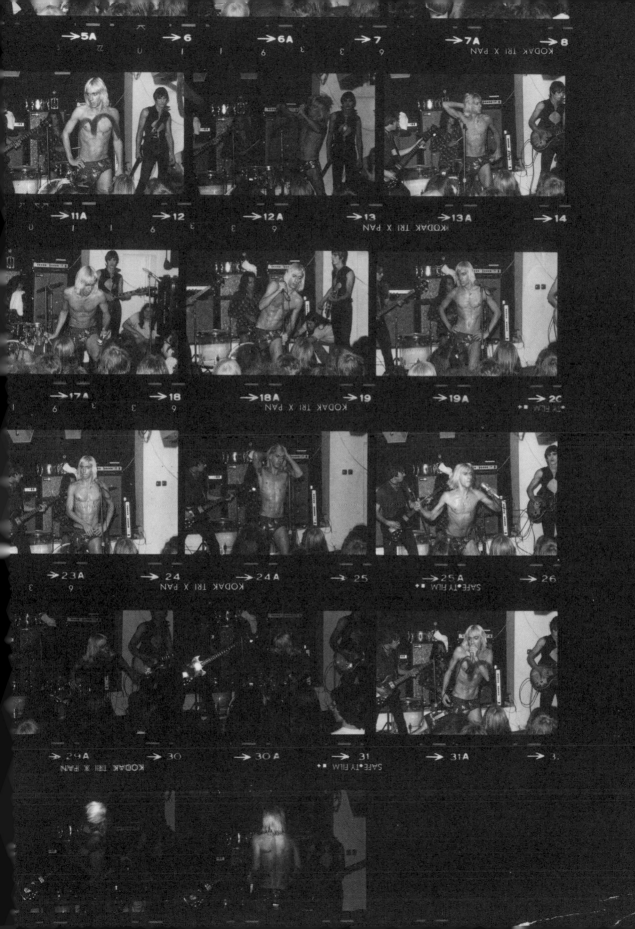

I'M SICK OF YOU
(1973)

Goodbye Betsy I'm goin' away
I'm sick of you and there ain't no way
Don't want to know, don't want to see
Don't you ever bother me
Sick of hanging around your pad
Sick of your Mom and sick of your Dad
Yes and Betsy,
It's sad but true,
But now I'm even sick of you

No way, no way, no way
No way, no way, no way
No way, for our love
No way for our love
'Cause I'm sick of you

No way, no way, no way
No way, no way, no way
No way, for our love,
No way for our love

Every evening and every day,
Seem to always turn out this way,
To get an end
I better find new love,
Then you'll pay,
Then you'll pay,
Ain't no way
'Cause I'm sick of you.
Goodbye Betsy I'm going away,
Sick of you and I don't want to stay
Don't want to know, don't want to see
Don't you ever bother me

Goodbye Betsy I'm going away
Sick of you and I don't want to stay
Don't want to know, don't want to see
Don't you ever bother me
Sick of hanging around your pad
Sick of your Mom and sick of your Dad
Yes and Betsy it's sad but true
Now I'm even sick of you

RAW POWER

(1973)

Dance to the beat of the living dead
Lose sleep, baby, and stay away from bed
Raw power is sure to come a-runnin' to you
If you're alone, and you got the fear
So am I, baby, let's move on outta here
Raw power is sure to come a-running to you

Raw power got a magic touch
Raw power is much too much
Happiness is guaranteed
It was made for you and me
Raw power, honey, just won't quit
Raw power – I can feel it
Raw power, it can't be beat
Poppin' eyes and a flashin' feet

Don't you try
Don't you try to tell me what to do
Everybody's always tryin' to tell me what to do

Look in the eyes of the savage girl
Fall deep in love in the underworld
Raw power is sure to come a-runnin' to you
If you're alone and you got the shakes
So am I baby and I got what it takes
Raw power is sure to come a-runnin' to you

Raw power got a healin' hand
Raw power can destroy a man
Raw power is more than soul
Got a son called rock and roll

Raw power – honey just won't quit
Raw power – I can feel it
Raw power, honey can't be beat
Get down baby and kiss my feet

Everybody always tryin' to tell me what to do
Don't you try
Don't you try to tell me what to do
Everybody always tryin' to tell me what to do
Don't you try
Don't you try to tell me what to do

Raw power's got no place to go
Raw power, honey
It don't want to know
Raw power is a guaranteed O.D.
Raw power is laughin' at you and me
And this is what I want to know

Can you feel it
Can you feel it
Can you feel it
Can you feel it
Can you feel it
Can you feel it

Raw power
Raw power
Raw power
Raw power
Can you feel it
Can you feel it
Raw power
Raw power
Raw power
Raw power
Raw power
Raw power
Can you feel it, baby

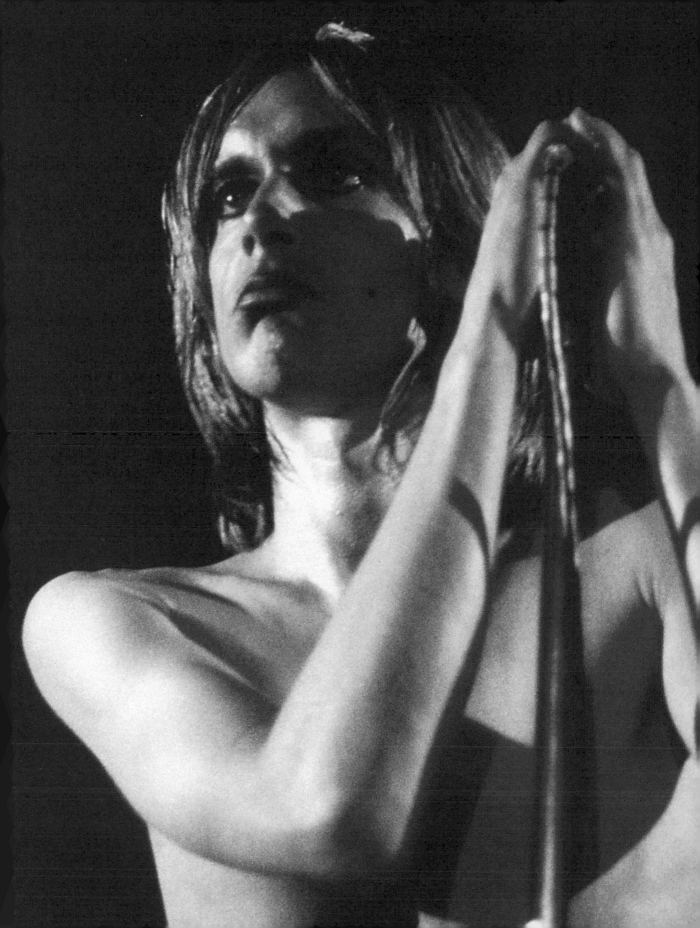

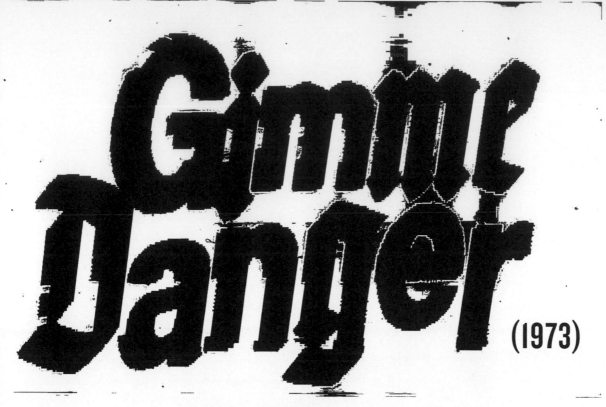

Gimme Danger (1973)

Gimme danger, little stranger
And I feel with you at ease
Gimme danger, little stranger
And I'll feel your disease
There's nothing in my dreams
Just some ugly memories
Kiss me like the ocean breeze

Now, if you will be my lover
I will shiver and sing
But if you can't be my master
I will do anything
There's nothing left alive
But a pair of glassy eyes
Raise my feelings one more time
Yeah

Yeah, find a little stranger, find a little stranger
Yeah, they're gonna feel my hand
Said die a little later, why no, little stranger?

Hurry on and feel my hand
Swear you're gonna feel my hand
Swear you're gonna feel my hand

Gimme danger
Little stranger
Gimme danger
Little stranger
Gimme danger
Little stranger
Gimme danger
Little stranger
Gimme danger
Gimme danger
Gotta feel the pain
Gotta feel the pain
You gotta feel it
Little stranger

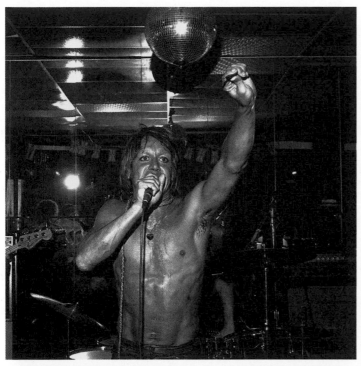

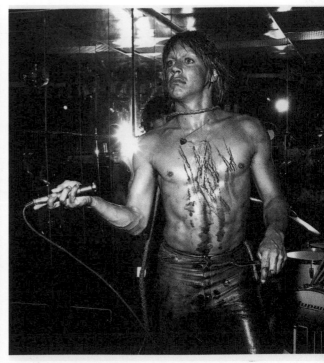

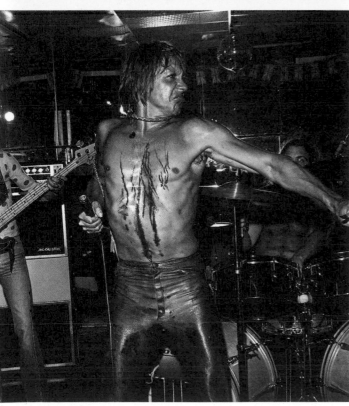

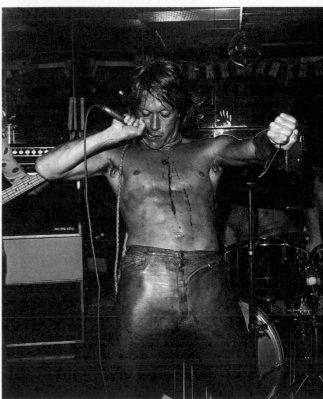

YOUR PRETTY FACE
IS GOING TO HELL
(1973)

Awwright! Woooohhhh!

A pretty face and a dirty look
Knew right away that I'd have to get my hooks in you
A-yeah yeah yeah
I'm running low on memories
If you wanna make a buck, boy you gotta be a tease, uh huh
I say yeah yeah

I need it all, baby, that's no lie
I need a lover with an alibi
I wanna fall into a love so sweet
Honey baby baby, I'm hard – hard to beat
Hot flesh and a touch of bone
Smells in the air but I'm feeling so alone, uh huh
I say yeah yeah
Hallucination true romance
I needed love but I only lost my pants, uh huh
And that ain't all

I'll tell ya honey, it's a crying shame
All the pretty girls, well they look the same
I wanna fall into a love so sweet
Honey baby baby, I'm hard, hard to beat

Your pretty face is going to hell
Your pretty face is going to hell
Honey, honey, I can tell
Your pretty face is going to
Hell!
That's right, baby!
Hell!

A pretty face and a dirty look
I knew right away that I had to get my hooks in you
I say yeah yeah
I'm running low on a-memories
If you wanna make a buck, boy, you gotta be a tease, uh huh
And that ain't all
Ooh!

I need it all, honey, that's no lie
I need a lover with an alibi
I wanna fall into a loving sweet
Honey baby baby, I'm hard, hard to beat
Wooo! Yeah! Hey!

Your pretty face is going to hell
Your pretty face is going to hell
Honey, honey, I can tell
Your pretty face is going to hell!

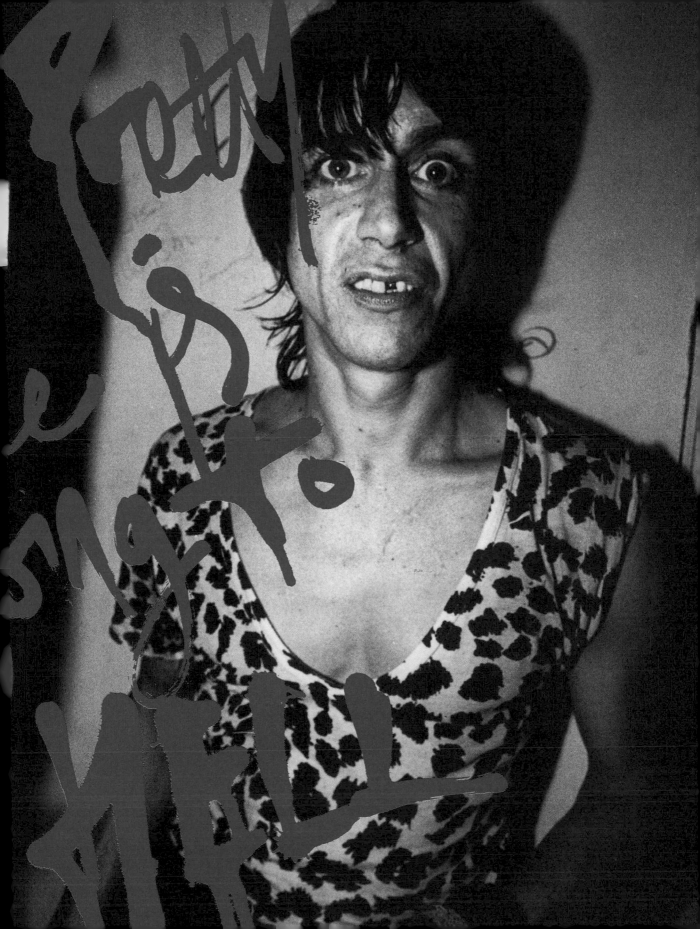

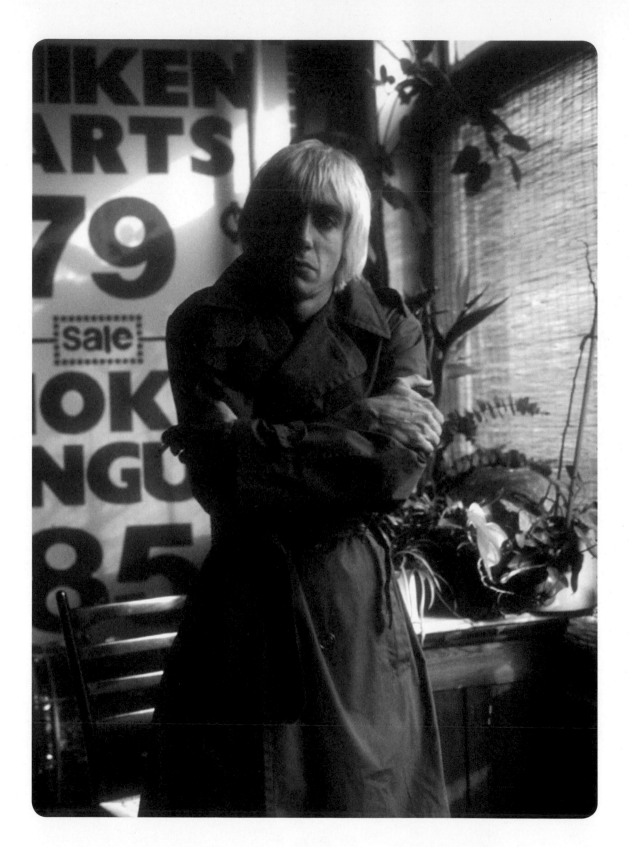

GIMME SOME SKIN

(1973)

Gimme some skin
Gimme some skin
Oh baby gimme some skin
Try to gimme some skin
Damn
Damn

Time for man
She got some
She uses me whatever I am
She uses me and takes what is grand
But I don't mind
If your mind is gone
If you want my body
You gotta gimme skin all night long
Gimme some skin
Gimme some skin
Better believe I ain't no fool
I'll be choosing if I think it's cool
Show them my rights
Baby baby baby gonna have mine

Oh man if you like my band
If you want my body
You just gotta gimme some skin
Gimme some skin
Gimme some skin
Oh baby gimme some skin
Gotta gimme some skin
Should
Can't fuck that up

Time for man
She got some
Live it all out, live it all in
Gotta come here honey gimme some skin
But I don't mind
If your mind is gone
If you want my body
You gotta gimme skin all night long
Gimme some skin
Gimme some skin
Honey gimme some skin
Gimme some skin
Gotta gimme some skin
Gimme some skin
Gotta gimme

Death Trip

(1973)

Say hey, hey
Said a hey, hey, hey
Honey, honey, honey, yeah, yeah
Said a yeah, yeah, yeah
Ooow

All right
And now my girl will steer you round
Something drive you blind
I move to master my machine,
baby, will not stand in line
A sick boy, sick boy goin' 'round,
barely losin' grip
Baby, wanna take you out with me,
come along on my death trip
My death trip, honey, my death trip
A-honey, honey, honey, my death trip
Baby, my death trip
Ooow

All right
Now tell me do you care for me
Once I care for you
A-honey, come and be my enemy so I
can love you true
A sick boy, sick boy fadin' out, I love it
to be cruel
Baby, whip me in the heat, turn me
loose on you
Loose on you
Honey, loose on you
A-honey, loose on you
Honey, loose on you!
Ooow

Turn me, turn me, loose on you
Turn me, turn me, loose on you
Turn me, turn me, loose on you
Turn me, right on, turn me, loose
Yeah

Ooh
Said who with you, you're with me
A-honey we're going down in history
Said I'm with you, you're with me
A-honey we're going down in history
We're going down
We're going down
We're going down
Going down
Going down
Going down
Blow my cool, bite my lip

See me through on my death trip
Free this slave, hear me sing
You can save me and everything
You're gonna save me
Save me
Save me
Save me
Save me
You're gonna save me
You're gonna save me
You're gonna save me
You're gonna save me, all right
You're gonna save me, save me,
save me now
Save me, save me, save me now
Save me, save me, save me now
Save me, save me, save me now
Hey, now

I say I'll stick you
You'll stick me
I say I'll stick you down
You'll stick me
I say I'll rip you
You'll rip me
Come on
I'll rip you
You'll rip me
Come on, rip
Kiss the rip
Ooow

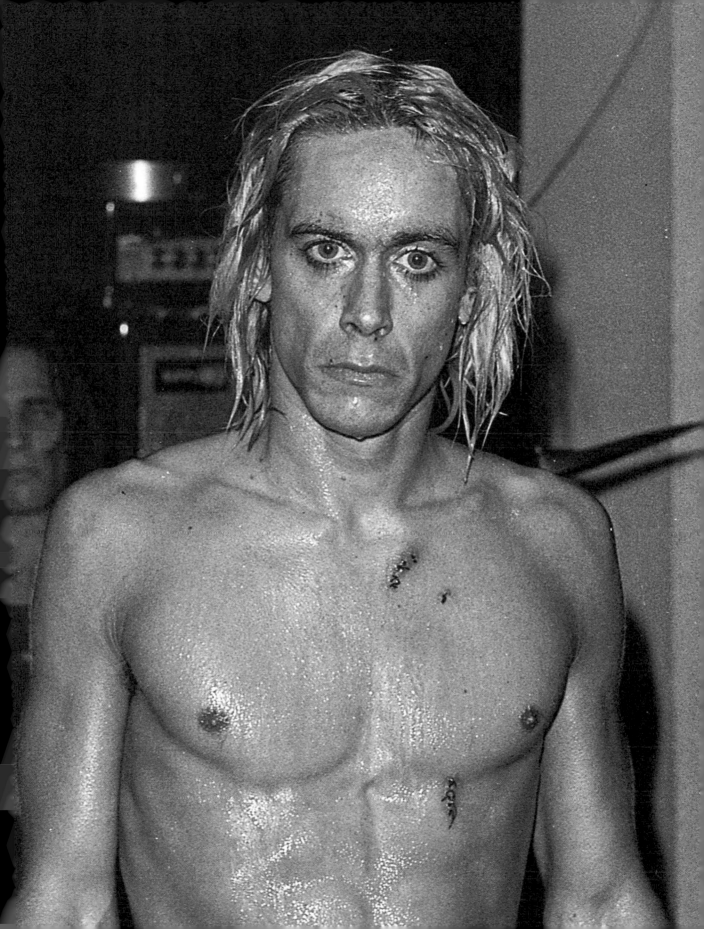

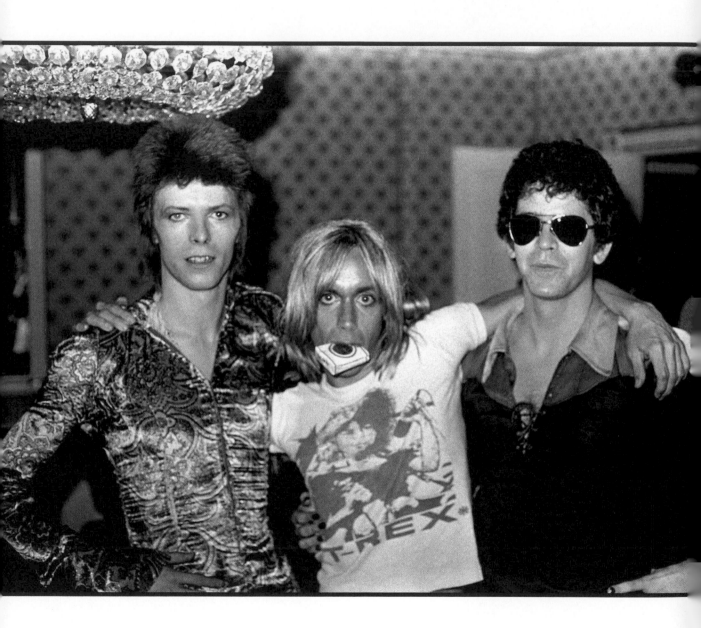

Do you know how I met Iggy - and Lou Reed? I was
at an RCA party at Max's Kansas City in New York
and was introduced to Lou. He immediately started
telling me some story about a guy who injected smack
through his forehead - that's typical Lou.

Anyway, up comes this funny ragged, ragged little
guy with broken teeth and Lou says: "Don't talk to
him, he's a junkie" - that was Iggy. You can't help
loving him, he's so vulnerable.

Bowie on Iggy, *Disc* (1973)

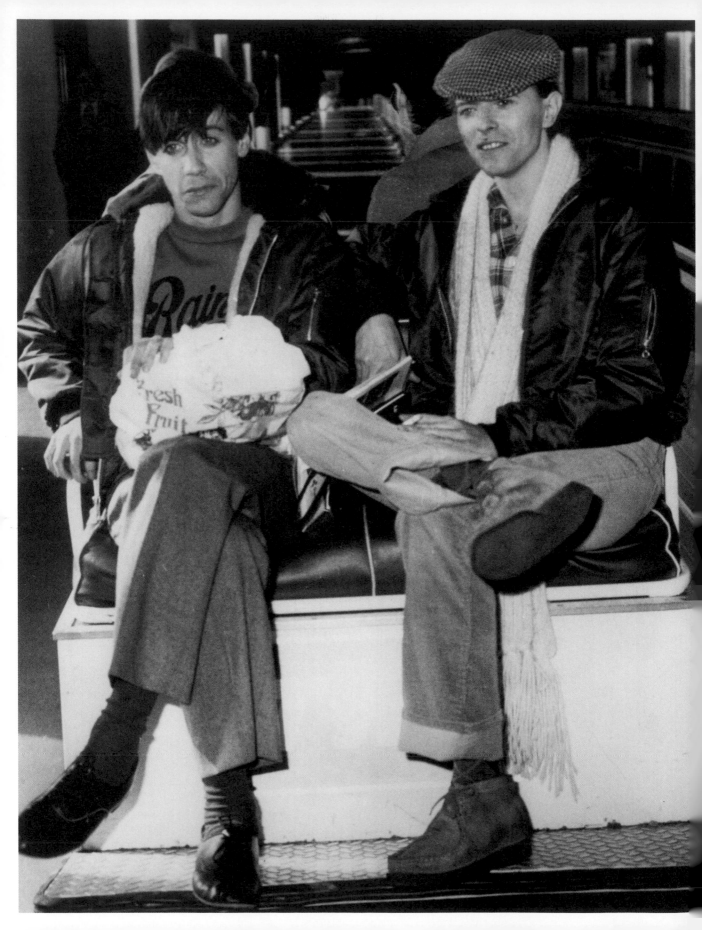

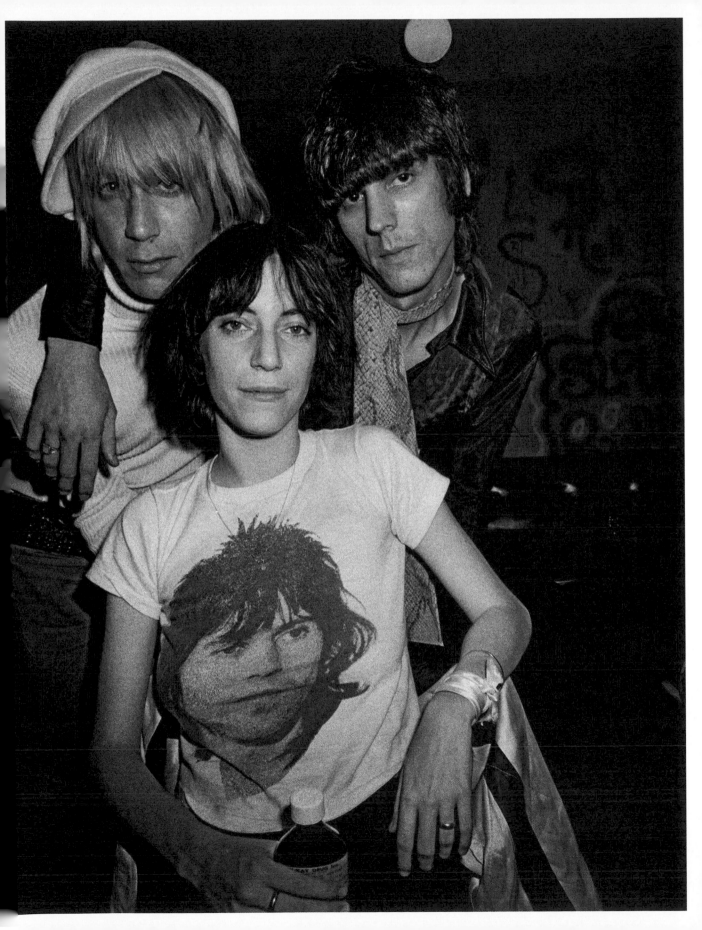

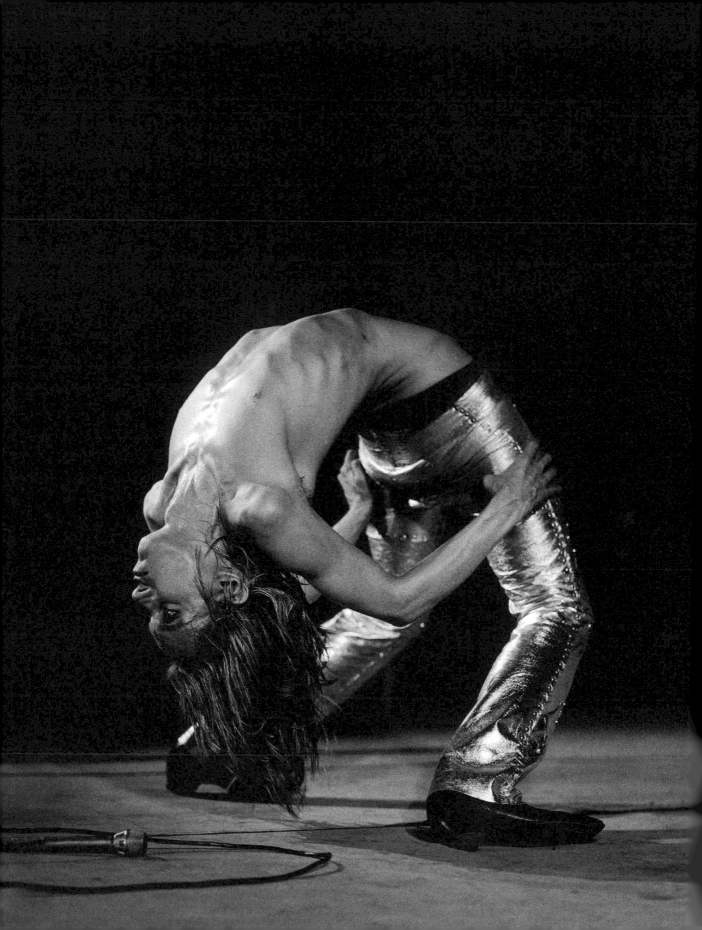

PENETRATION
(1973)

Penetrate	Penetration
Penetrate me	Come and take me
So fine	Come and take me
So fine	I'm alive (baby, baby)
So fine	I'm alive
I get excitement	I'm alive (baby, baby)
I get excited	Stick it hard, babe (baby, baby)
I'm alone	Stick it hard (baby, baby)
So fine	Purify (baby, baby)
Pull a line	Exetice
Every night at town	Penetrate (baby, baby)
Every night at town	Penetration (baby, baby)
I'm going now	Penetration (baby, baby)
Going now	Penetration (baby, baby)
I pulsate	Penetration (baby, baby)
Purify me	
Purify me	
Take a lay	
Take away	
Paralyze	

[GIBBERISH]

RICH BITCH

(1973)

Well I don't care if you throw all
the ice in the world, you're paying
5 bucks and I'm making
10 thousand baby, so screw ya!
Do you feel that beat?

Now when your mamma's too old to
buy your pills
And your daddy ain't around to pay
your bills
And your cunt's so big they could
drive through a truck
And every man you meet baby, he
knows you've sure been fucked

What you gonna do about it baby?
What you gonna do?
What you gonna do about it baby?
What you gonna do?
I think I'm gonna laugh at you rich
bitch
I think I'm gonna have my fun
'Cause you rich bitches of the world
My time has just begun, baby
I said my time has just begun
I said baby, I just can't choose ya

Take it from the drums
Take it down to the drums
Yeah, yeah

Hard hitter, hard hitter
Keep your hands off me
Hard hitter, hard hitter
Keep your hands off me
I'm sick of you messing with my heart
Sick of you messing with my heart
Sick of you messing with my heart

Take it down to the drums
Take it down to the drums, it's the
only way you'll ever get right
Take it down there to the drums,
yeah baby
I said a yeah baby, now come on
give me just the drums
Yeah baby
See what, he's got it
1-2-3-4, 2-2-3-4, 1-2-3-4, 2-2-3
I said a 1-2-3-4, 2-2-3-4, 1-2-3-4
Hard hitter, hard hitter
Keep your hands off me
Hard hitter, hard hitter
Keep your hands off me
I'm sick of you messing with my
heart
Sick of you messing with my heart
Sick of you messing with messing
with my heart

You can throw your goddamn cocks
if I don't care
Your pricks can throw every
goddamn thing in the world and
your girlfriend will still love me
You jealous cocksuckers!

Now when your mamma ain't
around to buy your pills
And your daddy's too old to pay
your bills
And your cunt's so big they could
drive through a truck
And every man you meet, he knows
you've sure been fucked

What you gonna do about it baby?
What you gonna do?
What you gonna do about it honey?
What you gonna do?
When you're laying down in your bed
And a man next to you rolls his eyes
back like he was dead
And he says, baby
I just can't choose ya
I just can't choose ya baby
I said I just can't choose
Get him out of her he's a prick!
I say I just can't fuck you no more
I said I just can't fuck you no more
I just can't choose baby
I just can't choose you baby
Yeah

That's what I'm gonna say
Keep your, keep your hands off me
Rich bitch
Keep your, keep your hands off me
Keep your, keep your hands off me
You're blind bitch
Keep your, keep your hands off me
Yeah
Keep your, keep your hands off me
Keep your, keep your hands off me
Keep your, keep your hands off me
Keep your, keep your hands off me
Keep your, keep your hands off me
Keep your, keep your hands off me
Keep your, keep your hands off me
Keep your, keep your hands off me

IGGY POP & Stooges

night of the iguana

RICHARD PETERSON

- Raw Power
- Head On
- Wet My Bed
- I Got Nothing

LIVE IN
NEW YORK
1973

2
- I Got A Cock - In My Pocket
- Search & Destroy
- Gimme Danger
- New Orleans
- Rich Bitch

BANG

recording

Ø COVER BY [logo] for Passout Productions

T085

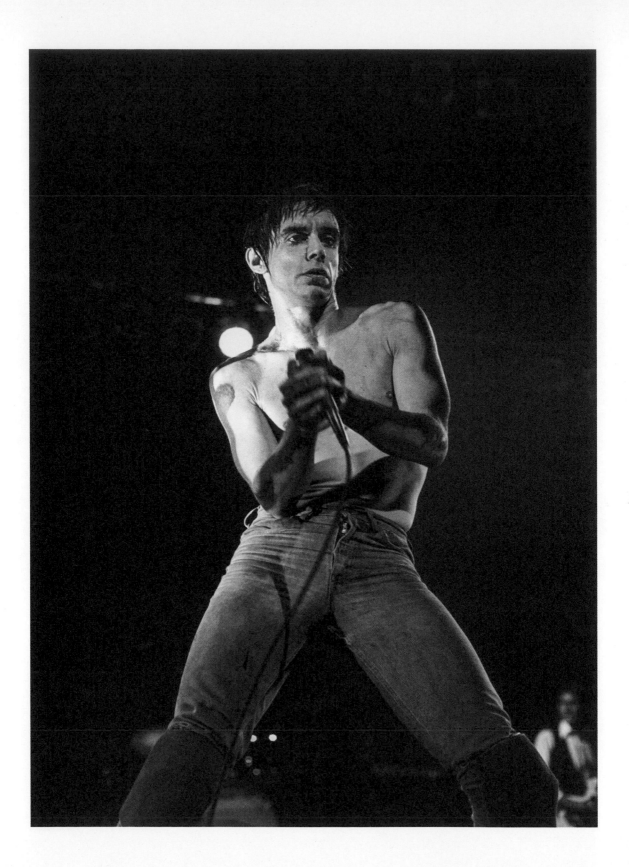

I was a freelancer at the time, and was the official photographer for *Record Mirror*. In that capacity, I headed over to see him at the Hammersmith Odeon.

Iggy was on absolute top form, contorting himself and rolling around and just generally being Iggy Pop. The great thing about photographing him is that he's not just a guy standing by a microphone or playing guitar - he's such a physical person, and that makes for a great image.

Of course at the time we were shooting in film. The lighting was poor and it's not like you could just check the back of your camera to see if you got the shot. I took the shot, but wasn't sure I had it until I got into the darkroom. It came out just how I'd hoped.

I only shot him this once. But I get told all the time by people that it's their favourite picture of him. I have to say, it's one of my favourites, too.

Steve Emberton

JOHANNA

(1975)

Oh yeah
Oh yeah
Oh yeah

I've been a dreamer
I've been a dreamer
Been a dreamer
For long lost love
Johanna, Johanna,
I hate you baby
Cause you're the one I love

I've been a mean one
I've been unclean
I've been a bitch
And I know it too
Johanna, Johanna,
I hate to say it
But I'm coming back to you

Screamin' murder
Screamin' murder
Bloody murder all in my brain
Johanna
Johanna
I hate you baby cause you're the one I love
Love – Love

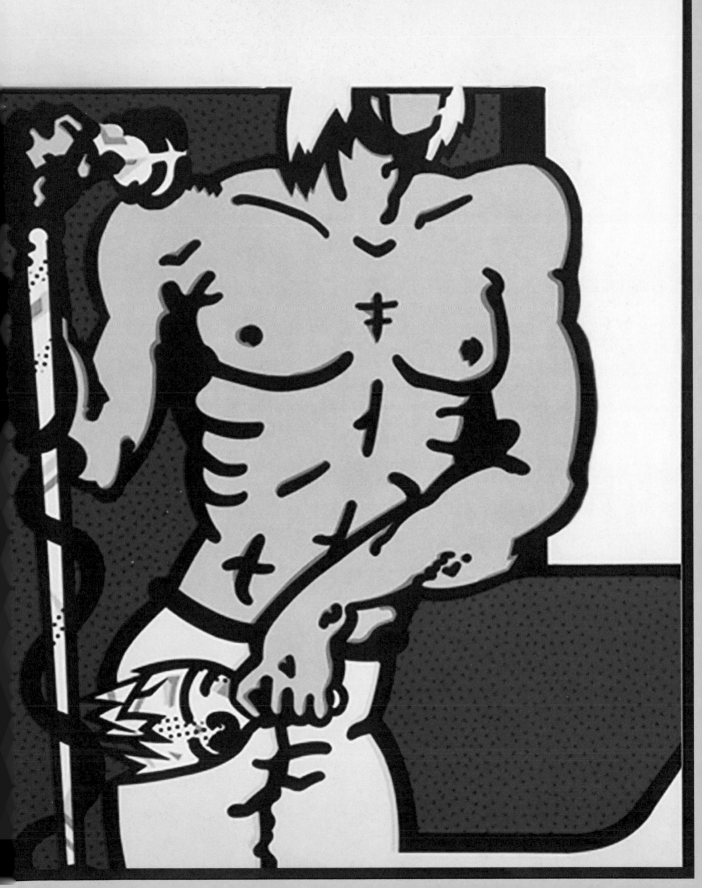

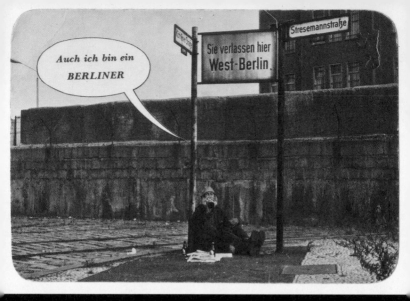

NASJONALGALLERIET, OSLO
Pablo Picasso:
Mann og Kvinne, 1903
Man and Woman (Le pauvre ménage)

Grafo Kortforlag A/S, Oslo - Tlf: (02) 55 17 92

57

printed by giovanni trimboli

Hi from Berlin—
me and
Esther found a dairy

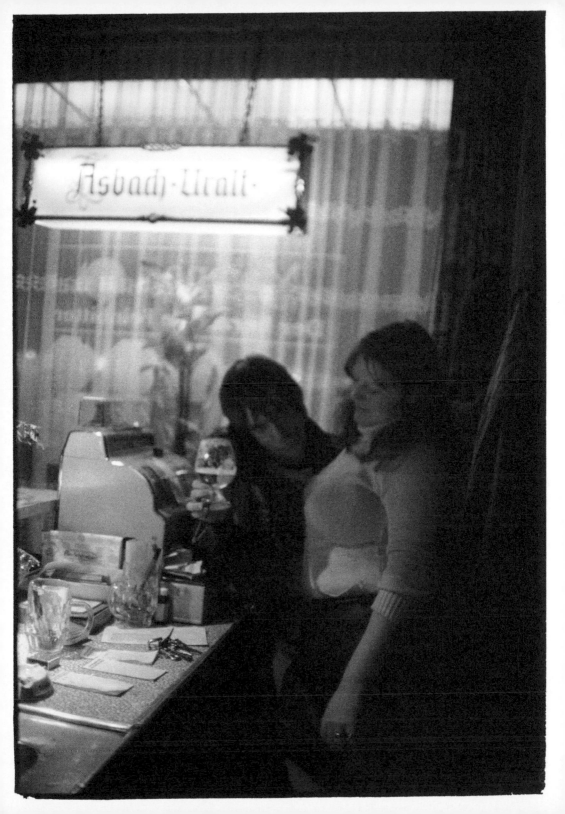

KILL CITY (1977)

Well, I live here in kill city,
Where the debris meets the sea
I live here in kill city,
Where the debris meets the sea
It's a playground to the rich
But it's a loaded gun to me

Well, I'm sick of keeping quiet
And I am the wild boy
I'm sick of keeping quiet
And I am the wild boy
But if I have to die here,
First I'm gonna make some noise

Give it up, turn the boy loose
Give it up, turn the boy loose
Give it up, turn the boy loose
Turn that boy loose

Give it up, turn the boy loose
Give it up, turn the boy loose
Give it up, turn the boy loose
Give it up, turn the boy loose
Give it up, turn the boy loose
Give it up, turn the boy loose
Give it up, turn the boy loose
Give it up, turn the boy loose

Yeah, the scene is fascination
Man and everything's for free
The scene is fascination, man
And everything's for free
Until you wind up in some bathroom
Overdosed and on your knees

CITY

Some Weird Sin

Well, I never got my license to live
They won't give it up
So I stand at the world's edge
I'm trying to break in
Oh, I know it's not for me
And the sight of it all
Makes me sad and ill
That's when I want
Some weird sin

Things get too straight
I can't bear it
I feel stuck, stuck on a pin
I'm trying to break in
Oh, I know it's not for me
But the sight of it all
Makes me sad and ill
That's when I want
Some weird sin
That's when I want
Some weird sin
Just to relax with

Yeah, some dumb, weird sin
For a while anyway
With my head on the ledge
That's what you get out on the edge
Some weird sin

Things get too straight
I can't bear It
I feel stuck, stuck on a pin
I'm trying to break in
Oh, I know it's not for me
When the sight of it all
Makes me sad and ill
That's when I want
Some weird sin
That's when I want
Some weird sin
Just to relax with
Yeah some dumb weird sin
For a while anyway
With my head out on the ledge
That's what you get out on the edge
Some weird sin
Some weird sin
Some weird sin

(1977)

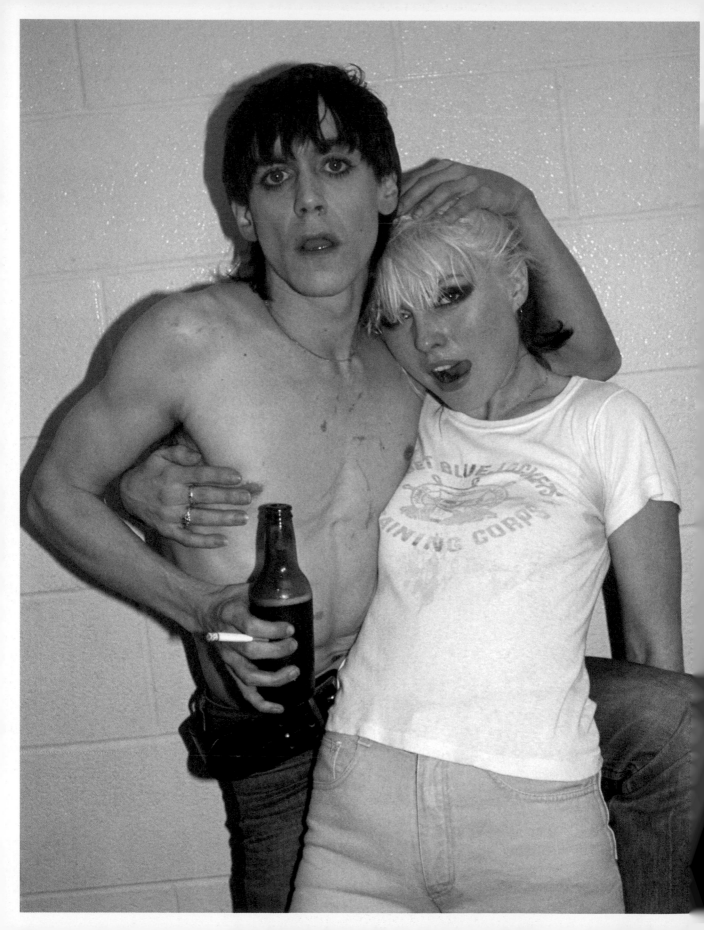

Iggy has such multi-dimensional talent: he's got that
wonderful voice. He's got this incredible voice and
personality. That voice is so distinctive, so rich,
very expressive and a lot of emotion.

DEBBIE HARRY

NIGHTCLUB

Nightclubbing we're nightclubbing
We're what's happening
Nightclubbing we're nightclubbing
We're an ice machine
We see people brand new people
They're something to see
Nightclubbing we're nightclubbing
Oh isn't it wild?

Nightclubbing we're nightclubbing
We're walking through town
Nightclubbing we're nightclubbing
We walk like a ghost
We learn dances brand new dances
Like the nuclear bomb
When we're nightclubbing
Bright-white clubbing
Oh isn't it wild . . .

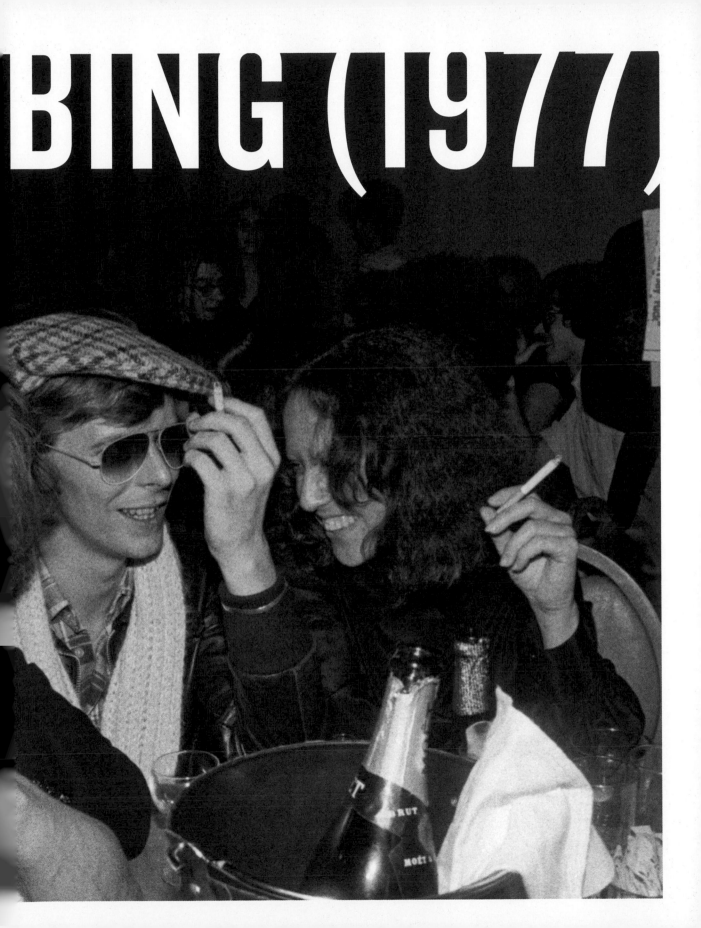

BING (1977)

lust for life

(1977)

Here comes Johnny Yen again
With the liquor and drugs
And the flesh machine
He's gonna do another striptease
Hey man, where'd you get that lotion?
I been hurting since I bought the gimmick
About something called love
Yeah something called love
Well, that's like hypnotizing chickens

Well I'm just a modern guy
Of course I've had it in the ear before
'Cause of a lust for life
'Cause of a lust for life

I'm worth a million in prizes
With my torture film
Drive a G.T.O.
Wear a uniform
All on a government loan
I'm worth a million in prizes
Yeah I'm through with sleeping on the
Sidewalk – no more beating my brains
No more beating my brains
With the liquor and drugs
With the liquor and drugs

Well I am just a modern guy
Of course I've had it in the ear before
'Cause of a lust for life
(Lust for life)
'Cause of a lust for life

I got a lust for life
Got a lust for life
Oh a lust for life
Oh a lust for life
A lust for life
I got a lust for life
I got a lust for life

Well I am just a modern guy
Of course I've had it in the ear before
'Cause of a lust for life
'Cause of a lust for life

Here comes Johnny Yen again
With the liquor and drugs
And the flesh machine
I know he's gonna do another striptease
Hey man, where'd you get that lotion?
Your skin starts itching once you buy the gimmick
About something called love
Oh love love love
Well, that's like hypnotizing chickens

Well I am just a modern guy
Of course I've had it in the ear before
'Cause of a lust for life
(Lust for life)
'Cause of a lust for life
(Lust for life)

Got a lust for life
Yeah a lust for life
I got a lust for life
Oh a lust for life
I got a lust for life
Yeah a lust for life
I got a lust for life
A lust for life
Lust for life
Lust for life
A lust for life

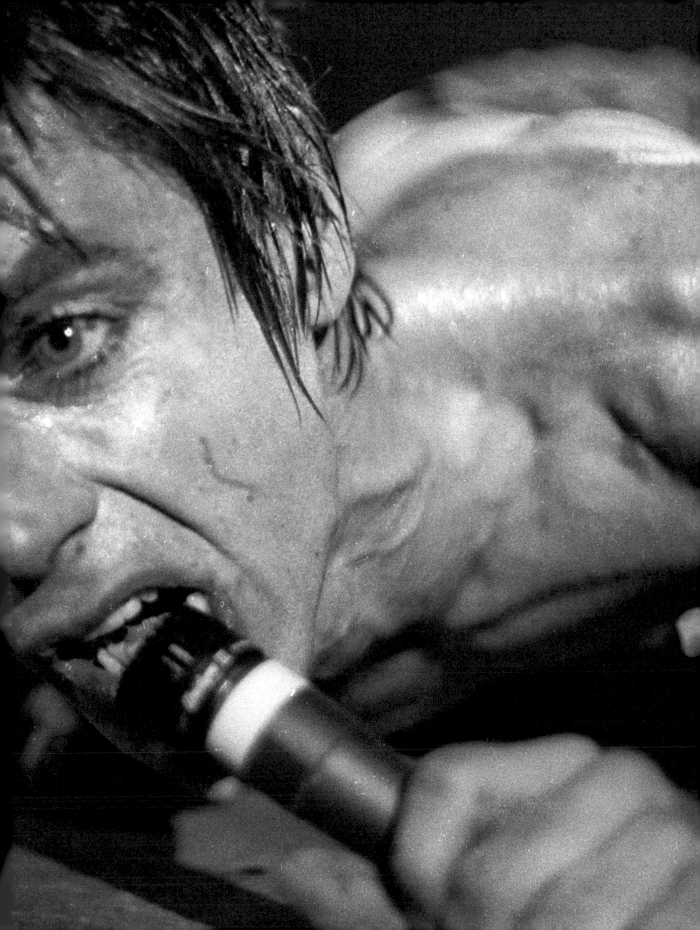

IGGY & ZIGGY
Iggy Pop & David Bowie Live in Seattle 4/9/77

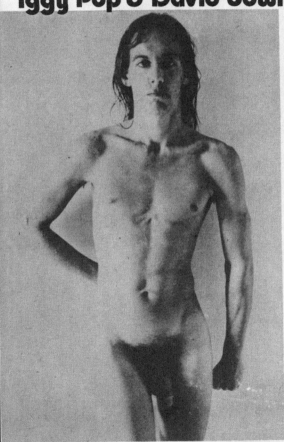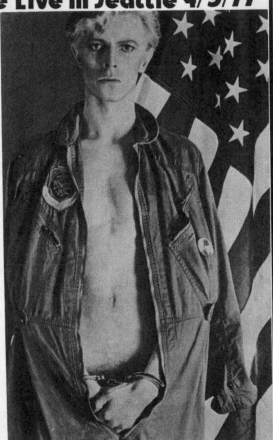

SIDE ONE: RAW POWER/ Medley:=1969/ NO FUN/ 96 TEARS// GIMME DANGER
SIDE TWO: CALLING SISTER MIDNIGHT// SEARCH AND DESTROY/ I WANNA BE YOUR DOG/ CHINA GIRL

DB POP
STEREO

CHINA GIRL (1977)

I could escape this feeling,
With my China girl
I'm just a wreck without my,
Little China girl
I hear her heart beating,
Loud as thunder
Saw the stars crashing
I'm a mess without,
My China girl
Wake up mornings there's
No China girl
I hear hearts beating, loud as thunder
And I'd see stars crashing down
I'd feel tragic like I was Marlon Brando
When I look at my China girl
I could pretend that nothing really meant too much
When I look at my China girl

I stumble into town
Just like a sacred cow
Visions of swastikas in my head
Plans for everyone
It's in the whites of my eyes
My little China girl
You shouldn't mess with me
I'll ruin everything you are
I'll give you television
I'll give you eyes of blue
I'll give you a man who wants to rule the world
And when I get excited
My little China girl says
Oh Jimmy, just you shut your mouth
She says, sh-sh-shhh

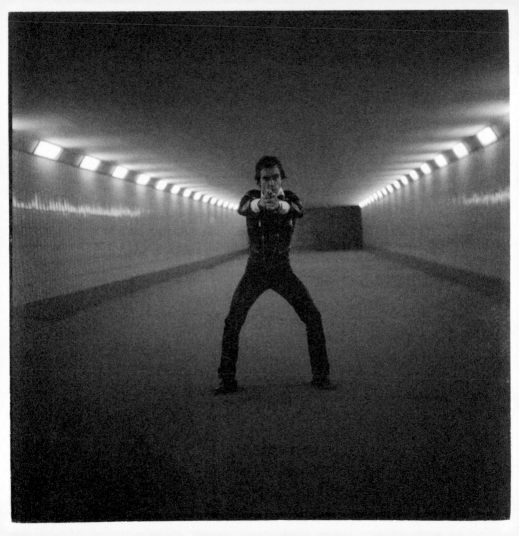

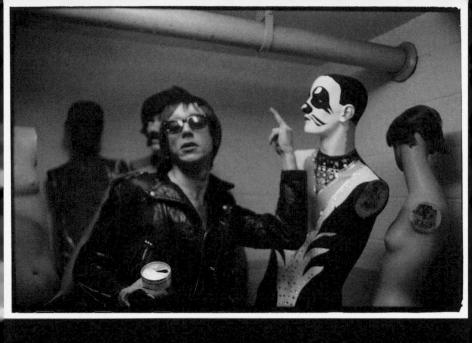

Jimmy is a poet and a dancer and working with him on stage or off was ~~special~~ always special.

Esther Friedman

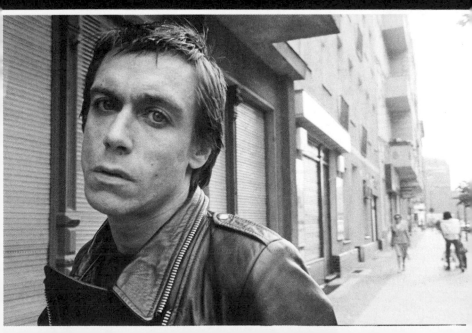

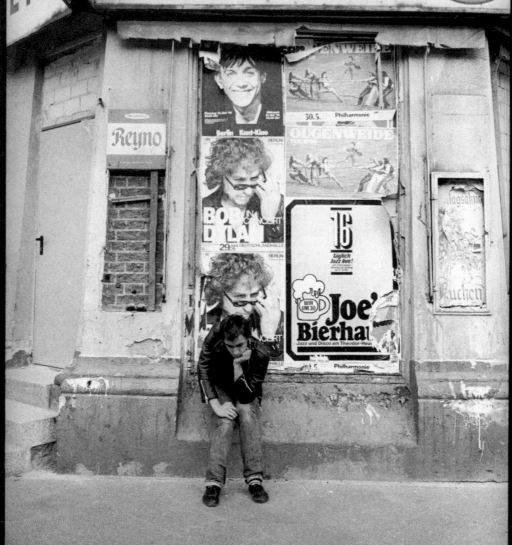

JIMMY

49/67
DATES / DAYS

SEPT.

7	BERLIN
8	MUNICH
9	OFF
(10)	FRANKFURT
(11)	HAMBURG
12	DUSSELDORF
13	OFF
14	STOCKHOLM
15	COPENHAGEN
16	OFF
(17)	AMSTERDAM
(18)	AMSTERDAM
19	BRUSSELS
20	OFF
21	LYONS
22	RHEIMS
23	OFF
(24)	PARIS
(25)	PARIS
26	OFF
27	NEWCASTLE
28	MANCHESTER
29	OFF
30	LONDON

OCT.

(1)	TORONTO	
(2)	MONTREAL	
3	OFF	BUS
4	BOSTON	ORPHEUM
5	HARTFORD	
6	OFF	
7	N.Y.	PALLADIUM
(8)	N.Y.	"

OCT

(9)	PHILADELPHIA	TOWER
10	OFF	
11	PITTSBURG	STANLEY THE.
12	WASHINGTON	
13	ATLANTA	FOX THEA.
14	OFF	
(15)	NASHVILLE	
(16)	MEMPHIS	ELLIS AUD.
17	ST LOUIS —	
18	OFF	
19	CHICAGO	UPTOWN THE.
20	MILWAUKEE	ORIENTIAL T.
21	OFF	
(22)	DETROIT	COBO HALL
(23)	CLEVELAND	
24	COLUMBUS	
25	CINCINNATTI	
26	OFF	
27	INDIANAPOLIS	
28	MINNEAPOLIS	
(29)	OFF	
(30)	NEW ORLEANS	
31	HOUSTON	

NOV.

1	DALLAS
2	OFF
3	TUCSON (OR PHOENIX)
4	SAN DIEGO
(5)	SAN FRANCISCO
(6)	OFF
7	VANCOUVER
8	SEATTLE
9	PORTLAND
10	OFF
11	L.A.
(12)	L.A.

This seems awfully heavy to me.
Jim and Wayne will cut it back some

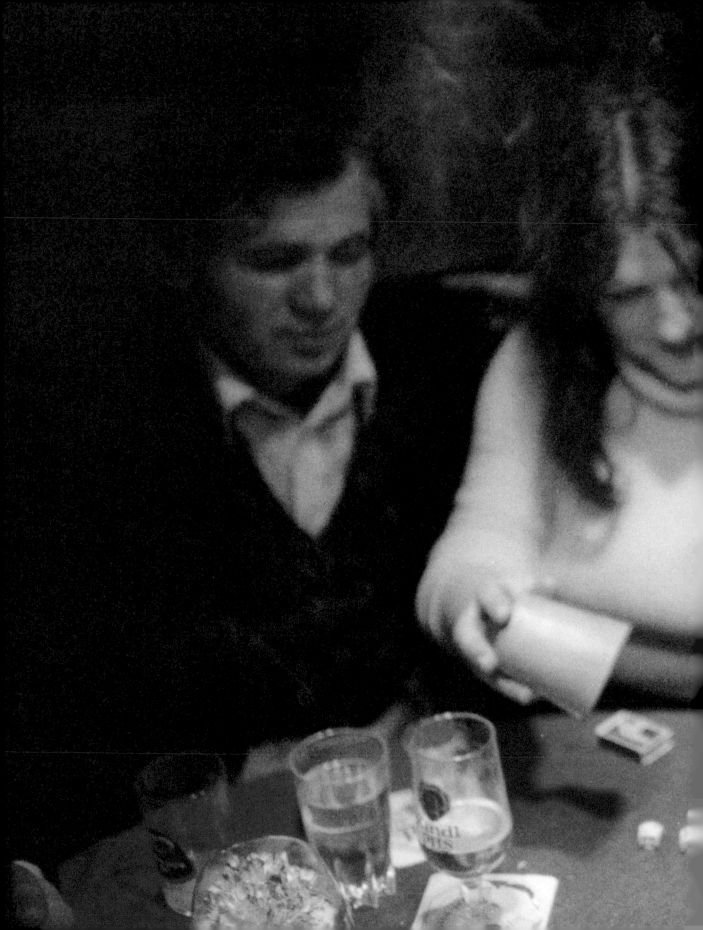

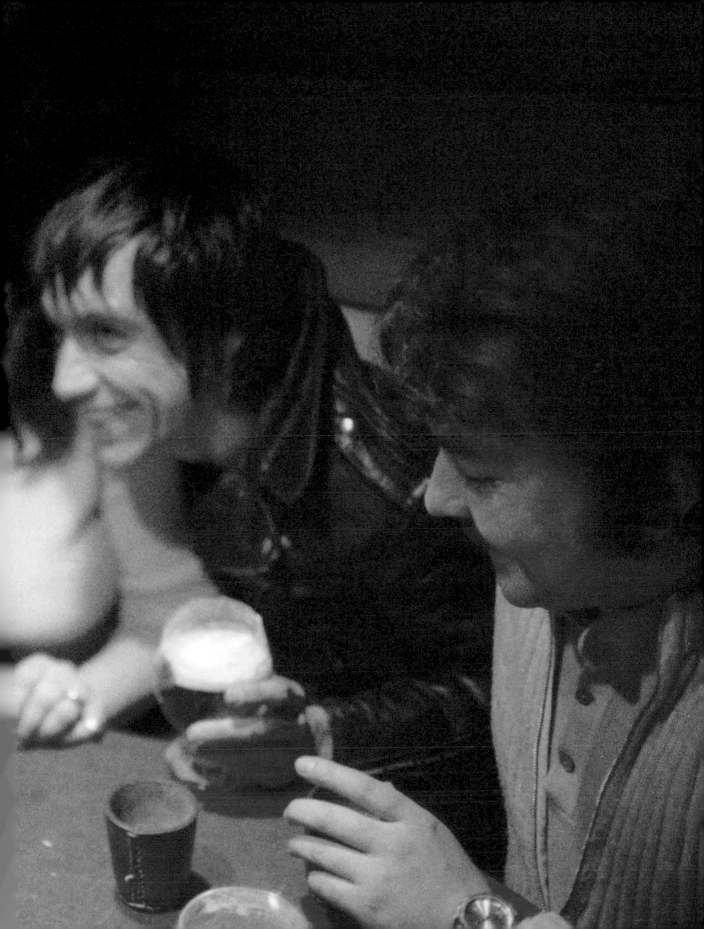

PASSEN

(1977)

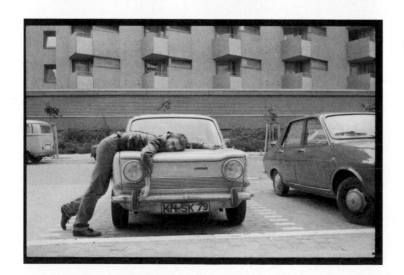

I am the passenger
And I ride and I ride
I ride through the city's backside
I see the stars come out of the sky
Yeah, they're bright in a hollow sky
You know it looks so good tonight

I am the passenger
I stay under glass
I look through my window so bright
I see the stars come out tonight
I see the bright and hollow sky
Over the city's ripped-back sky
And everything looks good tonight

THE
GER

Singin' la-la-la-la-la-la-la-la
La-la-la-la-la-la-la-la
La-la-la-la-la-la-la-la, la-la

Get into the car
We'll be the passenger
We'll ride through the city tonight
See the city's ripped backsides
We'll see the bright and hollow sky
We'll see the stars that shine so bright
The stars made for us tonight

Oh, the passenger
How-how he rides
Oh, the passenger
He rides and he rides
He looks through his window
What does he see?
He sees the silent hollow sky
He see the stars come out tonight
He sees the city's ripped backsides
He sees the winding ocean drive
And everything was made for you and me
All of it was made for you and me
'Cause it just belongs to you and me
So let's take a ride and see what's mine

Singin' la-la-la-la-la-la-la-la
La-la-la-la-la-la-la-la
La-la-la-la-la-la-la-la, la-la

Oh, the passenger
He rides and he rides
He sees things from under glass
He looks through his window inside
He sees the things he knows are his
He sees the bright and hollow sky
He sees the city asleep at night
He sees the stars are out tonight
And all of it is yours and mine
And all of it is yours and mine
Oh, let's ride and ride and ride and ride

Singin' la-la-la-la-la-la-la-la
La-la-la-la-la-la-la-la
La-la-la-la-la-la-la-la, la-la
Singin' la-la-la-la-la-la-la-la
La-la-la-la-la-la-la-la
La-la-la-la-la-la-la-la, la-la

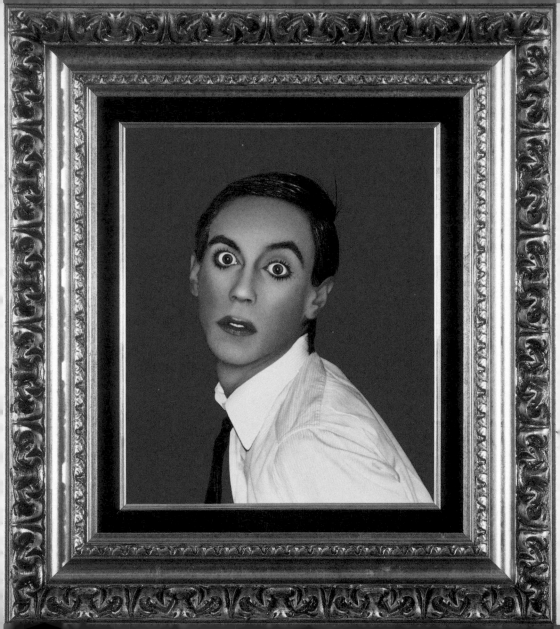

Wired off my head on cocaine, in London, in the late
seventies, listening to the "Passenger" off of *The Idiot*,
I truly believed it was about me: unable to drive yet, I
was constantly riding through the city's backsides, on
my way to score, my heart thudding and looking up at the
bright and hollow skies through the dirty, rain-dashed
windows of tube trains and buses . . .

Sometimes I think I've never left this fugal state,
courtesy of Mr Osterberg . . .

Will Self

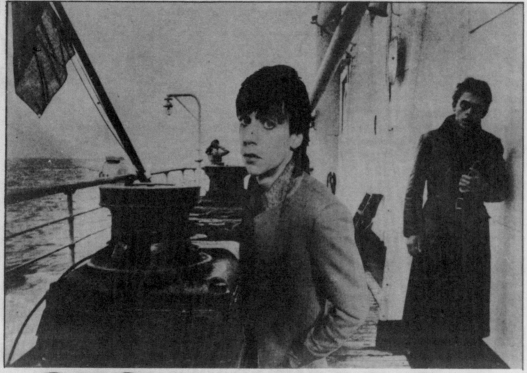

IGGY POP

STOWAWAY D.O.A.
FEATURING DAVID BOWIE

1 | I WANNA BE YOUR DOG
T.V. EYE
DIRT
GIMME SOME SKIN*
2 | FUNTIME
RAW POWER
TURN BLUE
I GOT A RIGHT*

IGGY POP: Vocals
RICK GARDINER: Electric Guitar
TONY SALES: Bass Guitar
HUNT SALES: Drums
and
DAVID BOWIE: Keyboards &
Cigarettes

*IGGY POP: Vocals
JAMES WILLIAMSON: Guitar
RON ASHETON: Bass Guitar
SCOTT ASHETON: Drums

Recorded 15 April 1977 at
Santa Monica Civic Auditorium
Santa Monica, California USA

*Recorded 1973 during the
'Raw Power' recording
sessions in London, England

STEREO

FUNTIME
(1977)

Fun
Hey baby we like your lips
Fun
Hey baby we like your pants
All aboard for funtime
Fun
Hey, I feel lucky tonight
Fun
I'm gonna get stoned and run around
All aboard for funtime
Fun
Last night I was down in the lab
Fun
Talkin' to Dracula and his crew
All aboard for funtime
Fun
I don't need no heavy trips
Fun
I just do what I want to do
All aboard for funtime

Fun
Baby baby we like your lips
Fun
Baby baby we like your pants
All aboard for funtime
Fun
Everybody we want in
Fun
We want some we want some
All aboard for funtime
Fun
Baby baby we like your lips
Fun
Baby baby we like your pants
All aboard for funtime

SUCCESS
(1977)

Here comes success
(here comes success)
Over my hill
(over my hill)
Here comes success
(here comes success)
Here comes my car
(here comes my car)
Here comes my Chinese rug
(here comes my Chinese rug)
Here comes success
(here comes success)
Yeeah

In the last ditch
(in the last ditch)
I'll think of you
(I'll think of you)
In the last ditch
(in the last ditch)
I will be true
(I will be true)
Sweetheart, I'm telling you
(sweetheart, I'm telling you)

Here comes the zoo
(here comes the zoo)
Here comes success
(here comes success)
Oh, hoo-ray success
(hurray success)
(Here comes success,
hurray success)
Oh, oh success
(oh, oh success)
I can't help myself
(I can't help myself)
I just-just got-to-got-to-got-to
(I just-just got-to-got-to-got-to)
Can't stand it
(got-to, got-to, got-to)

Here comes my face
(here comes my face)
It's plain bizarre
(it's plain bizarre)
Here comes my face
(here comes my face)
Out of the crowd
(out of the crowd)
Sweetheart, I'm telling you
(sweetheart, I'm telling you)

Here comes the zoo
(here comes the zoo)
In the last ditch
(in the last ditch)
Here comes success
(here comes success)
Here comes success
(here comes success)
I'm gonna do the twist
(I'm gonna do the twist)
I'm moved man, I'm wigged
(oh man, I'm wigged)
I'm crazy, I'm gonna, I'm gonna go crazy
Alright, baby, let's blast off
(oh, baby let's blast off)
Blast off on success
(blast off on success)
Oh, you slay me
(oh, you slay me, baby)
ooh
(Oh, you slay me, baby)
I'm gonna do the twist
(I'm gonna do the twist)
I'm gonna hop like a frog
(I'm gonna hop like a frog)
I'm gonna go out on the street and do anything
I want
(I'm gonna go out on the street and do anything)
Oh, shit
(oh, shit)

BABY
(1977)

Baby, don't you cry
Baby, I'll sing you a lullaby
We're walking down the
Street of chance
Where the chance is always
Slim or none
And the intentions unjust
Baby there's nothing to see
I've already been
Down the street of chance

Baby you're so clean
Baby please stay clean
We're walking down the
Street of chance
Where the chance is always
Next to none
And the intentions unjust
Baby there's nothing to see
I've already been
Down the street of chance

Baby you're so young
Baby please stay young
We're walking down the
Street of chance
Where the chance is always
Slim or none
And the intentions unjust
Baby there's nothing to see
I've already been
Down the street of chance

Baby, don't you cry
Baby, I've already cried
We're walking down the
Street of chance
The chance is always
Slim or none
The intention unjust
And the intention unjust
And the intention unjust

Pretty faces, beautiful faces
Body and soul,
body and soul
I give to you
I am an easy mark with my broken heart
Sweet sixteen
Show you my explosion
Sweet sixteen

Sweet sixteen
In leather boots
Body and soul,
I go crazy
Baby, baby I'm a hungry,
Sweet sixteen
Funky bar all full of faces

Go out to the funky bar
I get hurt,
Crying inside
'Cause everybody's so fine
And they don't need me.
Tell me what can I do
Sweet sixteen

(1977)

I give you my body and soul
Sweet sixteen
I must be hungry 'cause I go crazy
Over your leather boots
Now baby, I know
That's not normal
But I love you,
I love you
I love you, sweet sixteen

Everywhere I go, I'm lonely

SISTER MIDNIGHT
(1977)

Calling Sister Midnight
You've got me reaching for the moon
Calling Sister Midnight
You've got me playing the fool
Calling Sister Midnight
Calling Sister Midnight
Can you hear me call
Can you hear me well
Can you hear me at all

Calling Sister Midnight
Well I'm an idiot for you
Calling Sister Midnight
I'm a breakage inside
Calling Sister Midnight

Calling Sister Midnight
You know I had a dream last night
Mother was in my bed
And I made love to her
Father he gunned for me
Hunted me with his six-gun
Calling Sister Midnight
What can I do about my dreams

Listen to me Sister Midnight
You got me walking in rags
You put a beggar in my heart
Hey where are you Sister Midnight
Can you hear me call
Can you hear me well
Can you hear me at all

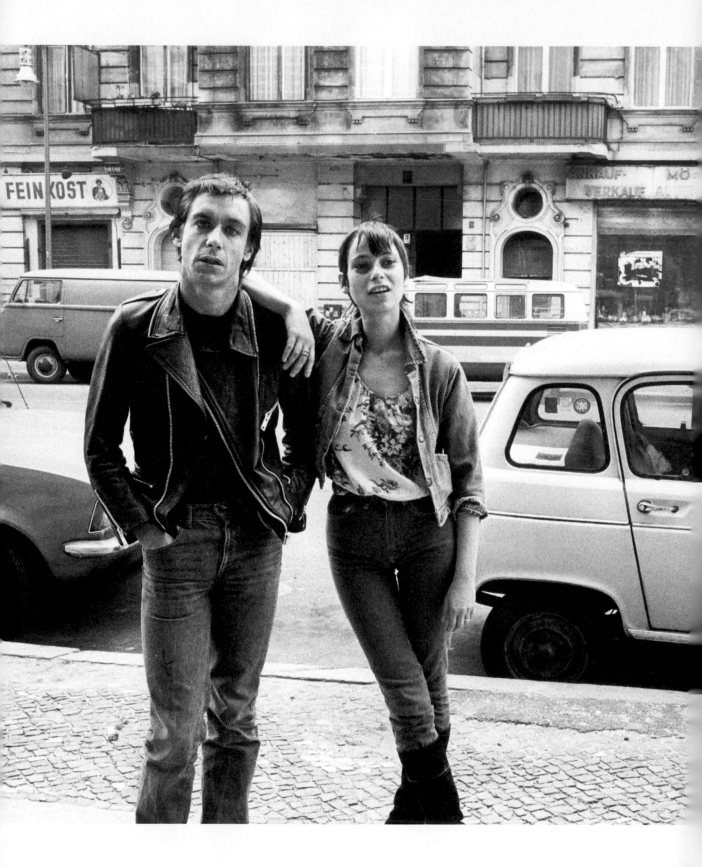

FALL IN LOVE WITH ME (1977)

You look so good to me
Here in this old saloon
Way back in West Berlin
A bottle of white wine
White wine and you
A table made of wood
And how I wish you would
Fall in love with me

You look so good to me
Standing out in the street
With your cheap fur on
Or maybe your plastic raincoat
And your plastic shoes
They look good too
Standing in the snow
You're younger than you look

Fall in love with me
Fall in love with me
How I wish you would
A table made of wood
And a, a bottle of white wine
And you and a bottle of white wine and you
And when you're standing in the street and it's cold
And it snows on you
And you look younger than you really are

I wish you would
Fall in love with me
I wish you would
Fall in love with me
I wish you would
Fall in love with me
I wish you would
Fall in love with me yeah, yeah

The way your eyes are black
The way your hair is black
The way your heart is young
There's just a few like you
Just the kind I need
To fall in love with me
Oh, and you look so good
Oh, yes, you look so good

A bottle of white wine
A cigarette and you
Here in this saloon
White wine and you
I wish you'd fall in love with me
I wish you'd fall in love with me
'Cause there's just a few like you
So young and real
There's just a few like you
So young and real

Fall in love with me
Fall in love with me
Fall in love with me
Fall in love with me
I wish you would
You look so good

Oh, when you're young at heart
There's just a few like you
You're young at heart
Won't you
Come to this old saloon?
Come to my waiting arms
A table made of wood
And I will look at you
'Cause you're so young and pure
And you're young at heart
You're young at heart
A bottle of white wine

And when you're tumbling down
You just look better
When you're tumbling down
You just look finer

DUM DUM BOYS

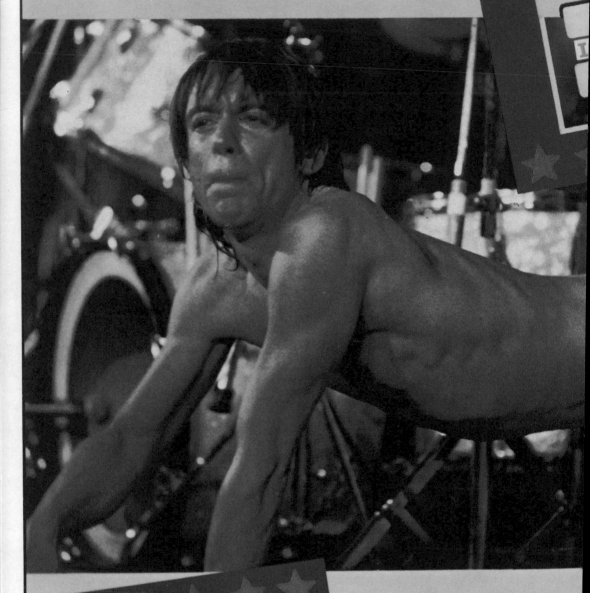

LIVE

1977

What happened to Zeke?
He's dead on the jones man
How about Dave?
Od'd on alcohol
What's Rock doing?
Ah, he's living with his mother
How about James?
He's gone straight

Well things have been tough
Without the dum dum boys
I can't seem to speak
The language
I remember how they
Used to stare at the ground
They looked as if they
Put the whole world
Looked as a they put
The whole world down

The first time I met
The dum dum boys
I was fascinated
They just stood in front
Of the old drug store
I was most impressed
No one else was impressed
Not at all
And we'd sing
Da-da-da-da-da-da
Dum dum day

Well where are you now my
Dum dum boys
Hey are you alive or dead
Have you left me the last
Of the dum dum days
And then the sun goes down
And then the boys broke down

People said we were negative
They said we would take but
We would never give
But we'd sing da-da-da
Da-da-da dum dum day
We'd sing da-da-da-da-da dum
And hope it would pay
We'd sing da-da-da-da it's been
A dum dum dum day
Dum dum day

Well now I'm looking for
The dum dum boys
Hey where are you now
When I need your noise

Now I'm looking for
The dum dum boys
The walls close in and
I need some noise

NEIGHBOURHOOD THREAT (1977)

Down where your paint is cracking
Look down your back stairs, buddy
Somebody's living there and
He don't really feel the weather
And he don't share your pleasures
No, he don't share your pleasures
Did you see his eyes?
Did you see his crazy eyes?

And you're so surprised he doesn't run to catch your ash
Everybody always wants to kiss your trash
And you can't help him, no one can
And now that he knows
There's nothing to get
Will you still place your bet
Against the neighbourhood threat

Somewhere a baby's pleading
Somewhere a mother's needing
Outside her boy is trying
But mostly he is crying
Did you see his eyes?
Did you see his crazy eyes?

And you're so surprised he doesn't run to catch your ash
Everybody always wants to kiss your trash
But you can't help him, no one can
And now that he knows
There's nothing to get
Not in this place
Not in your face
Will you still place your bet
Against the neighbourhood threat

Now that he knows
There's nothing to get
Nothing to get
Not in this place
Not in your face
Will you still place your bet
Against the neighbourhood threat

TONIGHT (1977)

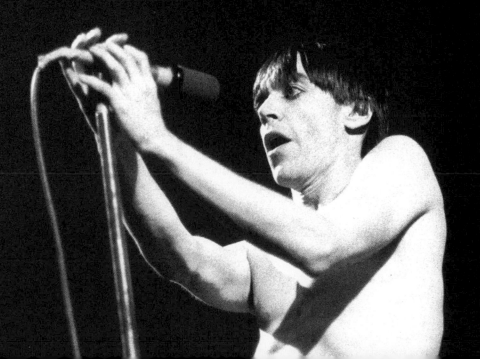

I saw my baby
She was turning blue
I knew that soon, her
Young life was through
And so I got down on my knees
Down by her bed
And these are the words
To her I said

I am gonna love her 'til the end
I am gonna love her 'til the end
I will love her 'til I die
I will see her in the sky
Tonight
Tonight
Tonight
Tonight
Tonight

Everything will be alright tonight
Everything will be alright tonight
No one moves
No one talks
No one thinks
No one walks tonight

Everyone will be alright tonight
Everyone will be alright tonight
No one moves
No one talks
No one thinks
No one walks tonight
Tonight

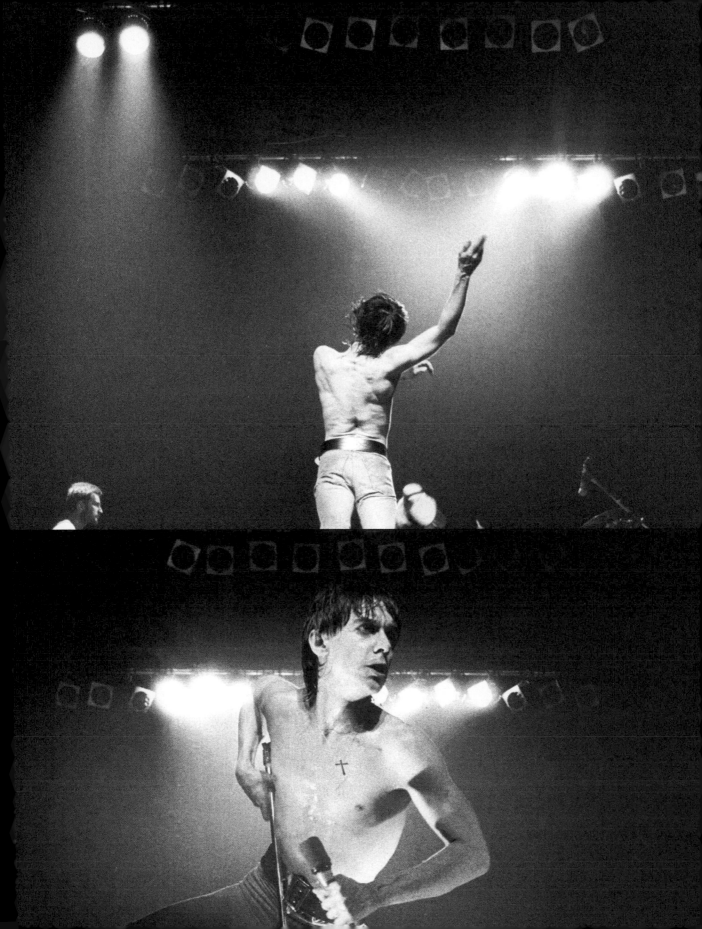

zigzag 70

Mar. 1977

30p. $1.50

IGGY POP
The stooge
steals the stage

RY COODER
On chicken skin
Tex Mex Music

NILS LOFGREN
The Rocking Athlete

JACKSON BROWNE
Talks about The Pretender

In concert, Iggy Pop was the most primal of rockers. He was like something caged and very angry about it. Something dreamed up by Carl Jung. That night I was a fascinated game hunter with a loaded lens. Dionysius in silver, breaking out! A totally immersive experience!

Mick Rock

D O N'T L O O K D O WN (1979)

Don't look down
They're making sorta crazy sounds

So why be bored
Who scared you
And why stay there
It's no piece of cake
When I hear that crazy sound
I don't look down
From Central Park to Shanty Town
I always hear that crazy sound
From New York to Shanty Town
There's always something else

I went this morning to the cemetery
To see old Rudy Valentino buried
Lipstick traces on his name remain
He never looked down
'Cause they were making crazy sounds
From Central Park to Shanty Town
He always heard that crazy sound
There's always something else

When I see you standing there
I can't see the clothes you wear
I just hear that crazy sound
And I can't look down
From Central Park to Shanty Town
I always hear that crazy sound
From New York to Shanty Town
There's always something else

So why be bored
who scared you
And why stay here
This is no piece of cake
When I hear that crazy sound
I don't look down
From Central Park to Shanty Town
I always hear that crazy sound
From New York to Shanty Town
I'm looking good
I don't look down
I'm looking good

0

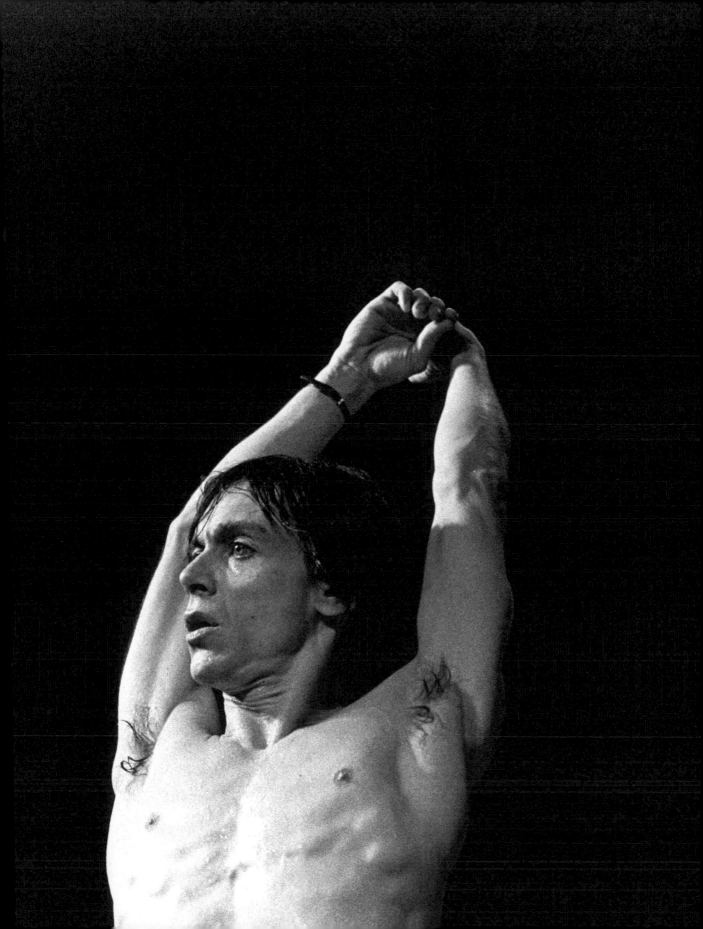

TELL ME A STORY (1979)

What must I do to take a holiday
Show me a bill that they can make me pay
Tell me a story
And maybe I'll believe it
Me I'm just a lucky guy
I'm young and free
Too hard to cry

Lorna from my school she's 21
She's good looking and American so
Tell me a story
Tell me a story
And man I ain't complaining
Man I ain't complaining
Me I'm just a lucky guy
I'm young and hard
Too tough to cry
Standing in a show
The lights ain't low
They're shining down on me
And I like, I like it
Just like I like I like it
I'm taking like I find it

What did they do to chill the joy away
What did they do to say you had to pay
And pay
And pay
Telling me stories
No I never can believe them
Never
Me I'm just a lucky guy
I'm young and free
Too dumb to cry

What must I do to take a holiday
Show me a bill that they can make me pay
Tell me a story
Yeah maybe I'll believe it
Me I'm just a lucky guy
I'm young and free
Too hard to cry

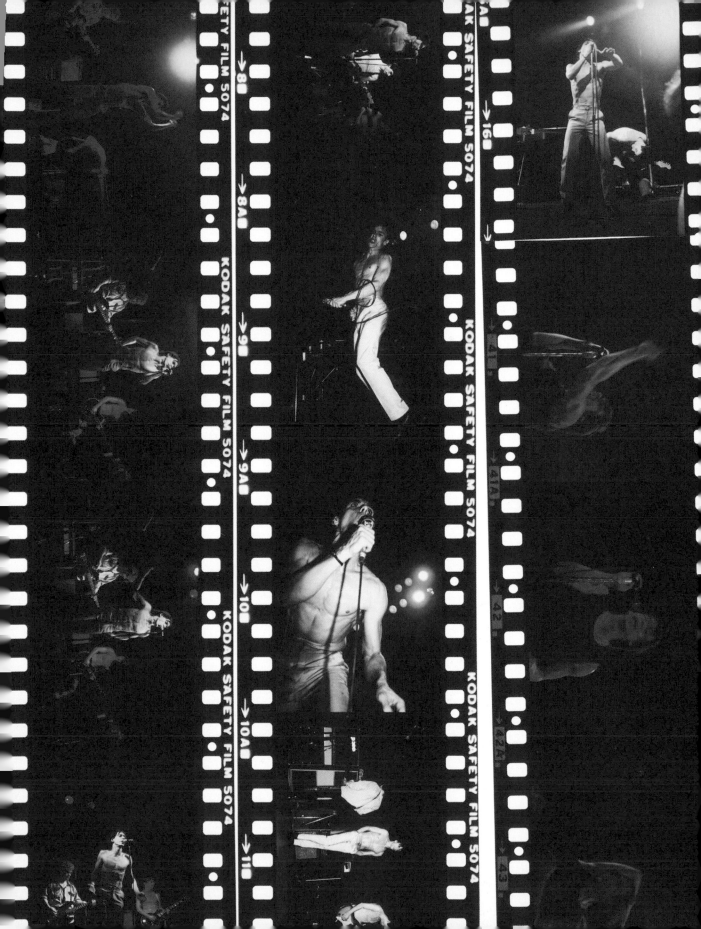

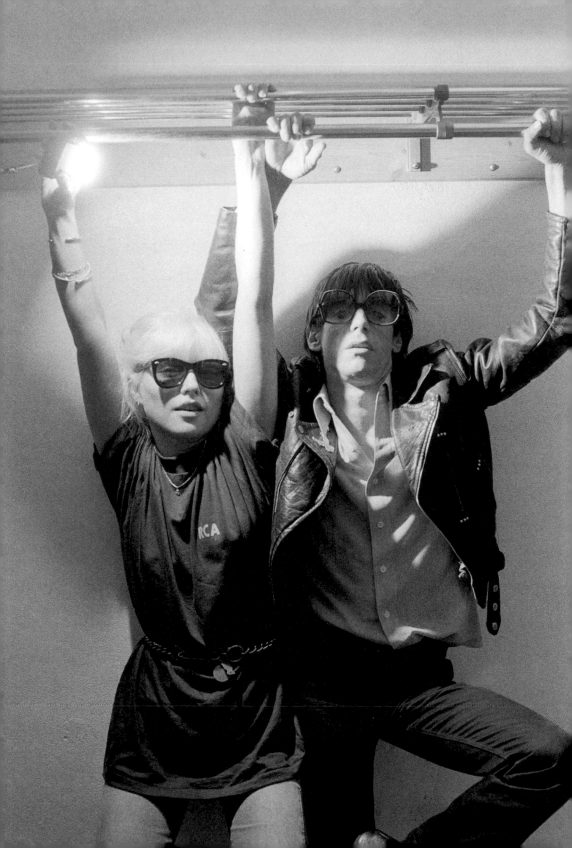

The Idiot tour in 1977 was an amazing experience. In a way, it kicked off our life on the road. We got word that Iggy and Bowie wanted us to open for Iggy on the tour. We played a show at Max's in New York, got into an RV that was parked outside the club, and drove to Montreal. I remember staggering out of the RV after some sleep and going into Le Plateau Auditorium to be confronted by Bowie and Iggy, who were standing there and greeted us. Bowie's taking a "back seat" to Iggy was a huge deal since David was already a mega-star. His taking the role of a session/backup musician said a lot about both his level of self-confidence and his respect for Iggy. In Seattle, Iggy, Clem, Gary, and I went to the local "punk house", a communal house that was the center of local activity. In an upstairs room, we did an impromptu show with borrowed guitars, amps, and drums. Iggy sang; the stage was a board on a mattress. We did "Wild Thing" and maybe a couple of Iggy songs. Years later, when returning to Seattle, I would sometimes be approached by people who said they were at the legendary event.

CHRIS STEIN

NEWS VALUES

NEW VALUES
(1979)

I'm healthy as a horse
Ah but everything is spinning
And if I use a gun
I'm sure to go to prison
I'm stubborn as a mule
And nobody breaks my rules
Ah, but nothing comes my way

I got a hard-ass pair of shoulders
I've got a love, you can't imagine
Yeah, and what I got I double
I swear, I'm keeping out of trouble
I'm looking for one new value
I'm looking for one new value
But nothing comes my way

We live in the same world
We were young in the 20th century
We live balanced

Ahh, but nothing comes my way

BILLY IS A RUNAWAY (1979)

Billy was a bird dog
He pulled up in a Bonneville
I went to see my manager
He usually handles these things
Billy pulled his wallet
Full of hundred-dollar bills
Took me for a joyride
Talking about the stereo
Driving in the left lane
I'm thinking about my burial

We pulled into the liquor store
And he was underage
And all he said to me was
Put your money away
'Cause Billy is a runaway
Billy's got a family
Going to skin him alive
His dope-dealing sister
Wants him to join the enterprise
I leave him at the motel
They can talk it all over
His sister's got a baby now
And Billy hardly knows her

Well I'm a friendly kind of guy
And I had to have him over
I gave him a drink
What do you think
His hands start shaking
His boots start quaking
Billy is a runaway
Billy is a runaway
Billy is a runaway
Billy is a runaway
Runaway
Runaway
Runaway

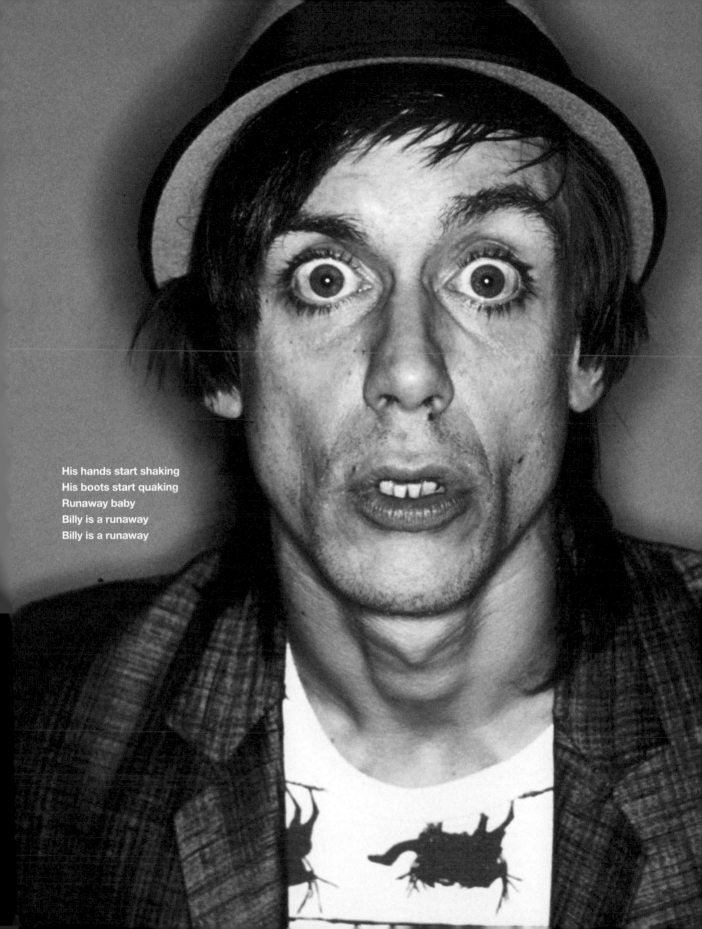

His hands start shaking
His boots start quaking
Runaway baby
Billy is a runaway
Billy is a runaway

FIVE FOOT ONE (1979)

Yeah, I like it
Ugh! Ugh! Ugh!

I'm only five foot one
I got a pain in my neck
I'm looking up in the city
What the hell what the heck
I stare at the concrete
The girders rise high
The steel's above me
There's love in my eyes
And I'm doing the things
A five-foot-one man can do

I'm only five foot one
I got a pain in my heart
All the night I'm working
In the amusement park
With a bottle of aspirin
A sack full of jokes
I wish I could go home
With all the big folks

And I wish life could be
Swedish magazines
I wish life could be
Swedish magazines
I wish life could be
Anything

I'm only five foot one
Unless the time has come
I won't grow anymore
Anymore, anymore, anymore

'Til I'm using my head
I'm checkin' it twice
I'm gonna find out who's naughty and nice
And I'm doing the things a five-foot-one man can do
I wish life could be Swedish magazines
I wish life could be Swedish magazines
I wish life could be Swedish magazines
I wish life could be
Yeah, I wish life could be
Oh
I wish life could be

I wish life could be Swedish magazines
I wish life could be Swedish magazines
I wish life could be
I won't grow anymore
I won't grow anymore
I won't grow anymore
Anymore, anymore, anymore, anymore, anymore
I'm only five foot one
I'm only five foot one
I'm only five foot one
I'm five foot one

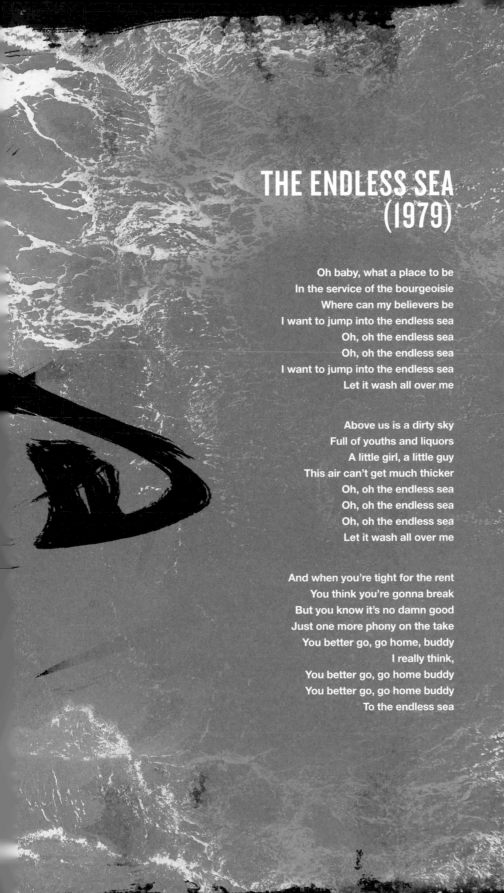

THE ENDLESS SEA
(1979)

Oh baby, what a place to be
In the service of the bourgeoisie
Where can my believers be
I want to jump into the endless sea
Oh, oh the endless sea
Oh, oh the endless sea
I want to jump into the endless sea
Let it wash all over me

Above us is a dirty sky
Full of youths and liquors
A little girl, a little guy
This air can't get much thicker
Oh, oh the endless sea
Oh, oh the endless sea
Oh, oh the endless sea
Let it wash all over me

And when you're tight for the rent
You think you're gonna break
But you know it's no damn good
Just one more phony on the take
You better go, go home, buddy
I really think,
You better go, go home buddy
You better go, go home buddy
To the endless sea

I'm bored. (1979)

I'm the chairman of the board.

board.

I'm a lengthy monologue, I'm livin' like a dog,

at night, I bore myself

I bore myself to sleep

I'm bored. I bore myself

in broad daylight, 'cause I'm bored.

Just another slimy bore. I'm free

'cause I'm bored. I'm free

to bore my well-bought friends,

And spend my cash until the end,

'cause I'm bored. I'm the chairman

of the board. I'm sick. I'm sick of all

my kicks. I'm sick

of all the stiffs, I'm sick of all the

I bore myself to sleep

dips, I'm bored. I bore myself in broad daylight

Just another

I bore myself in broad daylight

'cause I'm bored. I'm bored.

at night,

dirty bore. Alright now, face, come out and bore me.

I am sick. I am sick of all my kicks.

I'm sick of all the stiffs, I'm sick of all

when I go to sleep

I'm sick. I'm sick. I'm sick

the dips, I'm sick. I'm sick

I'm still sick in the broad

at night, I'm still sick in the broad

I'm bored.

daylight, 'Cause I'm bored.

of the board.

'm the chairman

Stinking fucking skinny tie dipshits mewing fake love in New Romantic hairdos, all to the beat of the dull ass drum machine. And I, the last squirming pocket of filthy resistance. I saw it all coming, the whole cheap cancerous future. I wrote to illustrate, but also to medicate. And as the decade turned over, Lo, out of the West! came the hordes in leather, chains. Screeching hair bands incessantly televised in bad lighting. This was the death decade for Rock and Roll.

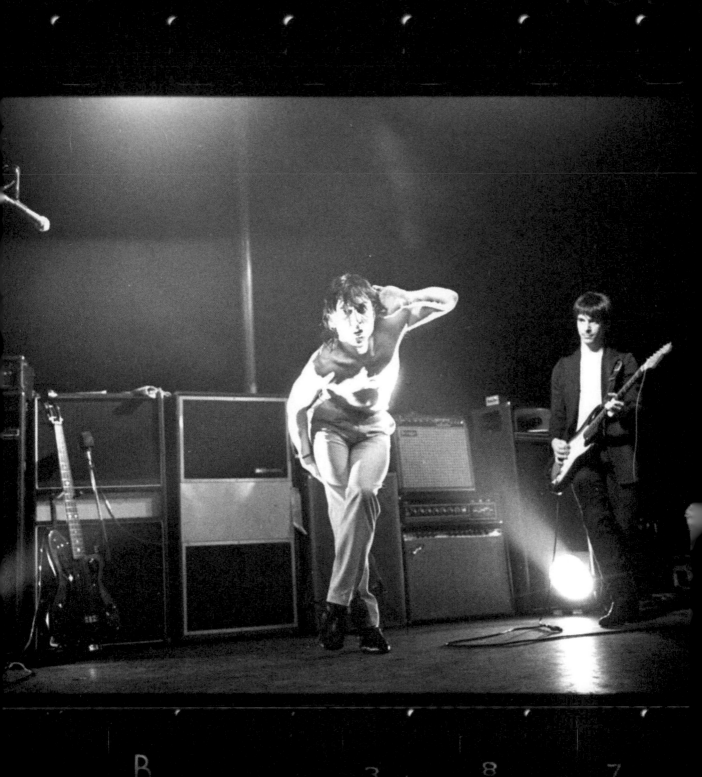

Meeting up with Jim was always unpredictable. He could be off his face, slurring and wild, or have his arms and legs swathed in gaffer tape while causing directors of a live, 6pm TV show stress and ultra vigilance because he's likely to pull down his trousers (always commando). He can be the sweetest, loveliest and funniest man in the room and definitely one of my very favourite people to have photographed because Jim is Iggy and Iggy is the very essence of rock and roll.

Virginia Turbett

KNOCKING 'EM DOWN IN THE CITY (1980)

We're seeking employment
We're ready and strong
Knockin' 'em down in the city
We're knockin' 'em down
We don't care where they fall
Knockin' 'em down in the city
And we don't care what your name is
We're only here to knock 'em down

We're coming to your house to state our appeal
Knockin' 'em down in the city
It doesn't take long 'cause the message is clear
Knockin' 'em down in the city

And you can change situations
Go ahead and knock 'em down
Go ahead and knock 'em down

The world has its problems but I can't see how
Knockin' 'em down in the city
I want expression and I get it now
Knockin' 'em down in the city
And I don't care what your name is
I'm only here to knock 'em down

Are you ready to knock 'em down
Are you ready to knock 'em down
Are you ready to knock 'em down
Are you ready to knock 'em down
Well I'm ready
We're ready
Are you ready
We're ready
Are you ready
We're ready
Are you ready to knock 'em down

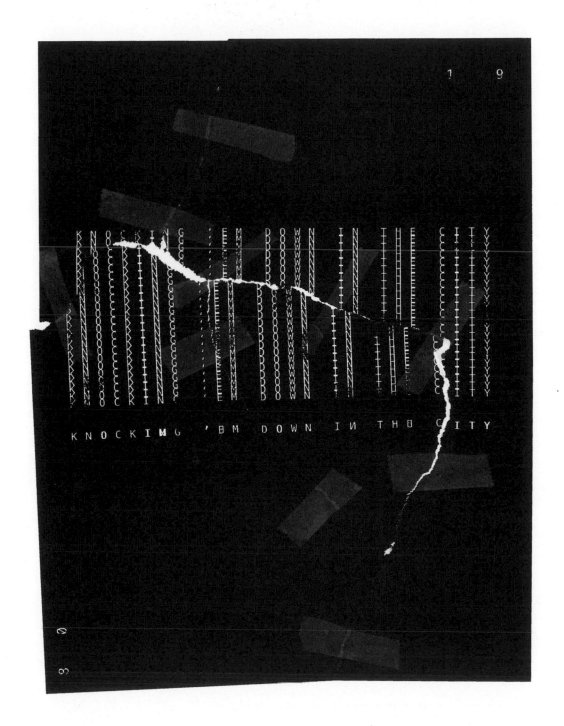

KNOCKING 'EM DOWN IN THE CITY

DOG FOOD
(1980)

I'm hanging around that same old scene
My girlfriend Betsy she's just fourteen
There's nothing better for me to do
I'm living on dog food

Dog food is so good for you
It makes you strong and clever too
Dog food is a current craze
Eat some every day

Dogfood
Dogfood

I chew up my *Sunday Mirror*
I read about the rich I fear
Dog food is my whole life
Dog food composes my wife
Dogfood
Yum, yum
Woof, woof, woof
Dogfood
Dogfood
Dogfood

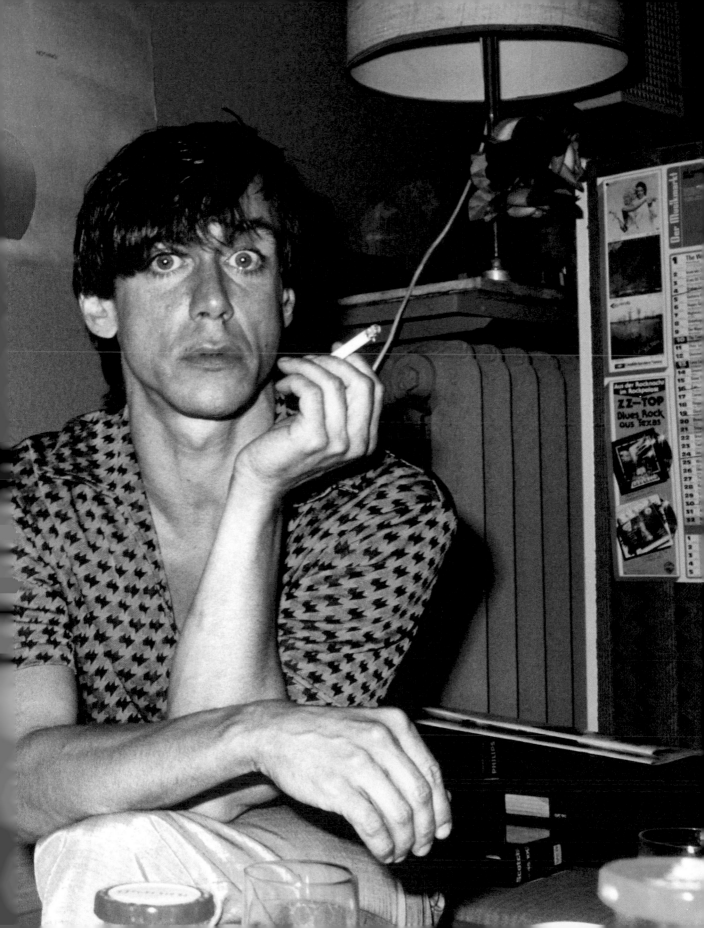

I'M A CONSERVATIVE (1980)

I used to lead a quiet life
In fact it was a bare existence
I passed out on many floors
I don't do that anymore

Hello my friends
Is everybody happy?

Hey look me over
Lend me an ear
I'm a conservative
I like the small black marks on my hands
I'm a conservative
I like the crazy girls that I screw
Hey, hey I know them all well
And when I run out of bread I laugh
All the way to the bank
Sometimes I pause for a drink
Conservatism ain't no easy job
I smile in the mornings
I live without a care
Nothing is denied me
And nothing ever hurts

I got bored so I'm making my millions
When you're conservative you get a better break
You're always on the right side
When you're conservative
You walk with pride
Pride is on your side
Pride pride pride
Is on our side
Oh boy
Pride is on our side

I like my beer
I like my bread
I love my girl
I love my head
I'm in the clear man
I'm in the clear
Because I'm a conservative
I'm a conservative

I really am
Oh yes I am

And it could mean so much to me
If you would only be like me
Yes it could mean so much to me

Hey look me over
lend me an ear
I'm a conservative

Iggy Pop
THE BREAKING POINT

ACCESS ALL AREAS

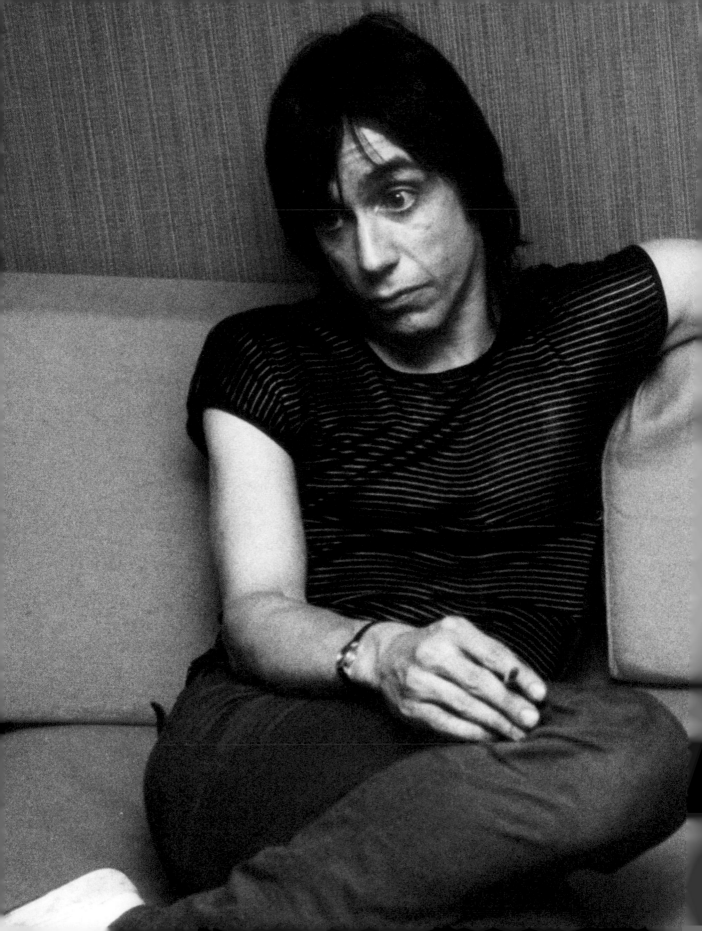

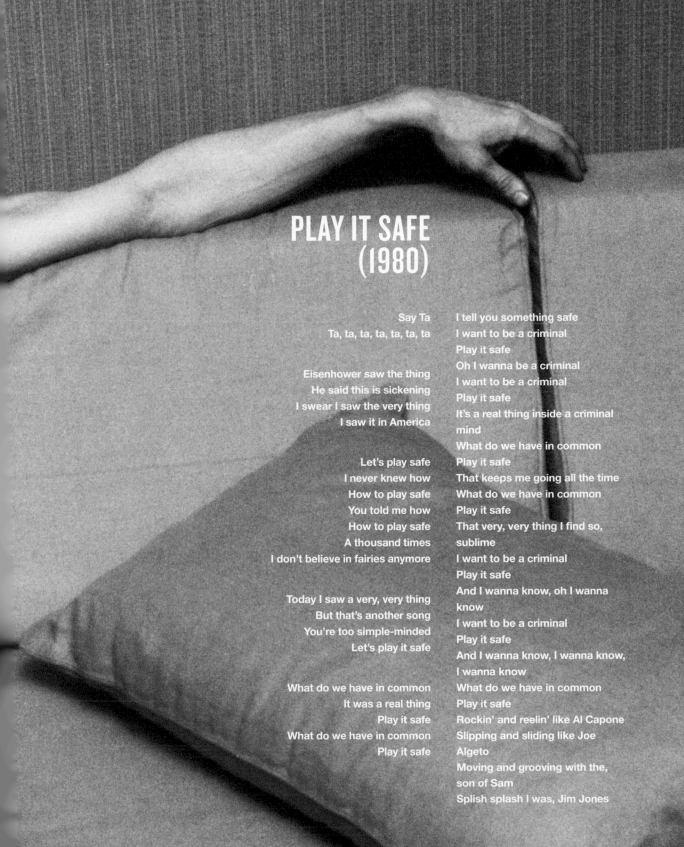

PLAY IT SAFE
(1980)

Say Ta
Ta, ta, ta, ta, ta, ta, ta

Eisenhower saw the thing
He said this is sickening
I swear I saw the very thing
I saw it in America

Let's play safe
I never knew how
How to play safe
You told me how
How to play safe
A thousand times
I don't believe in fairies anymore

Today I saw a very, very thing
But that's another song
You're too simple-minded
Let's play it safe

What do we have in common
It was a real thing
Play it safe
What do we have in common
Play it safe

I tell you something safe
I want to be a criminal
Play it safe
Oh I wanna be a criminal
I want to be a criminal
Play it safe
It's a real thing inside a criminal
mind
What do we have in common
Play it safe
That keeps me going all the time
What do we have in common
Play it safe
That very, very thing I find so,
sublime
I want to be a criminal
Play it safe
And I wanna know, oh I wanna
know
I want to be a criminal
Play it safe
And I wanna know, I wanna know,
I wanna know
What do we have in common
Play it safe
Rockin' and reelin' like Al Capone
Slipping and sliding like Joe
Algeto
Moving and grooving with the,
son of Sam
Splish splash I was, Jim Jones

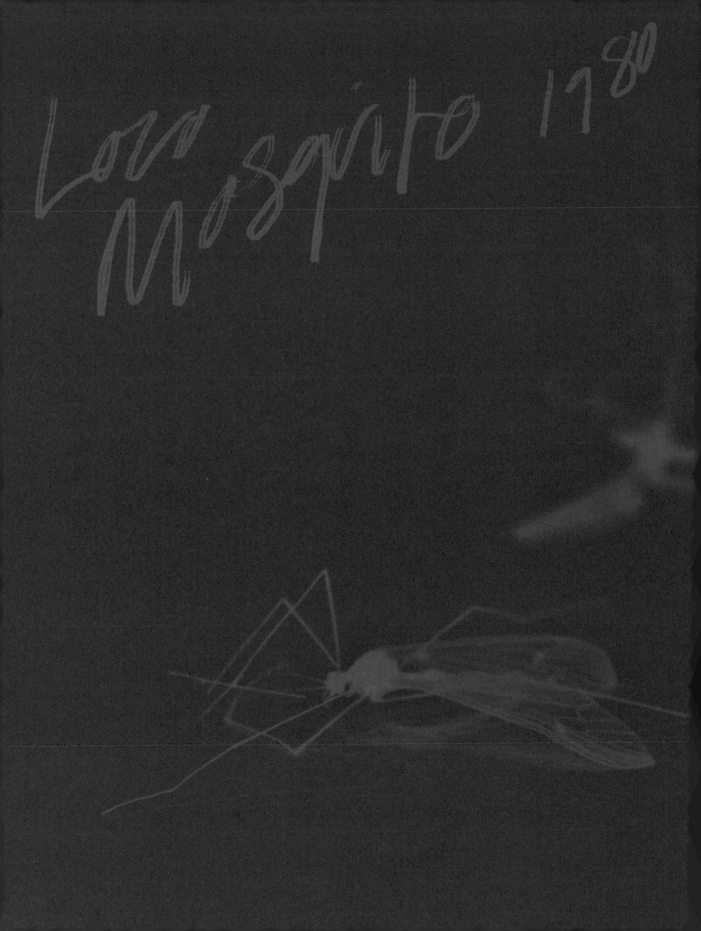

LOCO MOSQUITO
(1980)

My mommy told me
If I were goody
That she would buy me
A rubber dolly

I got some energy to burn
It makes me jumpy and nervous
But I'm too damn old to join the military service
Hup, two, three, four
I got to hit my baby on a Saturday night
You know the devil made me do it
I know it wasn't right

Like a loco mosquito
'Round and 'round and 'round I go
And when I'm hungry
Down I go

Please Mr. Custer I don't want to go
And spend my night in a bar with some stupid dodo
I'm sick of hanging 'round with old transvestites
They stare at my rubbers
It makes me uptight

And here I go
In love again
Here I go-oh, woo, woo
Like a loco mosquito

I got some energy to burn
But you always want to tap it
You're busy sucking on my gas tank
Before I can cap it

Like a loco mosquito
'Round and 'round and 'round I go
And when I'm hungry
Down I go

Loco – mosquito
Loco – mosquito
Loco – mosquito

I NEED MORE
(1980)

I walk around
I flop around
I need something that will be found
More venoms, more dynamite, more
disaster
I need more than I ever did before

I need more than an ordinary grind
Everybody ought to love his job
And live his life and keep his pride
Imperturbably happy with the one you love
With an exciting future
On the fat of the land

But everything is going up in price
My life is going all right up 'til now
Even so there's something missing

I need more than an ordinary grind
And the more I think the more I need
My life is going all right up 'til now
Even so it's not enough for me and

More truth
More intelligence
Ha ha
More future
More laughs
Ha ha ha
More culture
Don't forget adrenaline
More freedom

I need more
I need more
And I need more
I need more
And I need more
I need more
Oh oh oh oh
Oh oh oh oh
Oh oh oh oh
Oh oh oh oh

I need more than an ordinary grind
And the more I think the more I need
More cars
I'll take more money
More champagne
I can't forget my brain
More floors
More doors
More mustard
Pickle and relish

Than I ever did before
I need more
I need to lead a dissipate existence
And play scratchy records
And enjoy my decline
With more divorce, more distance,
more future, more culture
I need more
More

BANG BANG
(1981)

This isn't the right thing to do, so let's go

Young girls
Know what they're after
Young girls
Don't kiss me goodbye
Rockets
Shoot up to space
And buildings
Rise to the sky

Bang bang
I got mine
Bang bang
Reach for the sky

I keep a good friend
On video tape
He'll drive his sports car
Until it's too late
But we'll have a hot time
On the town tonight
'Cause love is my gadget
And it's the best yet
Bang bang
I got mine
Bang bang
The sun don't shine
Bang bang
Oh what a hot time
Bang bang
I oughta be in pictures
Let's go

Oh girl
Oh girl
My problems can't follow me
Phone calls
I take by machine
I want no intimacy
Lonely ha ha ha
What does it mean
Who, me
Bang bang
I got mine
Bang bang
And you're next in line
Bang bang
And that's all it means man
Here, have a glass of wine
Bang bang
Rise buildings
Rise to the sky
Bang bang
Young girls
Know what they're after
Bang bang
Young girls
Don't kiss me goodbye
Don't kiss me
Young girls
Young girls
Young girls

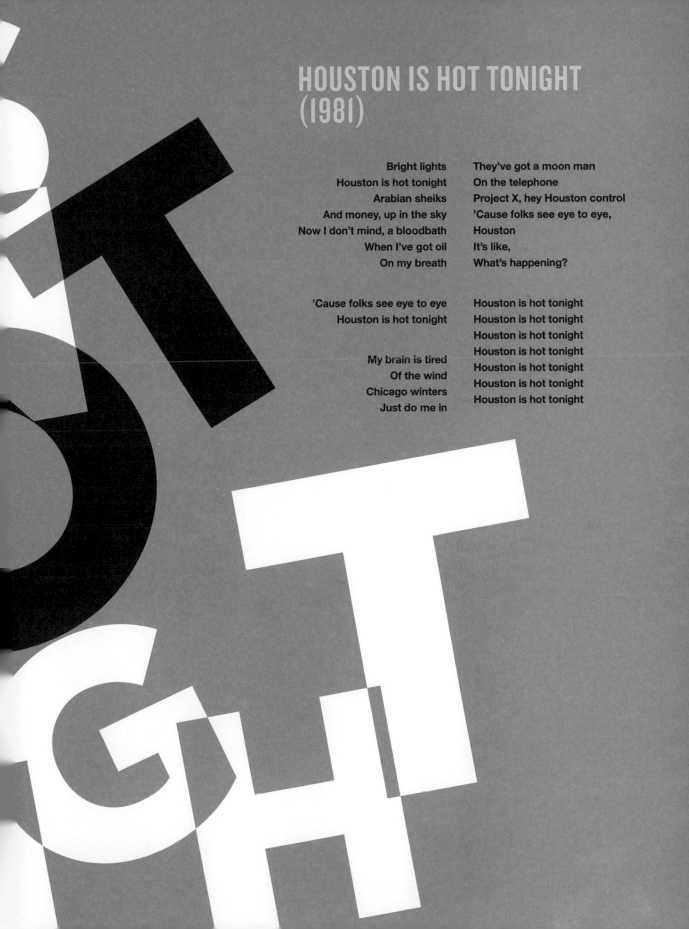

HOUSTON IS HOT TONIGHT
(1981)

Bright lights
Houston is hot tonight
Arabian sheiks
And money, up in the sky
Now I don't mind, a bloodbath
When I've got oil
On my breath

They've got a moon man
On the telephone
Project X, hey Houston control
'Cause folks see eye to eye,
Houston
It's like,
What's happening?

'Cause folks see eye to eye
Houston is hot tonight

My brain is tired
Of the wind
Chicago winters
Just do me in

Houston is hot tonight
Houston is hot tonight
Houston is hot tonight
Houston is hot tonight
Houston is hot tonight
Houston is hot tonight
Houston is hot tonight

PUM
for JIL

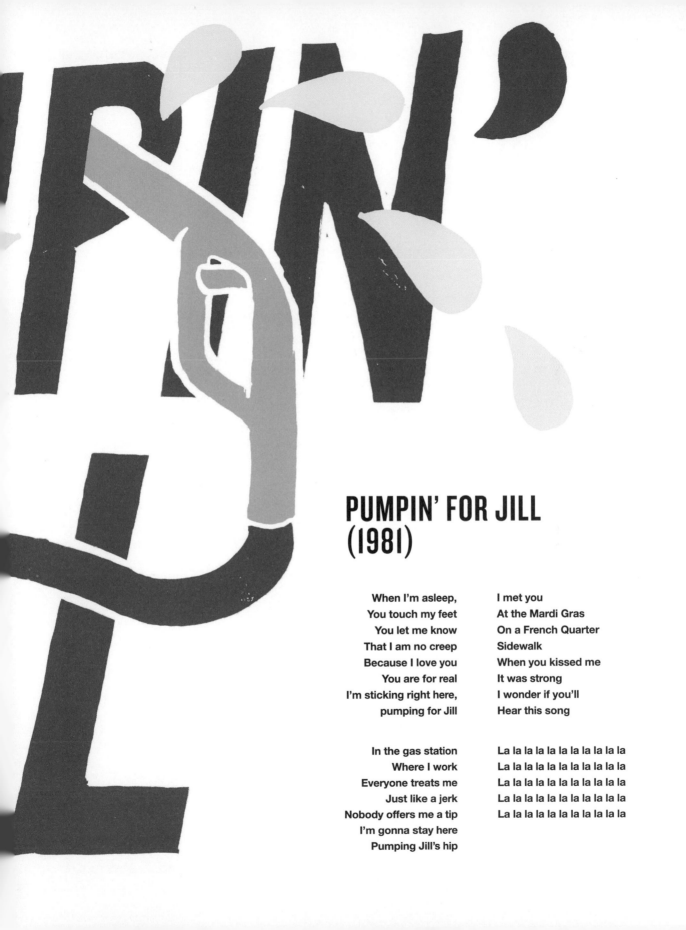

PUMPIN' FOR JILL (1981)

When I'm asleep,
You touch my feet
You let me know
That I am no creep
Because I love you
You are for real
I'm sticking right here,
 pumping for Jill

In the gas station
Where I work
Everyone treats me
Just like a jerk
Nobody offers me a tip
I'm gonna stay here
Pumping Jill's hip

I met you
At the Mardi Gras
On a French Quarter
Sidewalk
When you kissed me
It was strong
I wonder if you'll
Hear this song

La la la la la la la la la la la
La la la la la la la la la la la
La la la la la la la la la la la
La la la la la la la la la la la
La la la la la la la la la la la

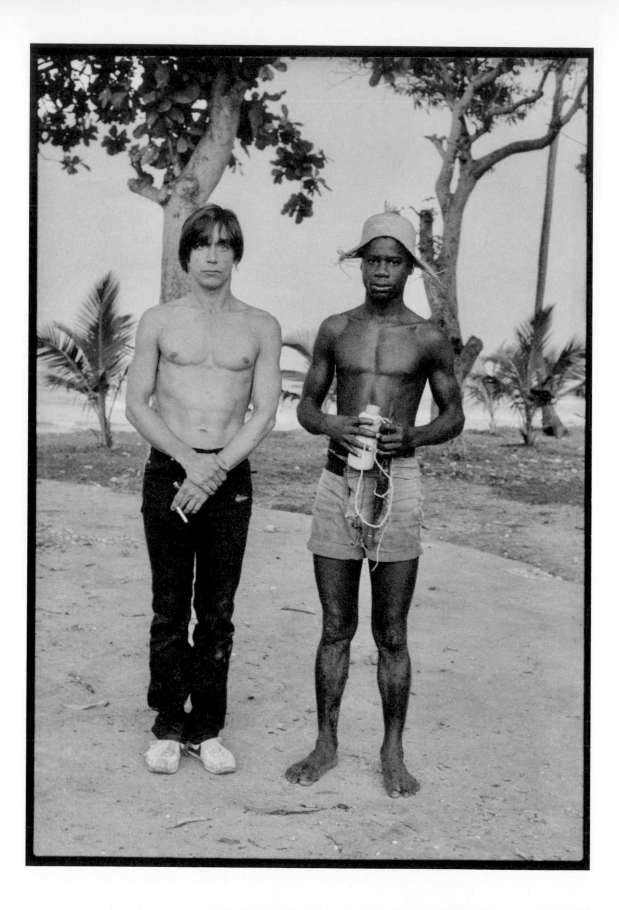

THE VILLAGERS
(1982)

The villagers are out tonight
Uptight and bored
They're pushing you
Underground

On wintry days they stand and gaze
Outlined in black and ignorant . . . villagers

Dark shadows house a sleepy malice
In the back brain
Of every body you meet
Man is the village animal
United by the glue
Of our loathsome qualities
We are sneaking peeping toms
In revolt against each other

The villagers are post insane
They live to die anonymous
And muted too . . . villagers
In revolt against the other
But not against the rules
So in the space age the village idiot rules
On TV for all to see as some good men
Walk the streets

Uh uh uh uh uh, uh uh uh uh

The villagers
You can't get lost, you can't get lost
In the village of space, you can't get lost

RUN LIKE A VILLAIN
(1982)

Big Dick is a thumbs-up guy
He shot a missile in the sky
It functioned just as advertised
Until the fire made him cry
Look into it later
When the dust is clearing off the crater

Run like a villain let the good times roll
Run like a villain to the sugar bowl
Run like a villain 'cause you can't adjust
To a saccharine suburb in the mush

I've got some loving arms around me
Darker than the tombs of Egypt,
Dumber than the crudest fiction,
Buried in a melting coffin
Nights like this appeal to me!

Tracy got an Afghan, pedigreed
Prescription shades and designer jeans
A Sony Walkman on her head
All she wants is to be fed
Run, run, run, 'cause you're soft
Run, run, but don't get lost

The shining moon the dead oak tree
Nights like this appeal to me
I've got some loving arms around me
The shining moon the dead oak tree
Nights like this appeal to me
I've got some loving arms around me
Trying to steal a moment of pleasantry
In this Z o m-beee birdhouse

Run, run, run

Run like a villain
Let the good times roll
Run like a villain to save your soul
It can't be done I already know
So I run like a villain to the sugar bowl

'Cause who you are nobody knows
Who you are nobody knows
Rings on your fingers
And bells on your toes

THE HORSE SONG (1982)

I never saw you before
I never smelled Spring before
Now I'm at your door
And I hope you're unusual
Very unusual, now I'm at your door

And when you nicely ask me in
I'm staring at your shoes
And I don't wonder why
I feel like a horse

We can stray out on the open range
Missing me every day
With its hidden claws
Spring snow

And when you brush me
You brush me with your eyes
I think you've noticed
That I don't want to be a bad guy anymore

I never saw you before
But you're unusual
And now I'm at your door
I feel safe and warm
I feel
I feel
I feel
I feel
Like a horse
What's this?

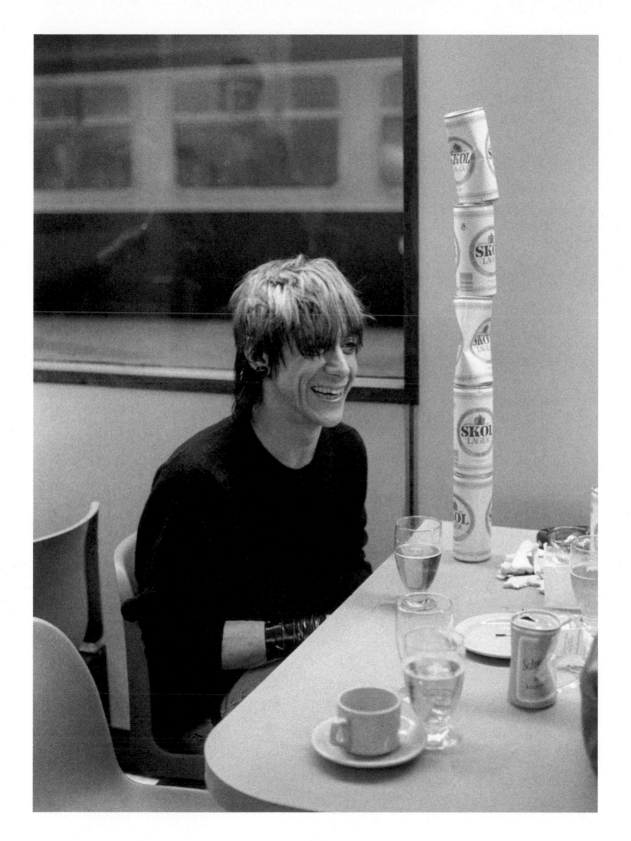

REPO MAN
(1984)

I was riding on a concrete slab
Down a river of a useless land
It was such a beautiful day
I heard a witch doctor say
I'll turn you into a toadstool

I'm looking for the joke with a microscope

A muscle twitch, an auto swerves
You want to speak you lose your nerve
Infinity throws you a curve
Dumps you in shit you don't deserve

As life roars by you in a blur
Leaves you murmuring a dirty word

A page out of a comic book
A chicken hanging on a hook
A reverie, a babbling brook
A sermonette, a TV cook

Shaking my hand at your fake head
A suicide, a certain look

A microphone, a blues guitar
Piques a feeling near and far
Stupidity a mental scar
Cruel cruelty, oh cruelty
Harboring no inspiration
An alcoholic at the bar
Every insult goes too far

I was pissing on the desert sands
When the desert whispered to me
It said, isn't this a shame?
Things will never be the same
I've learned this gets me so edgy

Now I'm looking for the joke with a microscope

I was a teenaged dinosaur
Stoned and obsolete
I didn't get fucked and I didn't get kissed
I got so fucking pissed

Using my head for an ashtray
Now I tell you who I am
I'm a repo man

And I'm looking for the joke
Yeah I'm looking for the joke
I'm looking for the joke
Looking for the joke
Looking for the joke
Looking for the joke with a microscope
I been looking for the repo repo repo repo man
Looking for the repo repo repo repo man
Looking for the repo man
Looking for the repo man
Looking for the repo man

Repo
Man

I love all Stooges songs. *Fun House* . . . is probably
the greatest rock'n'roll record ever made.

Jim Jarmusch

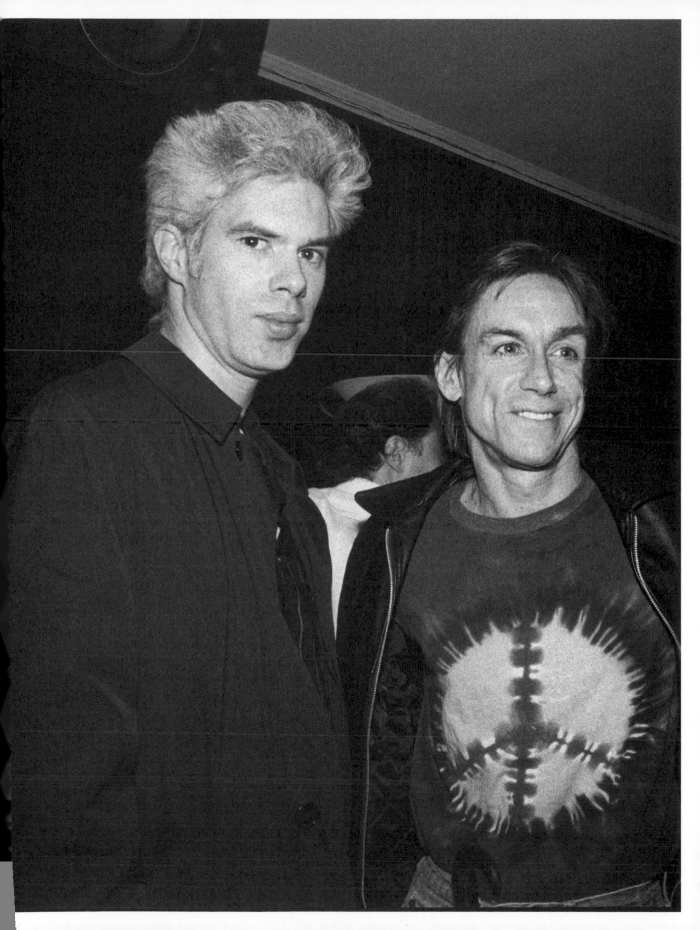

BLAH
BLAH
BLAH
BLAH

BLAH BLAH BLAH (1986)

Pop before the war
Lunch before the score
Steady as she goes
Following my nose
I'm a bull mongrel
That's me
Baby that's me

Shimon Peres
Whatcha gonna do
I'm from Detroit
Blow the reveille
Deatho knocko
That's me little ol' me
Glamorous me

Johnny can't read
Blah blah blah
I can't see
Blah blah blah
Tuna on white
Guns all night
Blah blah blah

Cat taboo girl –
Raped by an ape

Cat taboo girl

Jam the sucker in
You dig the mongrels
Guardian of the state
Says you gotta go
Bombin' low
Senator Rambo
Merrily you go
Monkey butcher knows
A cab to find a bank
A bank to find a loan
'Cause you can't be alone
You dig the mongrels
That's you
That's you
Liberated you

Violent peace
Blah blah blah
Buy it right now
Blah blah blah
We are the world
We are so huge
Blah blah blah
Johnny can't read
Blah blah blah
I can't see
Blah blah blah
Tuna on white
Guns all night
Blah blah blah

Blue jeans coolies
Everything huge
Petrified food
Pizza killers
From napalm to nice guy
Hit 'em where they live
Nifty fifty
The ranks of the glamorous
change constantly
The most spoiled brats
On god's green earth
Pop before the war

I made the Iggy Pop portrait in a Mayfair hotel suite, not a very inspiring situation. Iggy sorted things by putting a small cassette player on the mantelpiece and singing along to the The Muleskinners' song during the photo session. I could concentrate on him, not the surroundings.

Peter Anderson

OCTOBER 18, 1986 **55p** **POP-CULTURE**

SOUNDS

IGGY POP NOBODY'S STOOGE

WEATHER PROPHETS

ANTHRAX

MAGNUM

LIVE IN COLOUR
IRON MAIDEN

THE LEGENDARY IGGY POP. PHOTO BY PETER ANDERSON

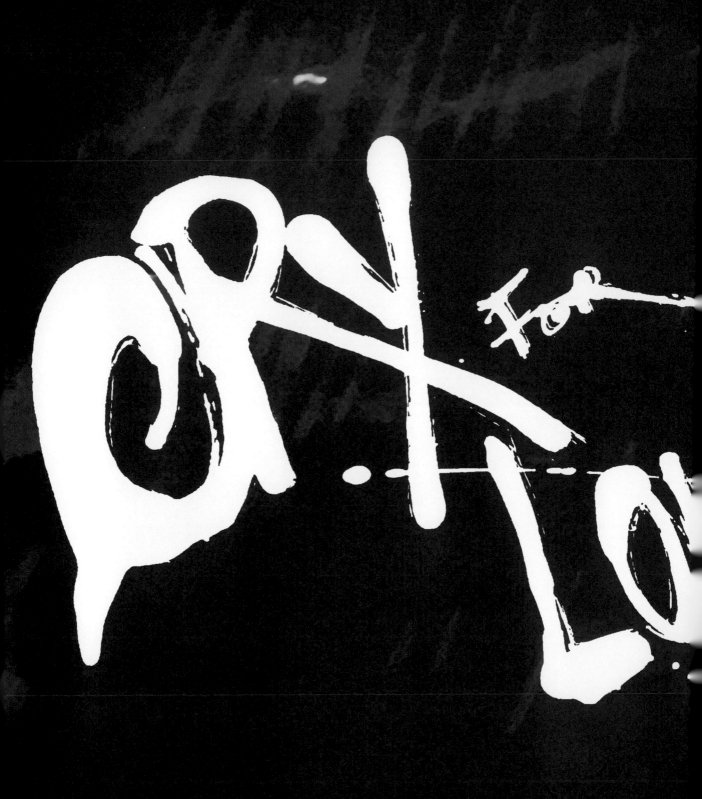

CRY FOR LOVE
(1986)

Status seekers
I never cared
Once I found out
They never dared
To seize the world
And shake it upside down
And every stinking bum
Should wear a crown

Saying I cry for love
'Til all the plates are broken
Cry for love
Until my eyes are soaking
Yeah I, cry for love
On every sammy morning
Yeah I, cry for love
Cause imitation's boring
Cry for love
Cry for love
Cry for love

Bad TV that
Insults me freely
Still I know what
I'm dying to see
In searching for
A meaningful embrace
Sometimes my self-respect
Took second place

And I cried for love
I did what my heart told me
Cried for love
Can't stand it
When they scold me
Yeah, I cried for love
On every sammy morning
Yeah I cry for love
Cause imitation's boring
Cry for love
Cry for love
Cry for love
Cry for love

Surfers ride for love
And wipe out when it hits them
Soldiers kill for love
And nobody admits it
If you're crying for love
Well, that's okay don't sweat it
If you're crying for love
Then there's still a chance you'll get it
Cry for love
Cry for love
Cry for love
Cry for love

Cry
For love

You gave me a present
The paper was blue and green
I unwrapped it with pleasure
These are the best shades I've ever seen
You can be my girlfriend
Forever and a day
I never thought I was worth much
Or that anyone would treat me this way

I'm not
The kind of guy
Who dresses like a king
And a really fine pair of shades
Means everything
And the light that blinds my eyes
Shines from you

It makes me come in the night
It makes me swim with delight
I like this pain
I like this mirror
I like these shades

I could have had a problem
I might have never followed through
The other guys are in trouble
They wouldn't listen to a girl like you
These shades say something

SHADES (1986)

I'll bet they cost a lot
I hope I don't break 'em
I hope we don't break up

I'm not
The kind of guy
Who dresses like a king
And a really fine pair of shades
Means everything
And the light that blinds my eyes
Shines from you

It makes me come in the night
It makes me swim with delight
I like this pain
I like this mirror
I like these shades

It makes me come in the night
It makes me swim with delight
You are my flag
Life's not a drag
I like these shades
I like these shades

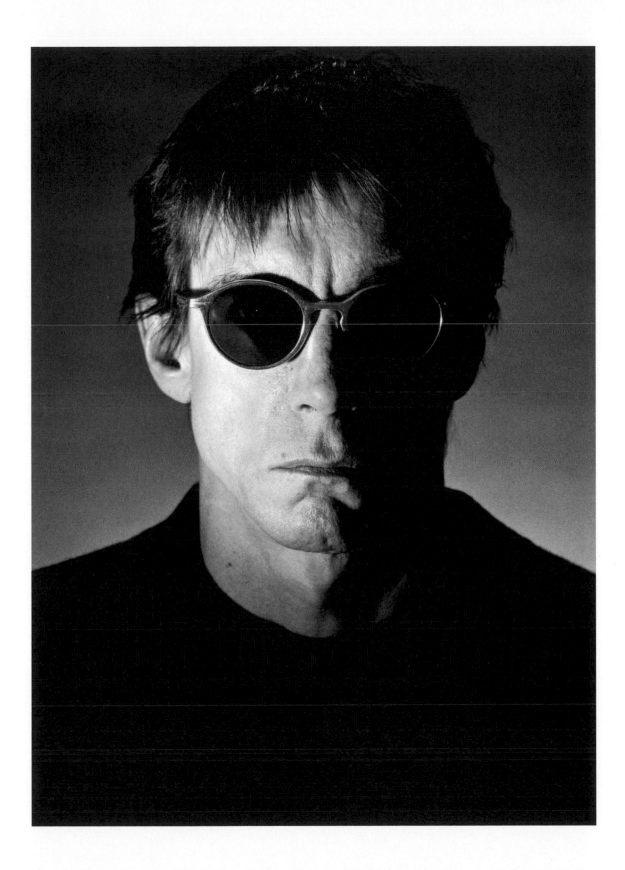

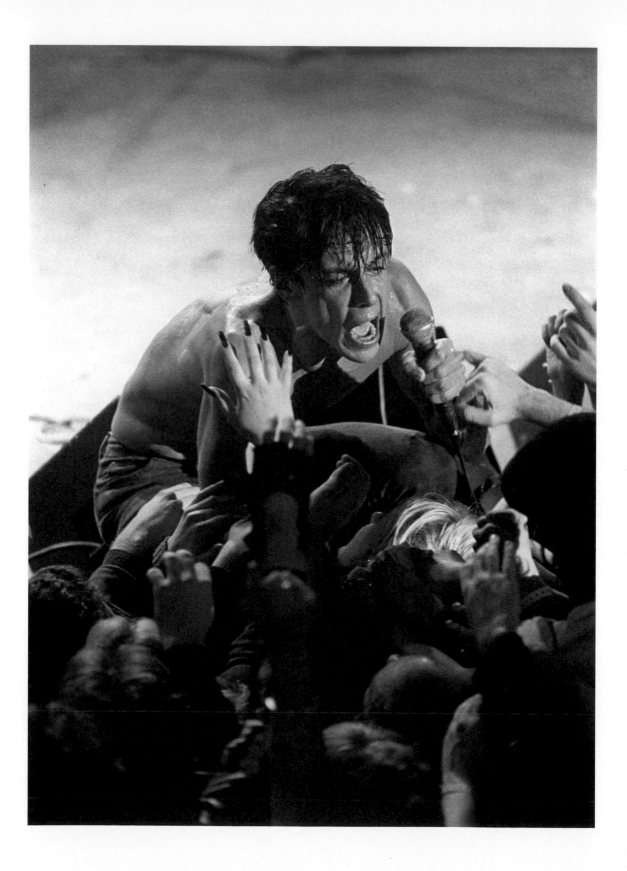

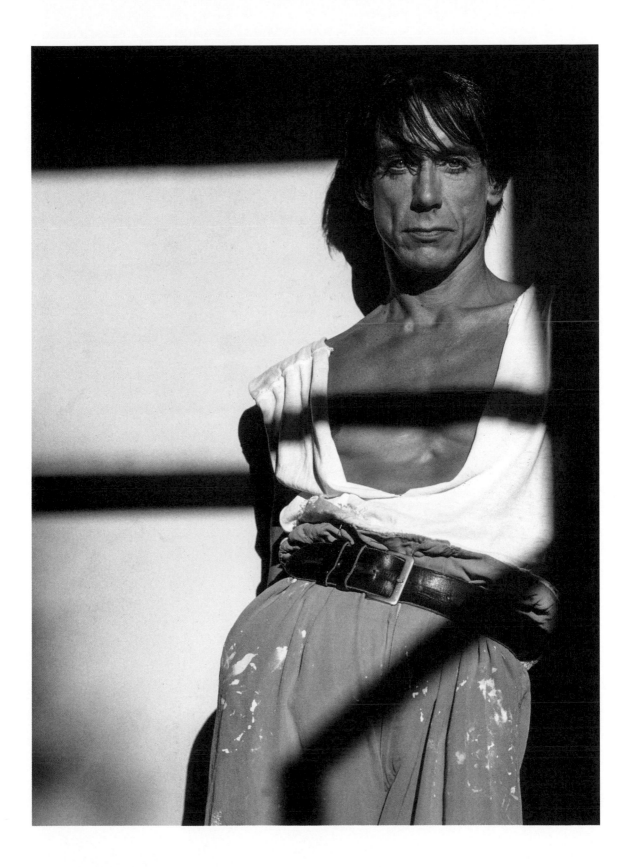

HIGH ON YOU
(1988)

I like your wooden door, baby
I never want to leave, baby
If I could rule the night, baby
I'd turn it into white
There wouldn't?

I'm getting high on you
I'm getting high on you
I'm getting high on you
High on you

I like your rugged cross, baby
I don't pray in churches, baby
I got nowhere to worship, baby
Because there isn't end
I don't need a monument

I'm getting high on you
I'm getting high on you
I'm getting high on you
High on you

Terrorist in my heart
Tearin' it all apart
Terrorist in my heart
Tearin' it all apart

I love the way you feel, baby
The mornin' sun is drunk, baby
Drinking of your soul, baby
And everything I know
Digs the way your body glows

I'm getting high on you
I'm getting high on you
I'm getting high on you
High on you
I'm getting high on you
I'm getting high on you
I'm getting high on you
I'm getting high

Corruption in the air
I really need you
You got two play rides
I really love them
I'm getting high
I'm getting high

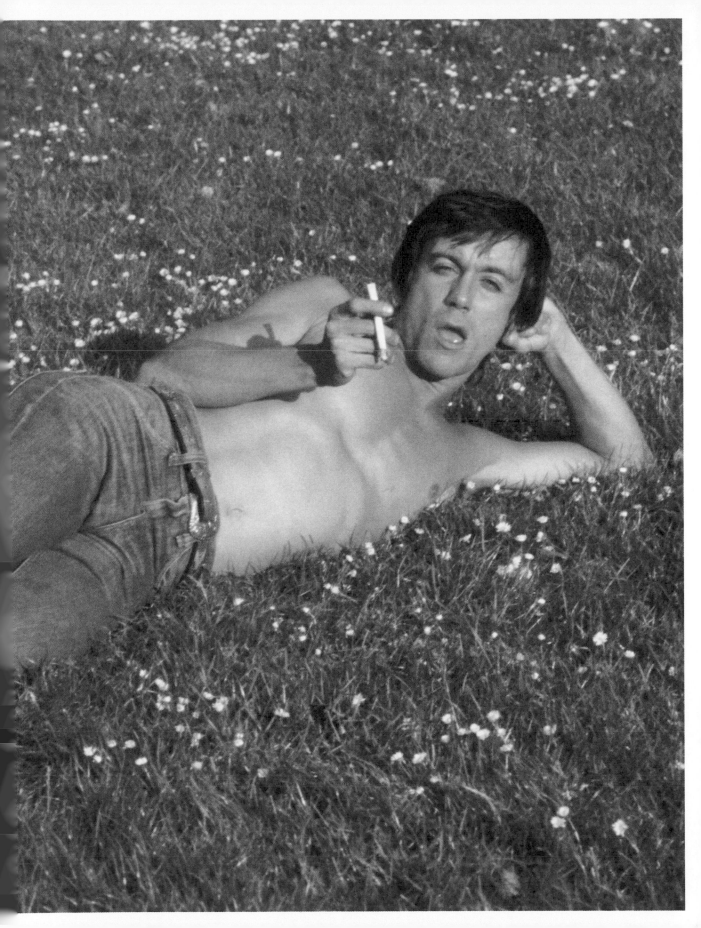

COLD METAL

(1988)

I played tag in the auto graveyard
I looked up at the radio tower
Rag tent by the railroad tracks
Concrete poured over steel bridge
Pondered my fate while they built the interstate

I'm a product of America
From the morgue to the prisons
Cold metal, when I start my band
Cold metal, in my garbage can
Cold metal, gets in my blood
And my attitude

Yeah, uh-huh

Threw my hide in an automobile
Heard a song called "Drive the Wheel"
Truckers, trailers, tractors caught me workin'
This is the song of my heritage
From the bad to the Buddha

Cold metal, that's what it be
Cold metal, from sea to sea
Cold metal, it's how we win
And also how we sin
How we sin, how we sin, how we sin, how we sin

Cold metal, in the afternoon
Sounds lovely like a Hendrix tune
Cold metal, it's the father of beat
The mother of the street
Cold metal, it rolls on by
Cold metal, gonna raise it high
Cold metal, it'll even fly
Rust buckets in the sky
Cold metal, got to be
Skeleton of the free
Cold metal, it's gotta be
Better save a tree
Save a tree, save a tree, save a tree, save a tree
Yeah

I have become an endangered species. My friends are doubtful, my enemies are hopeful. I can no longer preach to the converted, because they are so few, and so helpless. I realize I need a hit. I need a mortgage. I need a producer. I need a new champion. A voice tells me I need to get into the movies. They don't like me so much in the music business, so I need to pull an upward failure. I quit dope. Too much anxiety. Got an accountant. Got a haircut. Listened to my producer and got

the hit. Even got in the movies. Survived. Totally miserable of course. Still writing from the heart. The decade grinds on, no more hits. But wait! There's a New Gang in town, and they like me. And these are far from helpless. Mainstream rockers, movie stars, film directors, rich painters – things are looking up! Took a deep breath, said, "Fuck it," and moved to Miami.

There are few artists whose sacrifice has felt as
generative or as essential as Iggy Pop's.

New Yorker

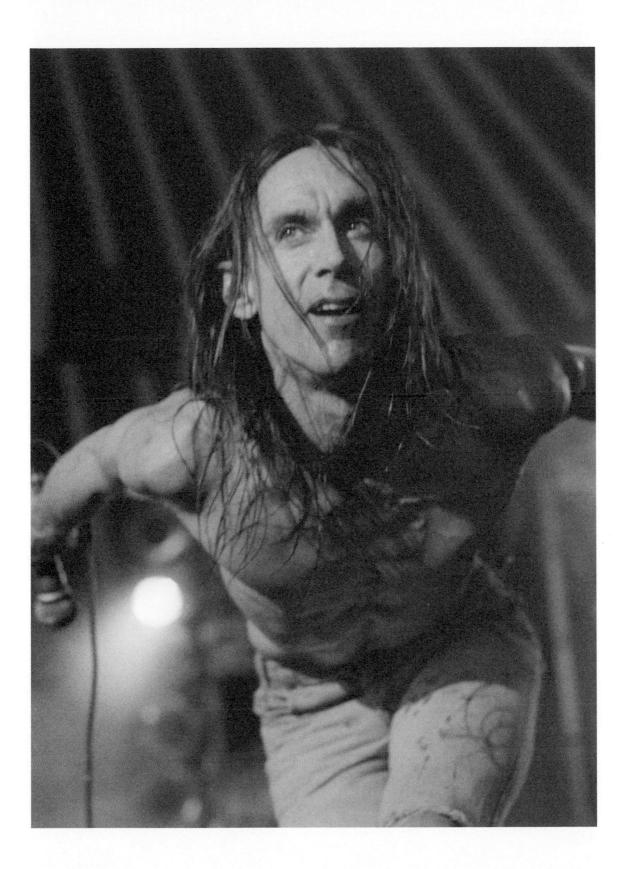

This whole country is scared of failure
My head keeps trying to sell me ambition
But in my heart, I want self-respect
There's a conflict

Boy, I feel so outgunned today
But I'll get up and fight back, anyway
You and I are not huge mainstream stars
But unlike them, we're really what we are

We got Main Street eyes
Watching as the big boys roll by
Under rotten television skies
We got Main Street eyes

I saw a kitten squashed in the street
I read about a plastic surgeon and his art collection

We are played for suckers all the time
Phony rock and roll
It's a crime
I don't want to dip myself in trash
I don't want to give myself for cash

We got Main Street eyes
Trying to do what's decent with our lives
Under funny television skies
We got Main Street eyes

Walking around sometimes
I see a tension under the surface
People are just about ready to explode
So hold me, and trust me
I love you, don't worry

Keep your Main Street eyes
Keep your Main Street eyes
Keep your Main Street eyes
Eyes
Eyes

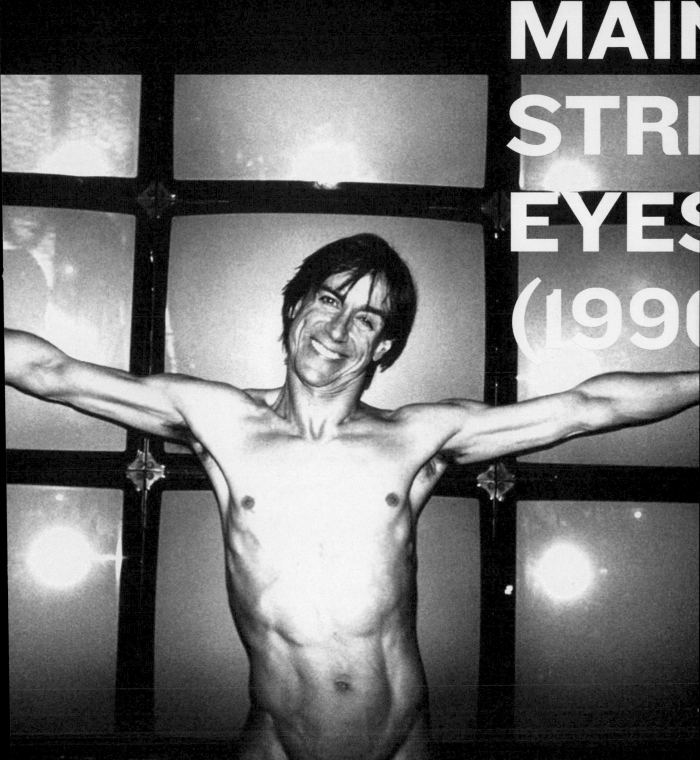

MAIN
STRI
EYES
(1990

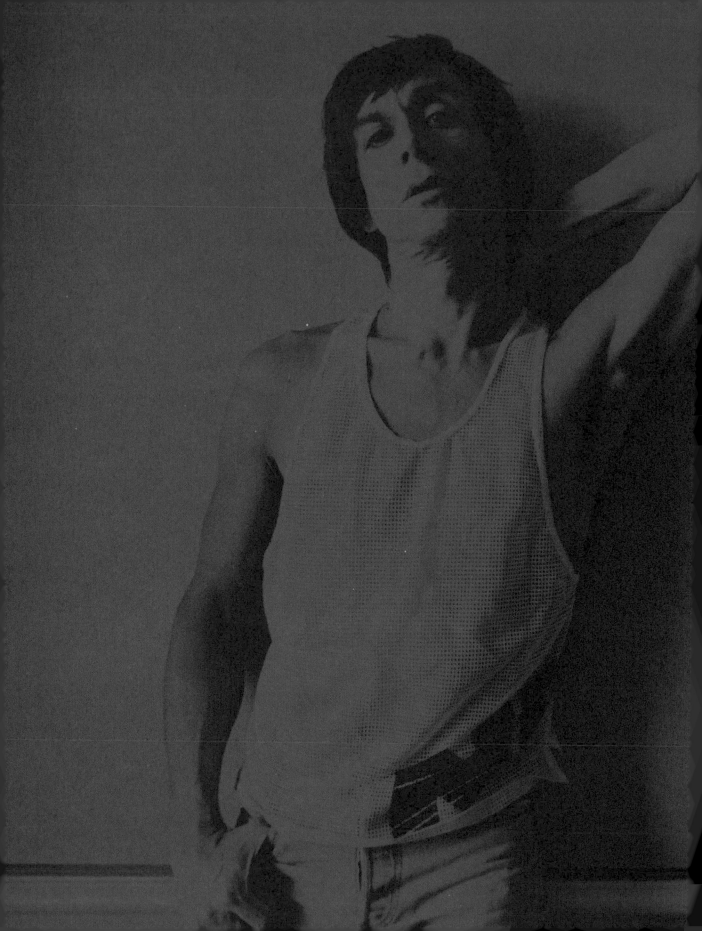

Candy

(1990)

It's a rainy afternoon
In ninteen-ninety
The big city
Geez, it's been twenty years
Candy, you were so fine

Beautiful, beautiful girl from the north
You burned my heart with a flickering torch
I had a dream that no one else could see
You gave me love for free

Candy, Candy, Candy I can't let you go
All my life you're haunting me, I loved you so
Candy, Candy, Candy I can't let you go
Life is crazy
Candy, baby

Yeah, well it hurt me real bad when you left
Hey, I'm glad you got out, but, but I miss you

I've had a hole in my heart for so long
I've learned to fake it and just smile along
Down on the street
Those men are all the same
I need a love
Not games
Not games

Candy, Candy, Candy I can't let you go
All my life you're haunting me, I loved you so
Candy, Candy, Candy I can't let you go
Life is crazy
I know, baby
Candy, baby

Whoa, Whoa, Whoa, Candy, Candy, Candy,
I can't let you go
All my life you're haunting me, I loved you so
Candy, Candy, Candy,
Life is crazy
Candy, baby
Candy, baby
Candy, Candy
Candy, Candy, Candy I can't let you go
All my life I'm waiting for I loved you so
Candy, Candy, Candy I can't let you go

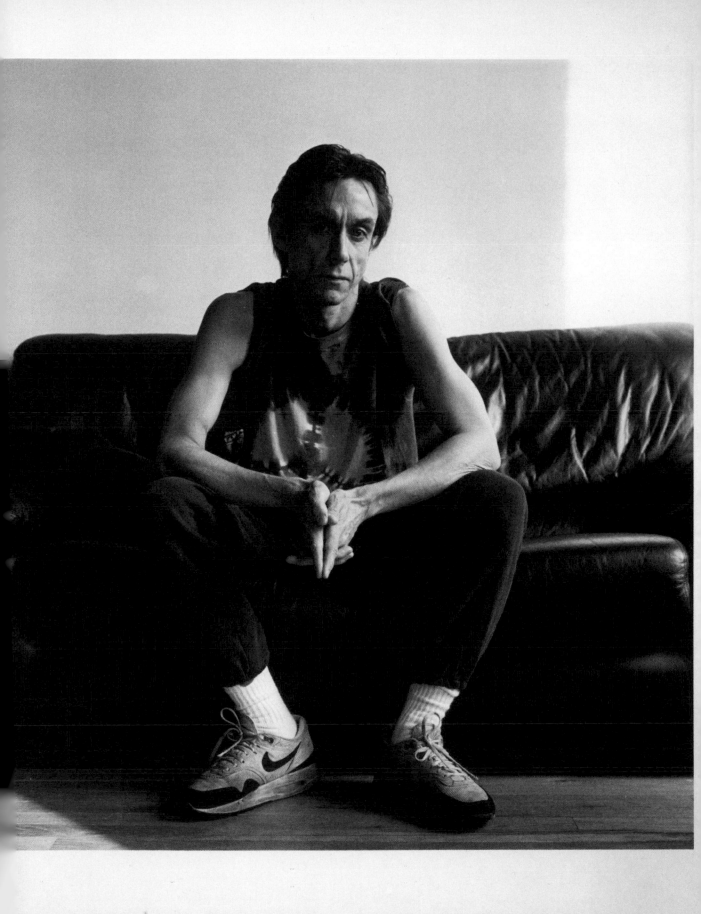

FUCK-ING ALONE

FUCKING ALONE (1993)

Fast young girl wants to go
Body's red mouth is whole
Not the worst in the world
But this won't be hassle-free
Lovers kiss in the heat
Body crush basement suite
Mind my eyes behind my hair
Hide my face and look nowhere
Change addresses ditch that guy
Don't pick up when he calls
Runaway everyday
Coffee beans and hideaways
They want these, they want those
First my nose then my toes
Presidents and super freaks
Litey dogs and love boutiques
Afternoons waking up
Neighborhood slouch and stuff
Drifters too in a flow
Nowhere they got to go
Shave-haired girl with a dog
Dressing cool not too new
I wanna talk I wanna know
What she feels and what she knows
I'm so fucking alone
I'm so fucking alone
OK OK this is me
OK OK this is me
Evening breeze river east
Music mix salsa speed
Metal rap lonely sax
Open jeep with the speakers back

Rock 'n' roll band practicin'
Shaking those walls next to me
Everybody's in a dream
Of what they want and who they need
To feel all right to be alive
To wipe out words that they despise
From a thunder brain
That's quick to pain
And only once to live again
When that set-up gets in the way
The dreamin' brain will make a play
To wipe it all outta space
Press record and then erase
'cause there's something here
They gotta face
Everybody in this place
It's the same for everyone
They gotta figure out something
They gotta figure out themselves
They gotta figure on their own
They gotta figure out, OK?
OK OK OK OK
I'm so fucking alone
I'm so fucking alone
Oh no, being alone
I'm so fucking alone
OK OK so this is me
OK OK so this is me
This is me
OK
I'm not even sure what she wanted
I'm not even sure what she wanted
What she wanted
What she wanted
What she wanted

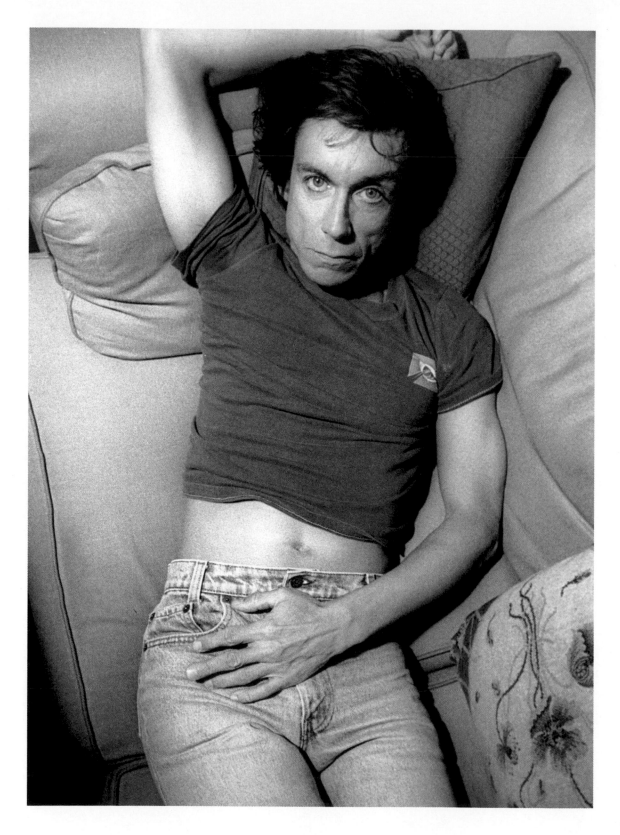

BESIDE (1993) YOU

I been hungry, way down in my heart
Waiting for a reason
I been hungry, like a lot of guys
I want to be, beside you
Lonely people, pass me in the street
Waiting for a reason

Beside you
Grey is turning to blue
You wake up love, in me
Beside you
Everything is new
You wake up love, in me

I been hungry, way down where it hurts
Waiting for a reason
I been hungry, like a lot of guys
I want to be, beside you

Beside you
Grey is turning to blue
You wake up love, in me
Beside you
Everything is new
You wake up love, in me

What a world
I really need you girl
You wake up love in me

Beside you
Grey is turning to blue
You wake up love, in me
Beside you
Beside you
I want to be beside you
Beside you
Beside you
I want to be beside you
I want to be beside you
I want to be beside you
I want to be beside you

LOUIE LOUIE
(1993)

And now the news
Yeah!
Louie Louie
Oh baby I gotta go now
Louie Louie
Woah baby I really gotta go now
The communist world is fallin' apart
The capitalists are just breakin' hearts
Money is the reason to be
It makes me just want to sing Louie Louie

Louie Louie
Oh baby I gotta go now
Louie Louie
Woah baby I really gotta go now

A fine little girl is waitin' for me
But I'm as bent as Dostoevsky
I think about the meaning of my life again
And I have to sing Louie Louie again

Louie Louie
Woah baby I gotta go now
Louie Louie
Woah baby I really gotta go now
Let's give it to 'em right now

Oh man, I dunno like, health insurance
The homeless and world peace and aids and education
I mean I'm tryin' to do right
But hey
Life after Bush and Gorbachev
The wall is down but something is lost
Turn on the news it looks like a movie
It makes me want to sing Louie Louie

Louie Louie
Oh baby, I gotta go now
Louie Louie
Woah baby I really gotta go now
Said I gotta go now
I gotta go now
I really gotta go now
Let's go

LOUIE

LOUIE

Iggy Pop is many things. Rock Star. Singer. Rebel.
Primitive. Stooge. The Jean Genie. Passenger. Legend.

Johnny Marr

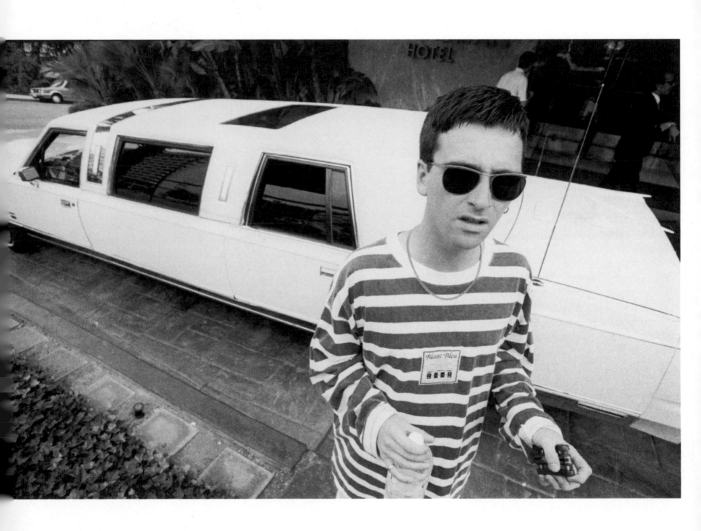

PLASTIC + CONCRETE

(1993)

Plastic and concrete, baby
These are the facts of life
I'm a nightmare child
Stuck on my own knife
I'm glad my mother loved me
I'm sick and paranoid
The hotel generator
Hums into the void
Of plastic and concrete

Plastic and concrete, baby
I gotta learn to slow down
Something new from chemistry
Is jacking my brain around
I have got the plastic
And I have got the stone
Out there in the suburbs
I learned to be alone
In plastic and concrete

Plastic and concrete sandwich
You'd like to eat me, but
Later you'll reject me
I'm too much to bite off
The salad on my outside
Is made of suicide
The guy that squirts my mayonnaise
Is on a one-way ride
In plastic and concrete
Plastic and concrete
Plastic and concrete

HIGHWAY SONG (1993)

I been walkin' down the road
What it means I dunno
I been walkin' down the highway
With the bad food flyin' by me
I'm an ordinary man
With a time bomb in my hand
It keeps tickin' an' I keep runnin'
Tryin' to find out where I come from

And there ain't nothin' gonna take this road away
There ain't nothin' gonna take this road away
Nothin' gonna take this road outta my heart
There ain't nothin' gonna take this road away
Nothin' gonna take this road away
Nothin' gonna take this road outta my heart

I wake up sweatin' in the night
Every town is only lights
I'm addicted to the highway
'Cause I just can't, do things their way

And there ain't nothin' gonna take this road away
There's nothin' gonna take that road away
Ain't nothin' gonna take that road outta my heart
There ain't nothin' gonna take this road away

There ain't nothin' gonna take this road away
There ain't nothin' gonna take this pain outta my heart

Highway I'm doin' fine
You help me draw the line
No use in being alive
If I'm just rentin'

I understand the circus well
I've played the clown when down he fell
But bein' down ain't bein' loser
So just look out here comes a bruiser

And there ain't nothin' gonna take my road away
There ain't nothin' gonna take a ma road away
Ain't nothin' gonna take a ma road outta my heart
There ain't nothin' gonna take a ma road away
There ain't nothin' gonna take a ma pain away
There ain't nothin' gonna take a ma road outta my heart
There ain't nothin' gonna take a ma road away
There ain't nothin' gonna take a ma road away
There ain't nothin' gonna take a ma road away
There ain't nothin' gonna take a ma pain away
Away

WILD AMERICA (1993)

But I mean I like it here
Do you have anything you'd like to say to America?

I'd just like to say at this point that
I'm 24-hour, 7-day-a-week, 365-day-a-year American

One night out in L.A.
I met a Mexicana

I was glad that Debbie

With a butchy girlfriend

Had a sense of humor

Who I thought was a man

This time of the morning

They took me to the alley

I tend to get gloomy

To have a little chat

She laughed and said Iggy

People lined the corners

You have got a biggy

Doin' this and that

I had no reply
So I just closed my eyes

In wild America
Wild America
Wild America
Wild America

In wild America
Wild America
Wild America
Wild America

Now I'm in a black car
With my Mexicana

Exterminate the brutes

She's got methedrine but

Exterminate the brutes

I want marijuana

Exterminate the brutes

I don't want to drive home

Exterminate the brutes

Not in my condition
So I ask my friend Matt

They're goin' wild

To handle the ignition

In wild America

Goin' wild

In wild America

Goin' wild

In wild America

Goin' wild

Wild America

They're goin' wild

Wild America

They're goin' wild
They're goin' wild baby

Exterminate the brutes

They're goin' wild baby

Exterminate the brutes

They got all kinds of fuckin' stuff

Exterminate the brutes

They got everything you could imagine

Exterminate the brutes

They're so god damned spoiled

Oh right

They're poisoned inside
They judge a man by what he's got
And they wanna have more and more

Yeah

More power, more freedom

Yeah

Taller kids, longer lives

Yeah

Everything, bigger houses, slaves

Wild America

MIXIN' THE COLORS
(1993)

All across the continents
Everywhere a soul is sent
A new mix of the races is takin' place
It's what Hitler didn't like
And it makes a pretty sight
Just look at what you see on
Your MTV

Out on the edges they're
Mixin' the colors
Some they don't like it
But me I don't mind
In every city they're
Mixing the colors
Different shades for the whole countryside
If you leave the hate alone tonight
Music's gonna get you home tonight
If you leave the hate alone tonight
Music's gonna get you home tonight
Mixin'
Mixin'

On the edges of the line
There's a different kind of kind
No one seems to claim for
The race war games
'Cause you don't have to choose sides

It just crucifies your mind
There's a hundred million ways
To live your life for yourself

Out on the edges they're mixin' the colors
Some they don't like it but me I don't mind
In every city they're mixin' the colors
Different shades for the whole countryside
I like the kids with the opened-up faces
I like the kids with the ways of their own
If you leave the hate alone tonight
Music's gonna get you home tonight
If you leave the hate alone tonight
Music's gonna get you home tonight
Mixin' mixin' mixin' mixin' the colors

Now a language that sounds new
Comes a-driftin' next to you
And the music that you hear is changin' too
Cuz they're mixin' the colors
Cuz they're mixin' the colors

Baby the colors

I Wanna Live
(1996)

I see my future shuffling
A shaky step at a time
I got no choice but careful
Thank God I've done my crime
The tools I see on TV
Can't stand it when they fake
A prick's a prick at any age
Why give one a break?

I wanna live
A little bit longer
I wanna live
A little bit longer now
I wanna live
A little bit longer
I wanna live live live live live

The soul is in the eyeball
For anyone to see
I'm better than a Pepsi
I'm cooler than MTV
I'm hotter than California
I'm cheaper than a gram
I'm deeper than the shit I'm in
An' I don't really give a damn

I wanna live
A little bit longer
I wanna live
A little bit longer now
I wanna live
A little bit longer
I wanna live live live live live

Step up it's fight time
Kick, scratch and bite time
Ain't talking about no more fun
But that don't bother my bad ass none

I wanna live
A little bit longer now
I wanna live
Just a little bit longer
I want to live live live live live
A little bit longer now
I wanna live live live live live
Just a little bit longer now
I wanna live live live live live
Just a little bit longer now
I wanna live live live live live
Just a little bit longer now
I wanna live live live live live
Just a little bit longer now
I wanna live live live live live
Just a little bit longer now

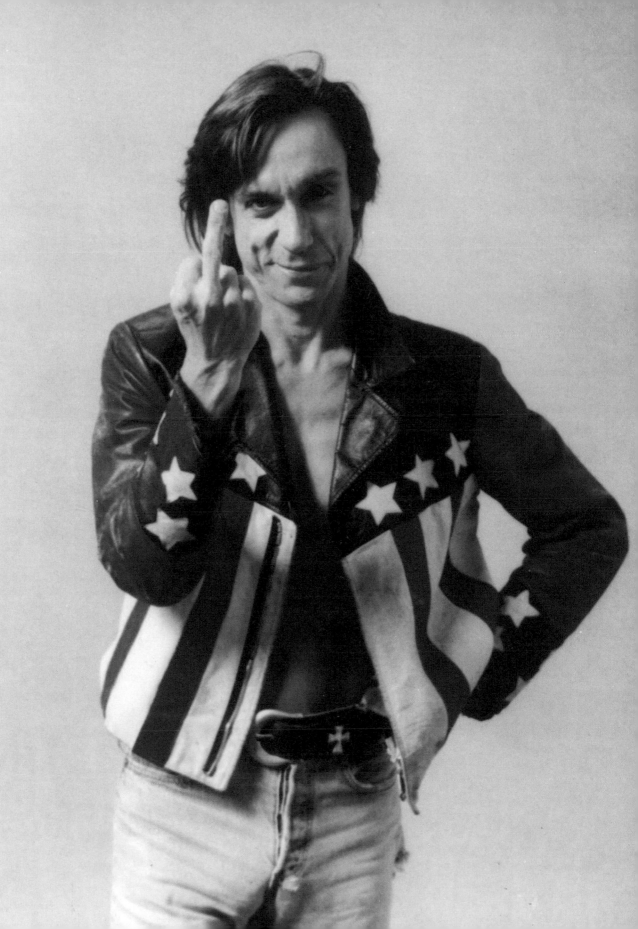

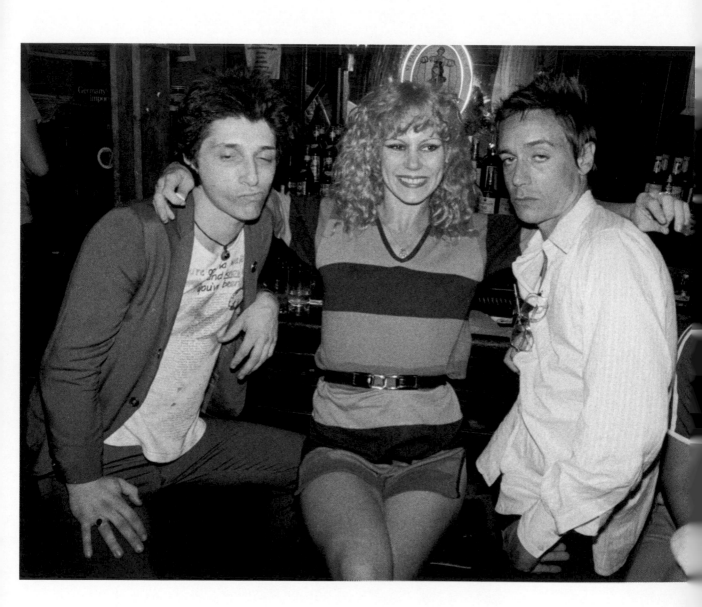

LOOK AWAY (1996)

I slept with Sable when she was 13
Her parents were too rich to do anything
She rocked her way around L.A.
'Til a New York Doll carried her away
Look away
Look away

Now he was blond and she was dark
They called him Thunder 'cause he had the spark
The dream he dreamed was straight and pure
But the confusion of life was gonna get him for sure
Look away
Look away

They shared their clothes and their cowboy boots
Left them all over the floor while they dyed their roots
They live the dream and they went non-stop
They did okay 'til the band broke up
Look away
Look away
Look away
Look away

Unfortunately, the needle broke
Their rock and roll love like a bicycle spoke
I found her in a back street with her looks half gone
She was sellin' something that I was on
Look away
Look away

Now Thunder and me did not part friends
What we did once, I wouldn't do again
So he stayed with the pure dream and followed the moon
'Til the drugs in his body made his mind a cartoon
Look away
Look away

So a few years later, Thunder died broke
Sable had a baby back at her folks'
Me, I went straight and serious, too
There wasn't much else that I could do
Look away
Look away

So now that I'm straight, I'm settled, too
I eat and I sleep and I work like you
I got lots of feelings, but I hold them down
That's a way I cope with this shitty town
Look away
Look away
Look away
Look away

From the drip drip drip of the teardrops
To the chink chink chink of the cash
From the end end end of the friendships
To the wack wack wack of the bash
Corruption corruption corruption
Rules my soul
Corruption corruption corruption
Rules my soul

From the tick tick tick of your time's up
To the yes yes yes of "I'll sell"
From the fact fact fact of the soulless
To the pact pact pact with hell
Corruption corruption corruption
Rules my soul
Corruption corruption corruption
Chills my bones
Corruption corruption corruption
Rules my soul
Corruption corruption corruption
Chills my bones

From the scream scream scream of the babies
To the retch retch retch of the youth
From the lie lie lie of the righteous
To the lost lost lost way I feel
Corruption corruption corruption
Rules my bones
Corruption corruption corruption
Chills my bones
Corruption corruption corruption
Rules my soul
Corruption corruption corruption
Rules my soul
Corruption
Corruption

Order in the court
Decision to abort
The monkey wants to speak
So speak, monkey speak

Speak monkey, speak
Speak monkey, speak
Speak monkey, speak
Speak monkey, speak

CORRUPTION
(1999)

Everything leads to corruption
Everything leads to corruption
Corruption

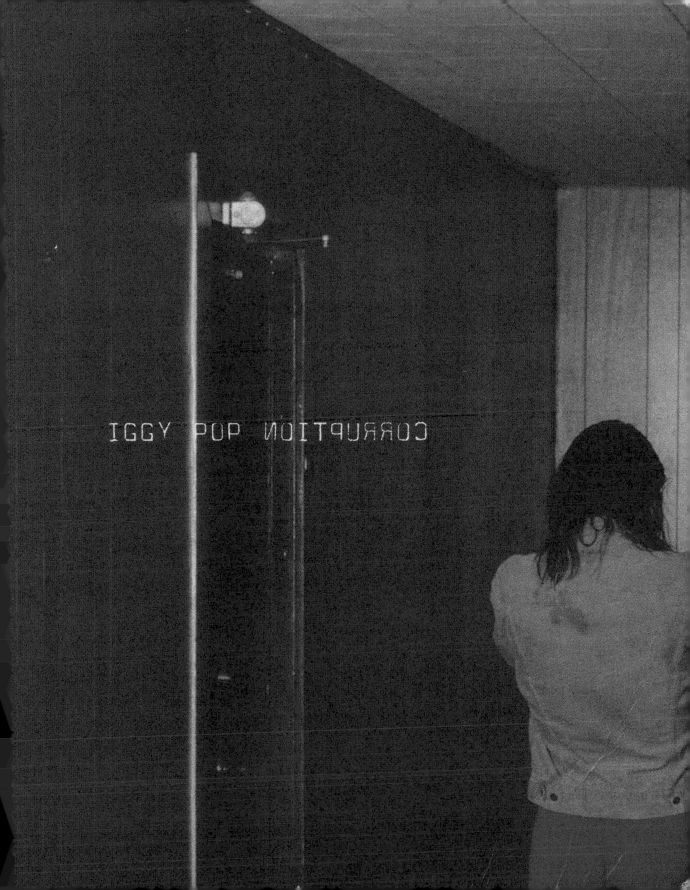

The twentieth century was finally over. Whew! I took a licking. But this was a whole new deal. Saturn must have moved. The Lord rolled away the stone, and I crawled out of my dark cave into the limelight of love and acceptance. Free pizza. Beloved Stooges reunited. Even evil Stooges reunited. Everybody is making money. Still plenty depressed at times, but that's the human condition. The phone is ringing, the birds are singing, the critics are at bay, and I am kind of at peace.

The Stooges were pioneers in sound, look, and live presentation, and along the way invented a genre - punk rock - and influenced countless others that followed. There was no precedent in rock music for what they did.

JACK WHITE

DRINK NEW BLOOD

(2001)

Blood!
Stupid is stupid,
Dumb is dumb,
Bloody is bloody,
Cum is cum,
Fake is fake,
A dick is a dick,
You're a target in the new demographic

We most need victims to be beaten,
Real rotten samples to be beaten,

Drink new blood,
Drink new blood,
Drink drink drink drink drink new blood,
Drink new blood,
Drink new blood,
Drink drink drink drink drink new blood

We got no dicks,
We need some bucks,
So we need to drink new blood,
Drink new blood,
Drink new blood,
Drink drink drink drink drink new blood,
So we need to drink new blood,
Blood!
Blood!

Mom and Dad who are they?
You got any money but are you gonna pay?
You're gonna pay for shit music,
Pay for shit food,
Pay for everything 'cause nobody wants you!

We most need victims to be beaten,
These nasty kids need to be eaten,
Drink new blood,
Drink new blood,
Drink drink drink drink drink new blood,
Drink new blood,
Drink new blood,
Drink drink drink drink drink new blood,
We got no dicks,
We need some bucks,
So we need to drink new blood,
Drink new blood,
Drink new blood,
Drink drink drink drink drink new blood,
Blood!
Blood!

Nobody likes you,
Nobody cares at all,
Your money is fucked up,
Everything is fucked up in your life,
Money money money,
That's all that will save you,
You'll never get enough anyway!

We must need victims to be beaten,
These nasty kids need to be eaten,

Drink new blood,
Drink new blood,
Drink drink drink drink drink new blood,
Drink new blood,
Drink new blood,
Drink drink drink drink drink new blood,
We got no dicks,
We need some bucks,
So we need to drink some blood,
Drink new blood,
Drink new blood,
Drink drink drink drink drink new blood,
Outburst! Outburst! Outburst! Outburst!
Infantile violent
Outburst!

Drink new blood,
Drink new blood,
Drink drink drink drink drink new blood,
Drink new blood,
Drink new blood,
Drink drink drink drink
Drink new blood,
We got no dicks,
We need some bucks,
So we need to drink some blood,
Drink new blood,
Drink new blood,
Drink, drink, drink new blood!

skull ring

(2003)

Skull rings	Skull rings
Fast cars	Fast cars
Hot chicks	Hot chicks
Money	Money

Skull rings	Skull rings
Fast cars	Fast cars
Hot chicks	Hot chicks
Fancy things	Fancy things

The touch of a hand in the wasteland — My life is dirtied, my mind is loaded
You're walking asleep and dreaming cheap — I'm feeling and breathing and fighting to see
A bird's wing don't beat for free — People get ready now
You're freezing cold and your family — Baby come on give your heart to me

Skull rings	Skull rings
Fast cars	Fast cars
Hot chicks	Hot chicks
Money	Money

Skull rings	Skull rings
Fast cars	Fast cars
Hot chicks	Hot chicks
Fancy things	Fancy things

Fingers on fire to do what's bad
Ring on the finger is a skull man
Strong as a bar of steel
Weaknesses that you can't feel

skull rings, fast cars, hot chicks, money

iggy pop

skull ring

new songs from iggy with the stooges,
sum 41, green day, peaches and the trolls.
produced by iggy pop
except "Little Know It All" produced by Greig Nori

WWW.IGGYPOP.COM
WWW.VIRGINRECORDS.COM

LITTLE KNOW IT ALL
WITH SUM 41
(2003)

I'm the kid that no one knows
I live a life I never chose
But these thoughts in my mind
Are my own, my own

I'm face to face with the unknown
My scary movie will be shown
I've got one evil mind
Of my own, of my own

We take from one another
And never stop to wonder
How it feels from the other side
Well nothing lasts forever
When stupid turns to clever
Why are you surprised?
Little know it all
Ten bucks in my hand
Little know it all
Don't cry I understand

I'm a target of the smart
They've got ambition I've got heart
Analysed and tagged
Before I start

So tell me who can I respect
I feel a leash around my neck
I find out there's shame
In the game

We take from one another
And never stop to wonder
How it feels from the other side
Well nothing lasts forever
When stupid turns to clever
Why are you surprised?

And I feel like
I'm caught outside the box
And I feel like
I'm sleeping when I'm not

We take from one another
And never stop to wonder
How it feels from the other side
Well nothing lasts forever
When stupid turns to clever
Why are you surprised?
Little know it all
Ten bucks in my hand
Little know it all
Don't cry I understand
Little know it all
Ten bucks in my hand
Little know it all
Don't cry I understand
You'll never know it all

DEAD ROCK STAR

(2003)

They think that I've got bread
They want to read my head
The position show his cool
Like football star in school

I gathered awful knowledge
You cannot get in college
Would you like Cain or Abel?
I'll bring them to the table

Someone to sell me
Someone to tell me

They try to rope me
They try to grope me
I'm a dead rock star
In a dead rock car
I'm a dead rock star

I'm a dead rock star
In a dead rock car
I'm a dead rock star

I'm so afraid of failing
I hang onto the railing
This cold hard graduation
Kills all infatuation
I took the hazing
They said "amazing"

What can I hope for?
What can I hope for?
Nothing to live for
Nothing to live for
I'm a dead rock star
In a dead rock car
I'm a dead rock star

I'm a dead rock star
In a dead rock car
I'm a dead rock star

You didn't ____ to do it
But you did it again
The night started out
Fuckin' around with your friends
Somebody screamed and things went bad
Now you're standing accused
And the prosecutor says you should be dead

And they're fryin' up your hair
In that little electric chair
They'll be fryin' up your hair
In that little electric chair
Fryin' up your hair
In that little electric chair

LITTLE ELECTRIC CHAIR (2003)

Electric chair Electric chair
Electric chair Electric chair
Electric chair Electric chair

Easy Street is nice in a lawless nation
The police put some flyers in circulation
Stuck one in my door with a scary mugshot
They're looking for some bad boys
Height, weight, age, race, tattoos too

The people are quietly hustling for blood
They wanna live in peace
But they don't wanna budge
From their lazy ways and lazy nations
Let 'em eat pigeon
And live in prison

And they're fryin' up your hair
In that little electric chair
They'll be fryin' up your hair
In that little electric chair
Fryin' up your hair
In that little electric chair
They'll be fryin' up your hair
In the little electric chair

And they'll be fryin' up your hair
In that little electric chair
They'll be fryin' up your hair
In that little electric chair
They'll be fryin' up your hair
In that little electric chair
They'll be fryin' up your hair
In that little electric chair

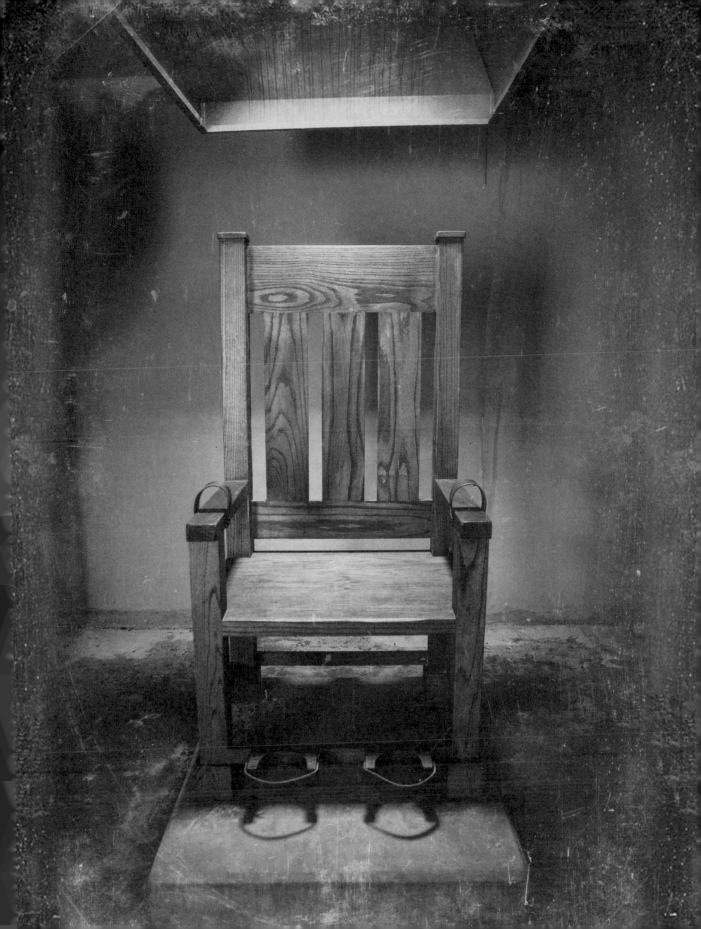

'TIL WRONG FEELS RIGHT

(2003)

I took a pounding
From the radio today
I heard the radio say
Some piece of shit
Was the sound of today

I took a beating
When I saw my TV play
I saw my TV play it over and over
And there was no escape

The box is hollow
And that riff is fucking dead
And that riff is fucking dead
But the riff is pounding
In my fucking head

They're gonna push it
Until false is true
Until day is night
They're gonna push it baby
Until wrong feels right
Until wrong feels right

It's a big industry
And they can beat my brains
With houses, cars, and shame
They are insane
But they can beat my brains

God and his captains
They wanna pull the fucking plug
They wanna pull the fucking plug
But give the skies back to
The birds and bugs

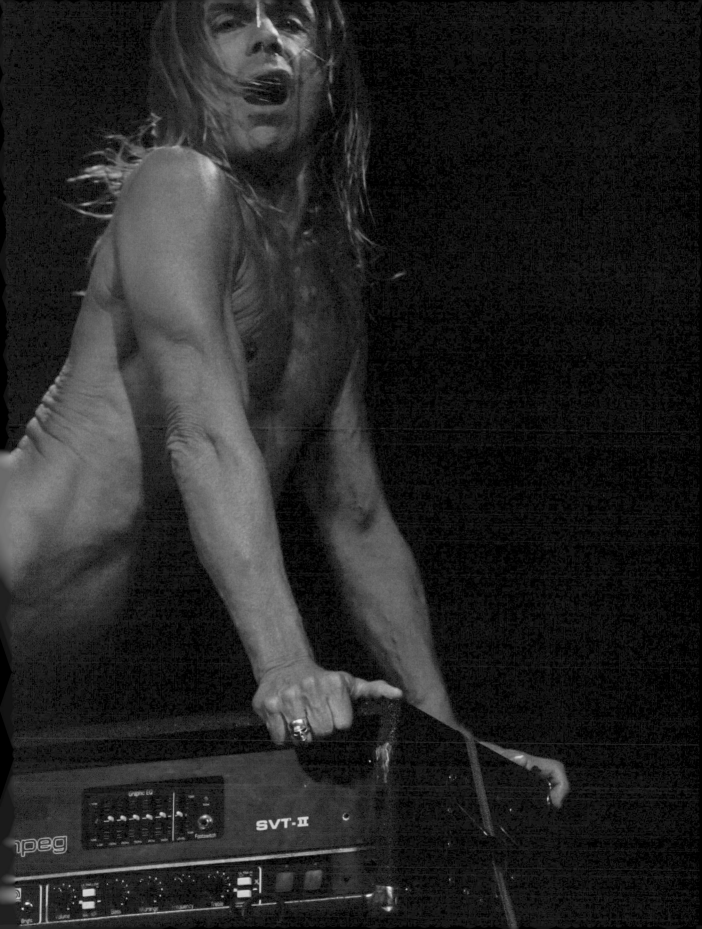

I'm the kinda guy
Who don't pick up the phone
I sneak around the room
I bitch about and moan
People make me nervous
Pretty soon they'll leave me alone
Free and freaky in the USA

My sister went to war
She tied a guy up on a leash
I think about it sometimes
While I'm sittin' on the beach
I hate it when people look at me the wrong way
Free and freaky in the USA
Free and freaky in the USA

England and France
These cultures are old
The cheese is stinky
And the beer ain't cold
When I go over there I gotta walk bold
Free and freaky in the USA
Free and freaky in the USA
Free and freaky in the USA
Woah, today, my mind begins to stray

I sit around an old house
Schemin' in the dark
I'm walkin' all alone
In a bath robe, in the park
I feel a touch of evil
But I guess it'll be okay
Free and freaky in the USA

Alabama
Dali Lama
Baby Mama

Free and freaky in the USA
Free and freaky in the USA

Rude madonna
Benihana
Antique father

Free and freaky in the USA
Free and freaky in the USA
Free and freaky in the USA
Free and freaky in the USA
Free and freaky in the USA
Free and freaky in the USA

(2007)

I WANT TO GO TO THE BEACH
(2009)

I wanna go to the beach
I don't care if it's decadent
I don't know where my spirit went
But that's alright

You can convince the world
That you're some kind of superstar
When an asshole is what you are
But that's alright

I wanna go to the deep
'Cause there's nowhere I want to be
And nobody I want to see
But that's alright

Waiting, hating the shit life throws my way
Hating, waiting to make my escape

I wanna go to the beach

Particles of pain in my brain
I guess they're here to stay
They work their way inside
And I can't hide or even walk away

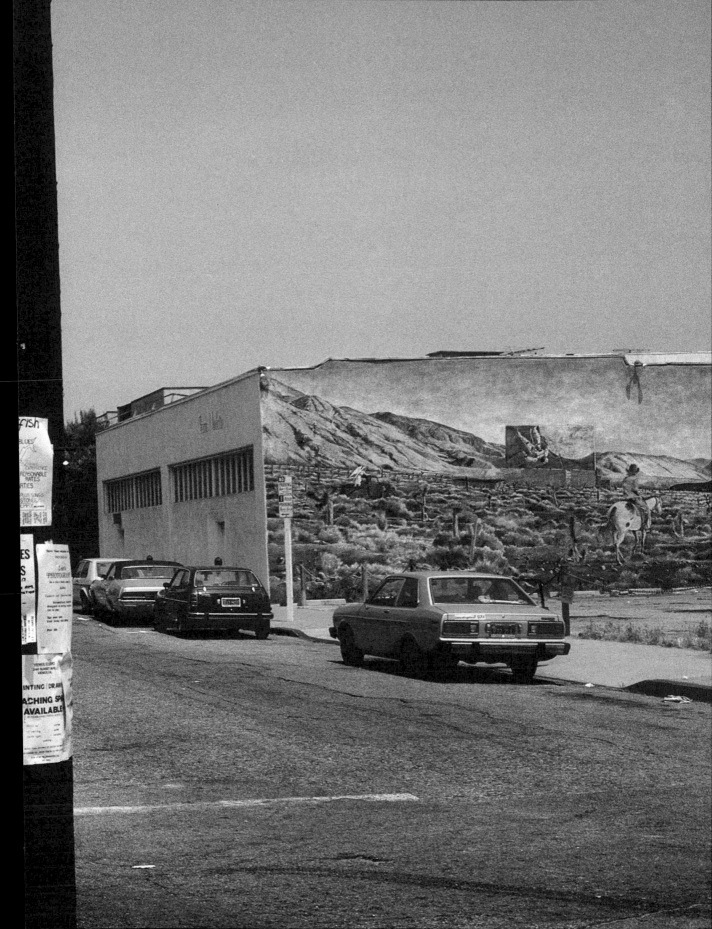

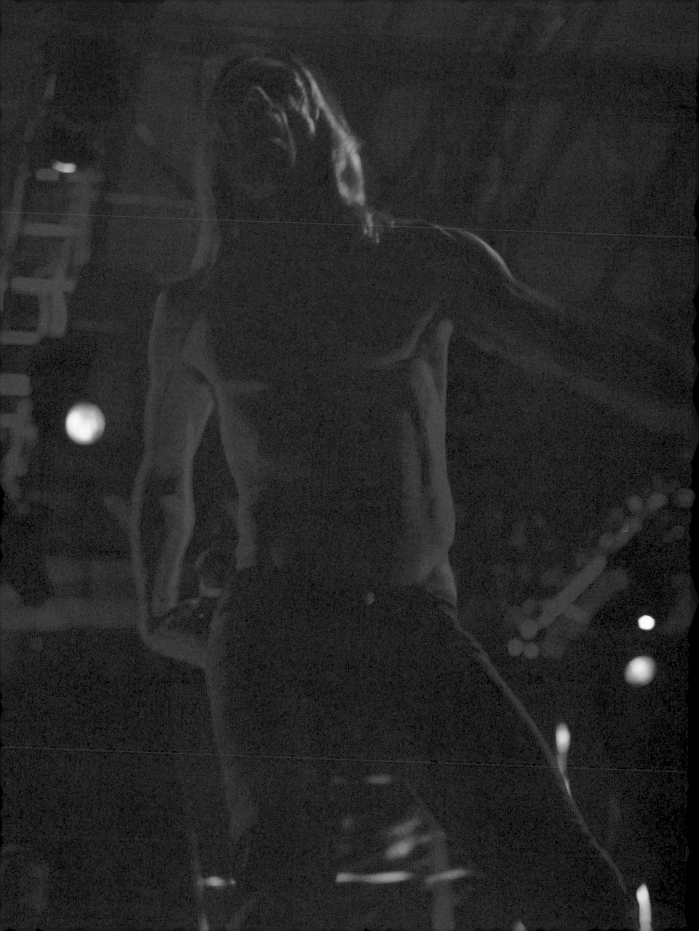

KING OF THE DOGS (2009)

I got a smelly rear
I got a dirty nose
I don't want no shoes
I don't want no clothes
I'm living like the king of the dogs

I got a piece of meat
In between my teeth
I will bite your throat
If you move on me
I am sovereign
I'm the king of the dogs

Polite life will fill you full of cancer
I don't even own a pair of pants
I'm a dancer

I'm hanging out where the spirits dwell
I can smell the things that you cannot smell

I'm deadly
I'm the king of the dogs

Lemmy is gone. Bowie is gone. He's the last of the
one-and-onlys . . . Everyone should take a knee for
Iggy. He deserves it.

Josh Homme

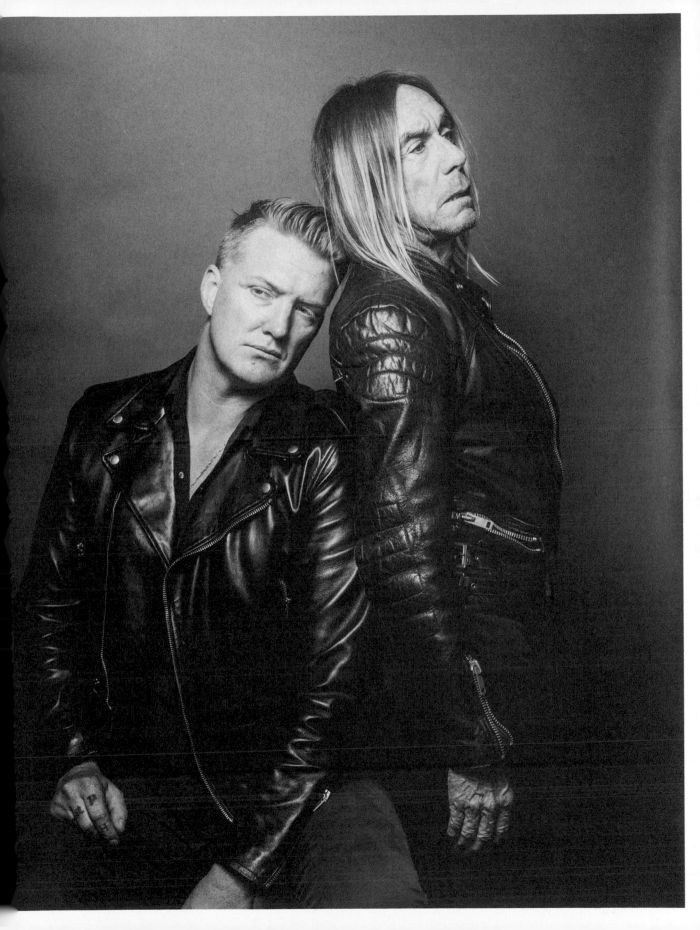

READY!
to ⊕
DIE

2013

READY TO DIE
(2013)

Got a depression and it won't let go
Got a depression and I hate it so
I'm shootin' for the sky
'Cause I'm ready to die
'Cause I'm ready to die

It's a lonesome town, and it's got me down
What a luxury to wear this frown
I'm shootin' for the sky
'Cause I'm ready to die
'Cause I'm ready to die

Now this lonely skin is wearing thin
I'm a hangin' judge of the world I'm in
I'm shooting for the sky
'Cause I'm ready to die
'Cause I'm ready to die

THE DEPARTED
(2013)

Where is the life we started?
Yesterday's a door
Opening for the departed
The life of the party's gone
The guests who still remain
Know they've stayed a little long
Party girls will soon get old
Party boys will lie
Both the sexes
Soon grow cold
And tears come to their eyes
Serious talks no fun
And when the lights go on
You'll feel like you wanna run
'Cause there's no one here but us
And by the end of the game
We all get thrown under the bus

I can't feel nothin' real
My lights are all burnt out
I can't feel nothin' real

What is the point of friendship?
It's nobody's fault
But this nightlife is just a death trip
You think you're getting a steal
But in the light of day
Everything's a dirty deal

And yesterday's a door
That's opening for the departed
Yesterday's a door
That's opening for the departed
So where is the life we started?

This house is as slick as a senator's statement
This job is a masquerade of recreation
Like a wreck,
I'm sinking fast

The key to everything
I crawl for Sunday
When I don't have to move
Caught up in dreams untangled one day
Where I don't have to prove
The days roll on and finally Sunday
A Sunday afternoon
I've got it all
But what's it for?
But getting some more

Always ready, always steady and
Always ready, always steady and

The street is as cold as a corporate lawsuit
A pride I can chide is telling me to wipe my boots
I'm a wreck
What did you expect?

The key to everything
I crawl for Sunday
When I don't have to move
Caught up in dreams, untangled one day
Where I don't have to prove
The days roll on and finally Sunday
A Sunday afternoon
I've got it all
And so what now?

Do what they say and endure what they say
Go back
Do what they say and endure what they say
Go back
Do what they say and endure what they say 'til Sunday
(Do what they say)
Until I'm black and blue
Oh, what can I do?

Always ready, always steady and
Always ready, always steady and

Got all I need and it is killing me
And you
Got all I need and it is killing me
And you
Got all I need and it is killing me
And you
Got all I need and it is killing me
And you

Got all I need and it is killing me
And you
Got all I need and it is killing me
And you
Got all I need and it is killing me
And you

AMERICAN
VALHALLA
(2016)

I have no plans,
I have no debts
The mind is not the carefree set

I don't know
I don't know
I don't know
I don't know

I'm looking for American Valhalla
So if it passes by,
give me a holler
Please

Where is American Valhalla?
Death is the pill that's tough to swallow
Is there anybody in there?
Who do I have to kill?
I'm not the man with everything
I've nothing but my name

I've shot my gun,
I've used my knife
This hasn't been an easy life
I'm hoping for American Valhalla
But if I have outlived my use
Please drink my juice

Lowly, lowly deeds
That no one sees
Lowly, lowly deeds
That no one sees

Innocence
It's so hard to figure it out
Innocence
It's so hard to figure it out

Where is American Valhalla?
Death is the pill that's hard to swallow
Is anybody in there?
And can I bring a friend?
I'm not the man with everything
I've nothing but my name

I don't know
I don't know
I don't know
I don't know

I've nothing but my name
I've nothing but my name

It's so hard to figure it out

I've nothing but my name

I've nothing but my name

BREAK INTO YOUR HEART
(2016)

I'm gonna break into your heart
I'm gonna crawl under your skin
I'm gonna break into your heart
And follow 'til I see where you begin

Time is so tight, it's closing in
Fourty more hours to go
When the tumbler spins, I'm getting in
Gonna be time to blow

I'm gonna break into your heart
I'm gonna crawl under your skin
I'm gonna break into your heart
And follow
'Til I see where you begin

Hooks go deep, but it's make believe
It's never gonna grow
Your heart is buried underneath
Mountains capped with snow

I'm gonna break into your heart
I'm gonna crawl under your skin
I'm gonna break into your heart
And follow 'til I see where you begin

Break them all
Take them all
Fake them all
Steal them all
Fail them all
Touch them all
Break them all
Break them

I'm gonna break into your heart
I'm gonna break into your heart
I'm gonna break into your heart
I'm gonna break into your heart
'Til it all comes crashing down

I'm gonna break into your heart
I'm gonna crawl under your skin
I'm gonna break into your heart
And follow 'til I get under your skin
And the wall is tumbling down
And you finally let me in
I break into your

When your love of life is an empty beach
Don't cry (don't cry)
When your enemy has you in his reach
Don't die (don't die)

When it's painful to express the things you feel (inside)
When it hurts to share because they're bare and real (so real)
So when every day is judgement day, I won't pray (don't pray)
When there's none to share that empty chair, well okay (okay)

When You get to the bottom You're near the top
The shit turns into chocolate drops
When You get to the bottom You're near the top
The shit turns into chocolate drops
When You get to the bottom You're near the top
The shit turns into chocolate drops
Drops

OLATE
PS
(2016)

So fly (so fly)
So fly (so fly)

When your love of life is an empty beach (don't cry)
When it's painful to express the things you feel (inside)

There is nothing in the stars if You fail to move
There is nothing in the dark, it's just some old excuse
Hanging on, let it go

PARAGUAY (2016)

While animals they do
Never wonder why
Just to do what they goddamn do
Just to do what they goddamn do
(Yeah)
I'm goin' where sore losers go
To hide my face and spend my dough
Though it's a dream, it's not a lie
And I won't stop to say goodbye

Paraguay
Paraguay

See I just couldn't take no more
Of whippin' fools and keepin' score
I just thought "well, fuck it man"
I'm gonna pack my soul and scram

Paraguay
Paraguay

Out of the way I'll get away
Won't have to hear the things they say
Tamales and the bank accounts
Are all I need so count me out

Paraguay
Paraguay

I'll have no fear
I'll know no fear
So far from here
I'll have no fear
Tra-la-la-la-la-la-la-la-la-la-la-la-la-la-la-la-la
Tra-la-la-la-la-la-la-la-la-la-la-la-la-la-la-la-la
Tra-la-la-la-la-la-la-la-la-la-la-la-la-la-la-la-la
Tra-la-la-la-la-la-la-la-la-la-la-la-la-la-la-la-la
Tra-la-la-la
Tra-la-la-la
Tra-la-la-la
Tra-la-la-la

While animals they do
Never wonder why
Just to do what they goddamn do

There's nothing awesome here
Not a damn thing
There's nothing new "wow!"
Just a bunch of people, scared
Everybody's fuckin' scared
Fear eating all the souls at once
I'm tired of it
And I dreamed about gettin' away
To a new life
Where there's not so much fucking knowledge
I don't want any of this "information"
I don't want "you"
No, not anymore
I've had enough of "you"
Yeah I'm talking to "you"
I wanna go to Paraguay
Live in a compound under the trees

With servants and bodyguards who love me
Free of criticism
Free of manners and mores
I wanna be your basic Clod
Who made good
And went away while he could
To somewhere where people are still human beings
Where they have spirit
You take your mother-fucking laptop
Just shove it into your goddamn foul mouth
Down your shit-eating gizzard
You fuckin' phony two-faced, three-timing piece of turd
And I hope you shit it out with all the words in it
And I hope the security services read those words
And pick you up and flay you
For all your evil and poisonous intentions
'Cause I'm sick and it's your fault
And I'm gonna go heal myself now
(Yeah)

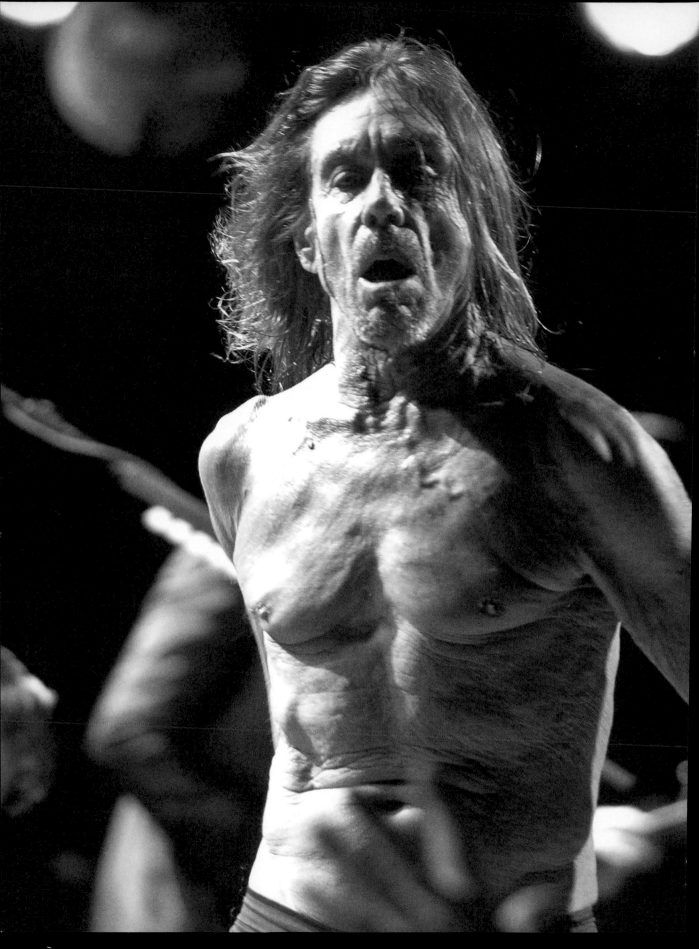

GARDENIA (2016)

Gardenia
Where are you?
Black goddess in a shabby raincoat
Where are you, tonight?
Cheap purple baby-doll dress
A gardenia in your hair
Much taller and stronger than me
A forbidden dream, a dream, a dream

All I wanna do is tell Gardenia
What to do tonight
All I wanna do is tell Gardenia
What to do tonight

Gardenia
Where are you, tonight?
The streets were your home
Now where do you roam?
Your hourglass ass
And your powerful back
Your slant devil eyes
And the ditch on your spine
Deep ass, deep ass

All I wanna do is tell Gardenia
What to do tonight
All I wanna do is tell Gardenia
What to do tonight

We lay in the darkness
Then she turned the lights on
I saw a dangerous habit
When she turned the lights on
There's always a catch
In the darkness when you
When you turn the lights on
There's always a catch
Oh well, oh well, oh well, oh well

All I wanna do is tell Gardenia
What to do tonight
All I wanna do is tell Gardenia
What to do tonight

Alone in the cheapo motel
By the highway to hell
America's greatest living poet
Was ogling you all night
You should be wearing the finest gown
But here you are now
Gas, food, lodging, poverty, misery
And Gardenia
You could be burned at the stake
For all your mistakes, mistakes, mistakes

All I wanna do is tell Gardenia
What to do tonight
All I wanna do is tell Gardenia
What to do tonight

LONELINESS ROAD
(2017)

My secret song
My secret song
Rolling around in my head
My secret mind
My secret mind
Tossing around in my bed

As I'm walking down loneliness road
As I'm walking down loneliness road

Looking for someone to love
Looking for someone to love me

Sha la la la
Sha la la la
Sha la la la na na
Sha la la la
Sha la la la
Someone to love

Sha la la la
Sha la la la
Sha la la la na na
Sha la la la
Sha la la la
Someone to love me

Sha la la la
Sha la la la
Sha la la la na na
Sha la la la
Sha la la la
La la someone to love me

I'm walking down loneliness road
Walking down loneliness road

Looking for someone to love me

I walked all night
Down loneliness road
Waiting for the dawn
Looking for someone to love

I stood there
At the corner of desperate avenue
Desperate avenue and loneliness road

Walking down loneliness road
Walking down loneliness road

My secret song
Rolling around in my head
My secret song
Rolling around in my head
Walking down loneliness road

Walking down loneliness road
Walking down loneliness road

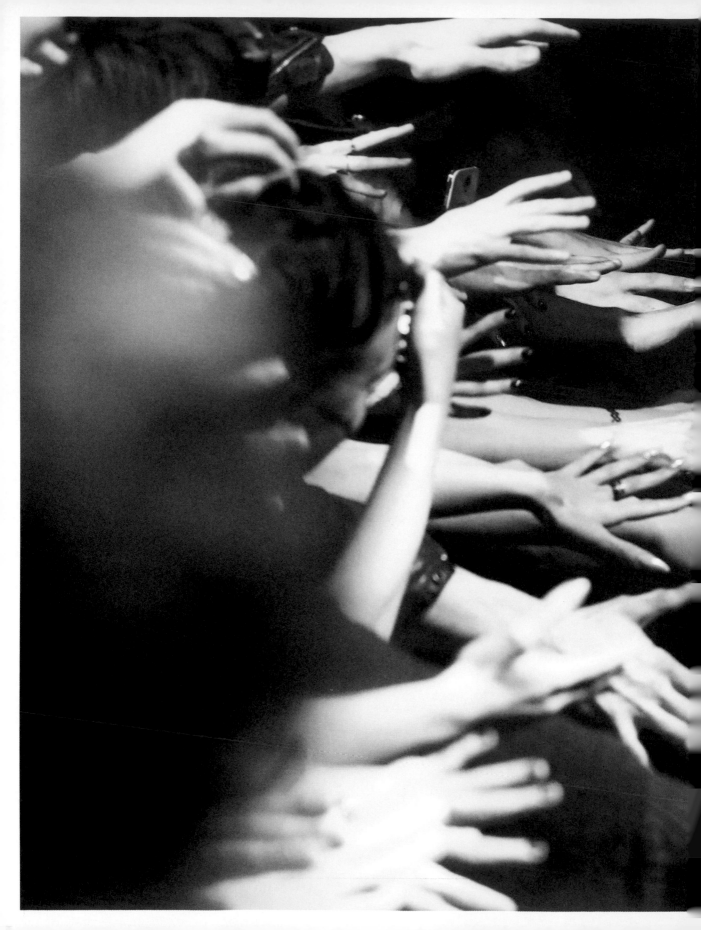

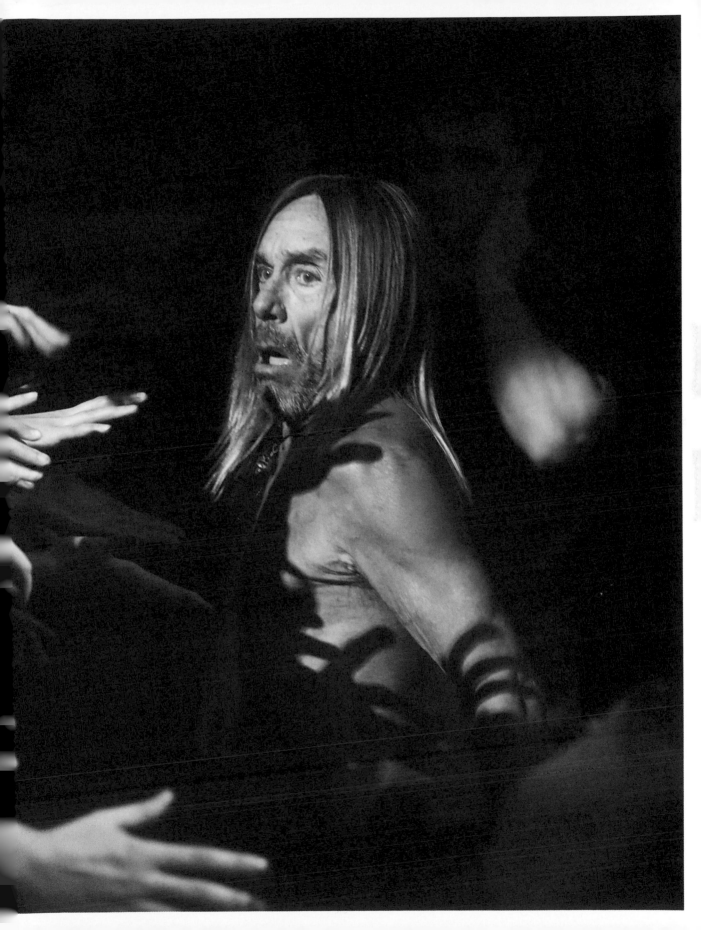

HAIL
TO THE THIEF
HAIL
TO THE THIEF
HAIL

(2017)

It's okay, it's alright
The promise of the tongue
Leaving them behind tonight
But I guess this time, I'm doubled up
I'm doubled down again
I got no time to turn it around again

Hail to the thief
And you won't get nothing much
Hail to the thief
And we'll keep what's left tonight

A little faith, too little pride
Will we ever get it right?
Keep looking for a sign tonight
But I guess it's time, I'm doubled up
And doubled down again
Got no time to turn it around again

Hail to the thief
And you won't get left in line
Won't you hail to the thief
And we'll keep what's left tonight
Hail to the thief
And you won't get left in line
Won't you hail to the thief
And we'll keep what's left tonight

THE PURE AND
THE DAMNED (2017)

Love, make me clean
Love, touch me, cure me

The pure always act from love
The damned always act from love
Every day I think about untwisting and
untangling these strings I'm in
And to lead a pure life
I look ahead at a clear sky
Ain't gonna get there
But it's a nice dream, it's a nice dream

Death, make me brave
Death, leave me swinging

The pure always act from love
The damned always act from love
The truth is an act of love

Some day, I swear, we're gonna go to a place
Where we can do everything we want to
And we can pet the crocodiles

Love

The pure always act from love
The damned always act from love
That's love
The pure always act from love
That's love
The pure and the damned
The pure and the damned
Love
The damned

THE PURE
AND THE
DAMNED

LOVES
MISSING
2019

LOVES MISSING
(2019)

She's thinking
About something we all need
All need
Clocks ticking
Not giving her room to breathe
To breathe
Loves screaming

A friend

She's thinking
And that isn't gonna help
No help
Clocks ticking
It's bad when she's by herself
Herself
Loves screaming

Loves missing

Loves missing

Loves screaming
So quietly and in pain
Loves absent
It's failing her once again
Again
Loves screaming
Loves screaming

Loves screaming

Screaming

Dark future
She just needs someone to say
To say
I love you
Before she gets pushed away

Loves absent
Loves absent
The centre won't hold the end
Loves absent
And she cannot touch a friend

THE DAWN
(2019)

Waitin' for the dawn again
The darkness is like a challenger
To all my schemes and orders
And forced good nature
To just lay down is to give up
You gotta do something
Something

Because the dark is like a challenge
And he will point out
The sore point
The wanting point

In my stage of the game
He'll point out memories
Basic, basic memories
The few moments that make life any fucking good
And he'll put those in my face
In the dark

Almost every night I wake up and have to go pee
I hate peeing in the middle of the night
But that's how things are at this point
When I do get through a whole night without waking up and peeing
This calls for a celebration

If all else fails
It's good to smile in the dark
Love and sex
Are gonna occur to you
And neither one will solve the darkness

'Cause the dark is like a challenger

A challenger

The dark is like a challenger

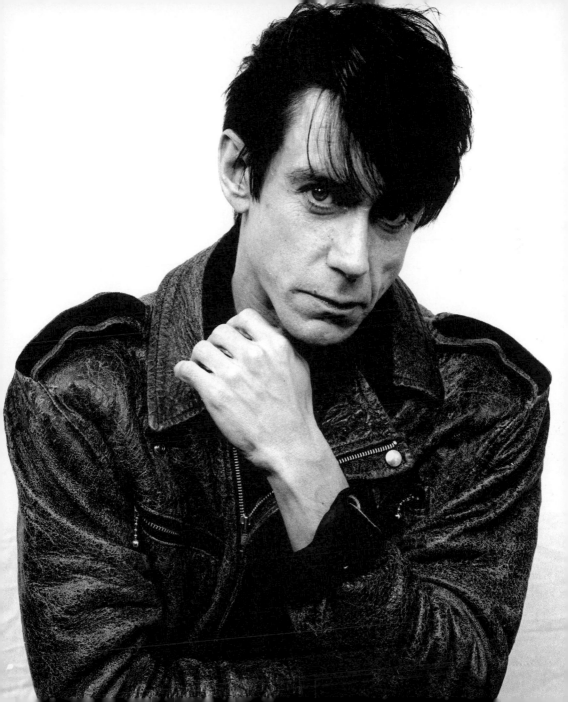

PICTURE CREDITS

The publisher is grateful for permission to reproduce the images on the following pages:

pp. 8-9, 52-3, 73: © Michael Ochs Archives/Getty Images
pp. 10-11, pp. 196-197: © Robert Matheu/Camera Press
pp. 12-13, 74: © Alec Byrne/über Archives/Eyevine
pp. 14-15, 16, 18-19, 20, 21, 24-5, 26-7: © Glen Craig
pp. 30-31: © Ed Caraeff/Getty Images
pp. 32-3, 38-9, 46-7: © Tom Copi/Michael Ochs Archive/
 Getty Images
pp. 36-7: © Donaldson Collection/Michael Ochs Archives/
 Getty Images
pp. 41, 43: © Danny Fields
pp. 44-5: © Jill Furmanovsky
pp. 56-7, 69: © Danny Fields/Gillian McCain
pp. 60-61: © Starfile/EMPICS Entertainment/PA
p. 63: © James Fortune
p. 65: © Anne Fishbein/Michael Ochs Archives/Getty Images
p. 66: © Roberta Bayley/Redferns/Getty Images
pp. 70-71, 128: © Mick Rock
p. 72: © Evening Standard/Getty Images
p. 78: © Steve Emberton
pp. 80-81: © Bomp! Records (1975)
pp. 82-3, 96-7, 98, 99, 100-101, 102-3, 104-5, 114, 115,
 120-21, 168: © Esther Friedman
pp. 84-85, 144-5, 158-9, 212-3, 264-5: © Getty Images
pp. 86, 126-7: © Ian Dickson/Redferns/Getty Images
pp. 88, 90-91, 220-21: © Bob Gruen
pp. 92-3, 110-11: © Richard E. Aaron/Redferns/Getty Images
p. 106: © Pierre et Giles
p. 125: © Daniel Prescott-Bennett
pp. 130-31, 132-3, 148-9, 156-7, 173, 175: © Virginia Turbett
p. 134: © Chris Stein
pp. 138-9: © Allan Tannenbaum/Images/Getty Images
pp. 142-3: © Maurizio Siani/Getty Images
pp. 146-7: © Frans Schellekens/Getty Images
pp. 152-3: © Ilse Ruppert/Opale/Leemage/Bridgeman Images
p. 177: © Catherine McGann/Getty Images
pp. 178-9: © Steve Pyke
p. 181: © Peter Anderson

TEXT PERMISSIONS

"Loneliness Road": words and music by Iggy Pop and Jamie Saft. Copyright © 2017 RareNoisePublishing/Top Notch Booty. All rights for Top Notch Booty administered by BMG Rights Management (US) LLC.

"American Valhalla", "Break into your Heart" and "Paraguay": words and music by Iggy Pop & Josh Homme. Copyright © 2016 Top Notch Booty Music/ Board Stiff Music. All rights for Top Notch Booty Music administered by BMG Rights Management (US) LLC. All rights for Board Stiff Music administered by Kobalt Music Publishing Limited.

"Gold": words and music by Iggy Pop, Daniel Pemberton, Brian Burton and Stephen Gaghan. Copyright © 2016 Top Notch Booty Music/Moncur Street Music Limited/Sweet Science. All rights for Top Notch Booty Music administered by BMG Rights Management (US) LLC. All rights for Moncur Street Music Limited administered by Peermusic (UK) Limited. All rights for Sweet Science administered by Kobalt Music Publishing Limited.

"The Pure and The Damned": words and music by Iggy Pop and Daniel Lopatin. Copyright © 2017 Top Notch Booty Music/Warp Music Limited. All rights for Top Notch Booty Music administered by BMG Rights Management (US) LLC, other rights by Warp Music Limited.

"Loves Missing": words and music by Iggy Pop and Leon Thomas Music. Top Notch Booty Music administered by BMG Rights Management. Leon Thomas Music administered by BMG Rights Management.

"The Dawn": words and music by Iggy Pop and Sarah Lipstate. Top Notch Booty Music administered by BMG Rights Management. Sarah Lipstate published by Mute Song Ltd.

All rights reserved.
Published in the United States by Clarkson Potter/Publishers,
an imprint of Random House, a division of Penguin Random House LLC, New York.
clarksonpotter.com

Originally published in hardcover in Great Britain by Viking,
a division of Penguin Random House Ltd., London, in 2019.

CLARKSON POTTER is a trademark and POTTER with colophon is
a registered trademark of Penguin Random House LLC.

Library of Congress Cataloging-in-Publication Data is available upon request.

ISBN 978-0-593-13597-6
Ebook ISBN 978-0-593-13598-3

Printed in China

Cover photographs: (front) Steve Emberton; (back) Steven Dewall/Redferns/Getty Images
Photograph credits appear on pages 278–279.
Text permissions appear on pages 280–285.

10 9 8 7 6 5 4 3 2 1

First American Edition